MICKAËL KRA

JEWELLERY BETWEEN
PARIS GLAMOUR
AND AFRICAN TRADITION

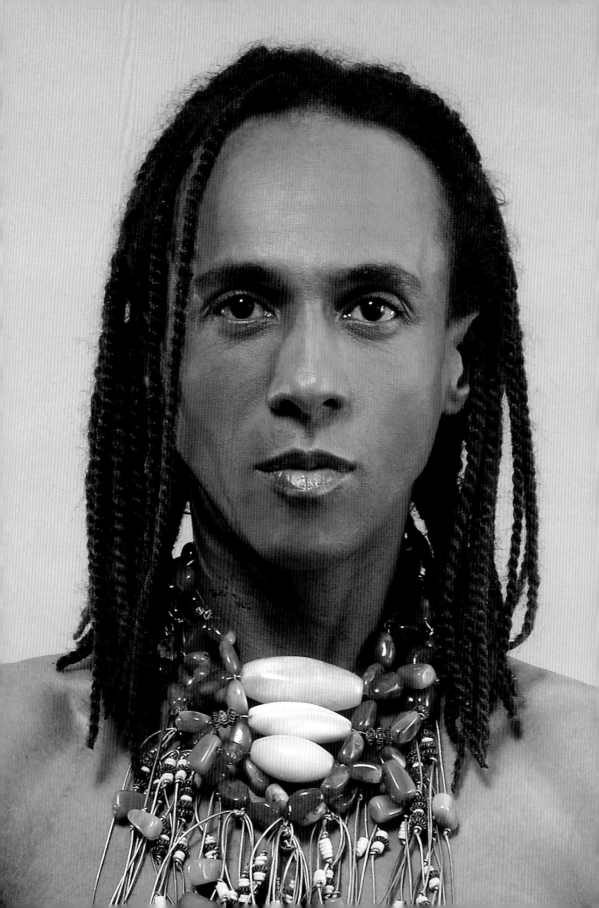

Annette Braun, Francine Vormese et al.

MICKAËL KRA
JEWELLERY BETWEEN
PARIS GLAMOUR
AND AFRICAN TRADITION

LEARNING
RESOURCES
CENTRE

ARNOLDSCHE

www.arnoldsche.com

Editor / Éditeur
Church Development Service – An Association
of the Protestant Churches in Germany (EED)
Service des Eglises Evangéliques en
Allemagne pour le Développement (EED)
Co-ordinator / Coordination
Annette Braun
Authors / Auteurs
Annette Braun / WIMSA Team
Esther Kamatari
Adam Levin
Sandra Tjitendero
Francine Vormese
Editorial work / Rédaction
Winfried Stürzl, Stuttgart
**Translation into French /
Traduction française**
Catherine Debacq, Stuttgart (Texts by WIMSA/
Annette Braun and Sandra Tjitendero)
Layout / Mise en page
Silke Nalbach, Karina Moschke,
nalbachtypografik, Stuttgart
Offset reproductions / Reproductions offset
Repromayer, Reutlingen
Druck / Impression
Rung-Druck, Göppingen

This book has been printed on paper that is
100% free of chlorine bleach in conformity
with TCF standards.
Ce livre est imprimé sur du papier blanchi
sans chlore et conforme aux normes TCF.

**Bibliographic information published by
Die Deutsche Bibliothek**
Die Deutsche Bibliothek lists this publication
in the Deutsche Nationalbibliografie; detailed
bibliographic data is available in the Internet
at http://dnb.ddb.de.

ISBN 10: 3-89790-226-5
ISBN 13: 978-3897-90226-8

Made in Europe, 2006

Photo credits / Crédit des illustrations
All photo credits are included in the captions
(see pages 164 – 169).
The licence-holders have been contacted
about permission to publish them here.
Since, in spite of minutious inquiries it has
not been possible to trace some licence-holder,
the publishers request anyone concerned in
this matter to contact ARNOLDSCHE Art
Publishers.
Tous les crédits des illustrations sont inclus
dans les légendes (voir pages 164 – 169).
Dans quelques cas, et en dépit de recherches
minutieuses, il ne nous a pas été possible
d'identifier les propriétaires des droits. Nous
les prions de se mettre en relation avec
l'éditeur.

Front Cover / Verso de couverture
Photo: Jaime Ocampo. Model/Mannequin:
Princesse Esther Kamatari. Styling/Stylisme:
Mickaël Kra

**The "Pearls of the Kalahari" collection /
La collection «Les Perles du Kalahari»**
The regional San (Bushmen) organisations
have established structures for the production,
ordering and marketing of the "Pearls of the
Kalahari" ready-to-wear collection. Marketing
this jewellery collection helps to ensure a
sustainable source of income for the San and
links outstanding design with Fair Trade
principles.
Les organisations régionales San (Bushmen)
ont établi des structures pour la production,
les commandes et le marketing de la collec-
tion prêt-à-porter des «Perles du Kalahari».
Le marketing de cette collection de bijoux
contribue à assurer une source de revenus
durable pour la population San et lie
un design éblouissant aux principes du
commerce équitable.

Botswana
Gantsi Craft
P.O. Box 196
RB – Ghanzi
Botswana
Phone: 002 67/659 62 41
E-mail: gantsicraft@botsnet.bw

Namibia
Omba Arts Trust
PO Box
SWA – 24240 Windhoek
Namibia
Phone/Fax: 002 64/61/24 27 99
E-mail: karin.leroux@omba.org.na

Europe
arts, interior Petra Lochbaum
An der Pforte 9
D – 63477 Maintal (Germany)
Phone: 0049(0)61 09/5 07 41 01
Fax: 0049(0)61 09/5 07 41 07
Mobile: 0049(0)163/4 24 21 01
petra.lochbaum@artsinterior.de
www.artsinterior.de

Contact
mickael.kra@noos.fr

Contents / Sommaire

Introduction

Francine Vormese

Silhouette longiligne, voix nonchalante, allure adolescente, Mickaël Kra se déplace avec la grâce d'un danseur. On l'imaginerait aisément chez William Forsythe ou à la compagnie Alvin Ailey. Parfois, avec ses cheveux mi-longs nattés, il évoque les princes de l'Égypte ancienne. Ou plus proches, les peuhls Woodabe, pasteurs nomades aux visages effilés, du Niger. Sa voix a tour à tour l'accent américain, parisien, ivoirien (quand il blague à coup de proverbes judicieux sur un comportement, un look, une élégante...). Son regard est rieur, mais avec des nuances de pudeur et de distance. Designer et artiste, Mickaël Kra aurait pu devenir architecte d'intérieur. Les hasards et les amitiés de la vie l'ont conduit vers les bijoux, les parures du corps, la Haute-Couture française et depuis peu, vers une aventure créative qui le plonge dans une joie quasi mystique. Invité à mener des ateliers chez les San, la population native dans le désert du Kalahari, en Namibie, puis au Botswana, il a créé avec eux la ligne «Les perles du Kalahari». «L'idée de ce workshop», explique Annette Braun, coordinatrice culturelle de l'organisation EED (Service des Églises Évangéliques en Allemagne pour le Développement), initiatrice du projet, «est de développer des savoir-faire nouveaux en matière de design chez les artisans San. A élaborer une nouvelle expression, fusion de la tradition et de la modernité». EED travaille en réseau avec des associations locales: leur objectif est de contribuer à préserver la culture des San en créant avec eux une dynamique économique durable.

Les San utilisent depuis des temps immémoriaux les coquilles d'œuf d'autruche. Actuellement, les coquilles sont récupérées dans les fermes d'élevage.

Une vingtaine environ de femmes et d'hommes ont participé aux ateliers, dessiné, travaillé coquilles d'œuf d'autruche, perles, peaux de chèvre. Une mutuelle inspiration vit le jour entre eux et Mickaël suscitant des bijoux originaux pour de nouvelles lignes et des pièces exclusives. Les difficultés techniques dues à l'isolement et donc au manque de matériel furent surmontées. Les fermoirs classiques sont trop chers à acquérir? Qu'à cela ne tienne, Mickaël invente une solution: se passer de fermoir en réalisant des colliers «bandoleros» que l'on enroule une ou deux fois autour du cou.

«Non seulement je me suis senti privilégié, dit Mickaël Kra, d'assumer cette tâche, mais j'ai eu aussi le sentiment qu'il était de mon devoir de transmettre

Introduction

Francine Vormese

A long, lanky silhouette, a nonchalant voice, an adolescent air: Mickaël Kra moves with the grace of a dancer. One might easily imagine him with William Forsythe or the Alvin Ailey company. At times, with his shoulder-length braided hair, he recalls the princes of ancient Egypt. Or, to take a more recent example, the Woodabe Fulani, pastoral nomads with sharp faces from Niger. His voice, by turns with an American, a Parisian and an Ivorian accent (when he is joking through wise sayings about behaviour, a look, a fashionista ...). His glance is smiling but with overtones of bashfulness and detachment. Both a designer and an artist, Mickaël Kra could have become an interior decorator. Chance and chance acquaintanceships led him towards jewellery, body necklaces, French haute couture and, only recently, towards a creative venture which plunges him into a state of almost mystical rejoicing. Invited to conduct some workshops with the San, the indigenous population of the Kalahari Desert in Namibia, he has created with them "The Pearls of the Kalahari".

"The idea behind this workshop," explains Annette Braun, cultural co-ordinator of the EED organisation (Church Development Service – An Association of the Protestant Churches in Germany), who initiated the project, "is to develop new skills in design among San artisans. To clarify the point with a current expression, a fusion between tradition and modernity." EED works by networking with local associations: their goal is to contribute to preserving San culture by creating with the San a lastingly dynamic economy.

The San have been using ostrich eggshells since time immemorial. Nowadays, the eggshells are obtained from ostrich farms.

About twenty men and women are to participate in the workshops, designing, working ostrich eggshells, pearls, goat skins. A mutual admiration has been born between them and Mickaël in reviving the original jewellery for new lines and one-off pieces. The technical difficulties resulting from isolation and, therefore, from material shortages, have been overcome. Classic clasps are too expensive to purchase? No problem at all, Mickaël invents a solution: do without a clasp by realising "bandolero" necklaces one wraps once or twice about one's neck.

"It's not just that I feel privileged," says Mickaël Kra, "on taking on this task, but I have also had the feeling that it was my duty to pass on my knowledge and my

mon savoir et mon expérience professionnelle à ceux qui survivent dans un profond dénuement. Et j'en ressens une sensation d'accomplissement. Une paix qui s'installe. »

Ivoirien par son père, français par sa mère. Mickaël Kra a l'âme métis. Ouverte sur le monde. Ses parents se sont rencontrés pendant leurs études en France. Il nait à Lille et vit sa petite enfance en Suisse. Ils rejoignent Abidjan en 1968. Mickaël, âgé de 8 ans fréquente le collège français où toutes les nationalités se croisent. La Côte d'Ivoire des années 70 considérée comme les Etats-Unis du continent, affiche fièrement la puissance de son melting-pot de dizaines d'ethnies.

Abidjan est une ville luxuriante. Débauche de fleurs et de couleurs. Cassias, bougainvillées, flamboyants, tulipiers du Gabon, hibiscus ... Cette opulence végétale, l'insouciance de ces années, font germer son goût du bonheur et des beautés du monde. Dans le jardin familial, il s'amuse à faire pousser ses fleurs.

Du collège, il se souviendra toujours d'une professeure, Madame Mouleau qui l'encourage à dessiner « elle m'a donné confiance ».

Abidjan et la Côte d'Ivoire vivent alors en pleine euphorie. Le pays est un producteur de confection industrielle qui dépasse l'Asie du Sud-Est.

Comme partout en Afrique de l'Ouest, chaque famille entretient des relations privilégiées avec les tisserands, ébénistes, teinturières, bijoutiers...

La mère de Mickaël Kra, artiste, décore la maison, commande des meubles auprès d'artisans. Elle lui inculque le respect du fait-main. Lui fait partager sa passion du beau, de la mode, des arts.

Il adore l'observer. Ses gestes, le temps qu'elle s'accorde, l'allure qu'elle élabore, l'élégance qui émane d'elle. Auprès d'elle, il apprend l'harmonie d'une robe bien coupée, l'impact de la chevelure, du maquillage, de la parure.

professional experience to those who have survived in such dire destitution. And I have a feeling of having accomplished something. Calm which is setting in."

Ivorian on his father's side, French on his mother's. Mickaël Kra has a hybrid soul. Open to the world. His parents met while studying in France. He was born in Lille and spent his infancy in Switzerland. They returned to Abidjan in 1968. Mickaël, at the age of eight, attended the French College, where all nationalities met. The Ivory Coast of the 1970s was regarded as the United States of the African continent, proudly advertising its potential as a melting pot of a great many ethnic groups.

Abidjan is an exuberant city. A riot of flowers and colours. Cassia, Bougainvillea, Flamboyant trees, Gabon tulip trees, hibiscus … The vegetal opulence, the care-free existence of those years, formed his taste for happiness and the beauties of this world. He enjoyed growing flowers in the family garden.

From the college he will always remember one teacher, Madame Mouleau, who encouraged him to draw: "she gave me confidence."

Abidjan and Ivory Coast were living a euphoric existence then. The country sur-passed South-East Asia as a producer of off-the-rack clothing.

As everywhere in West Africa, every family maintained privilege relations with weavers, furniture-makers, dyers, jewellery-makers …

Mickaël Kra's mother, an artist, decorated the house, ordering furniture from craftsmen. It was she who inculcated in him respect for what is handmade. Made him share her passion for beauty, fashion, the arts.

He loved to watch her. Her gestures, the pace she was attuned to, the charm she cultivated, the elegance she radiated. From being with her, he learned the har-mony of a well-cut dress, the impact made by hair, make-up, a necklace.

New York, that magical city
where I FIRSt arrived on
christemas day 1979....
M. KRA

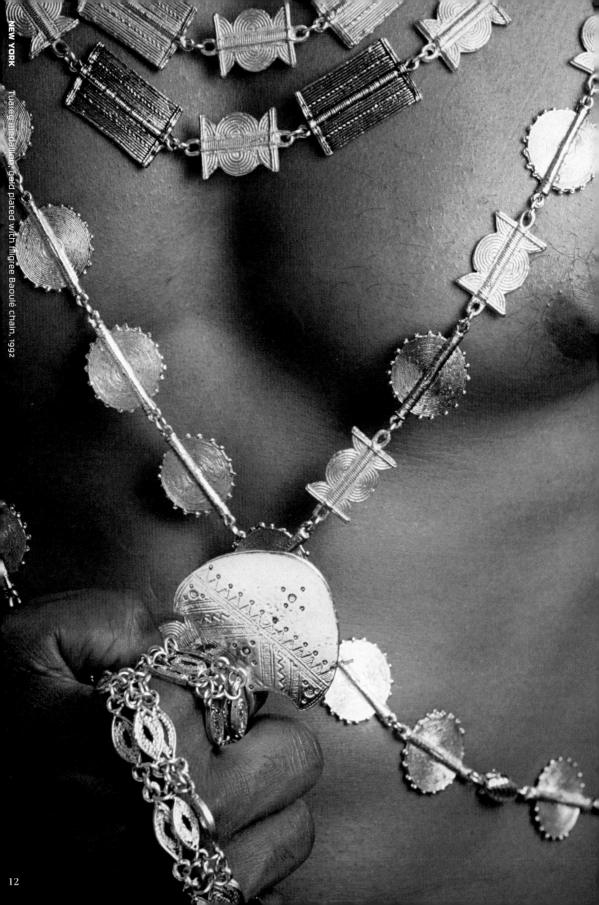

Tuareg medallion, gold plated with filigree Baoulé chain, 1992

NEW YORK

Francine Vormese

A 17 ans, il quitte Abidjan et arrive à New York une nuit de Noël. La ville, recouverte de neige, semble un décor entre kitsch et onirisme. Il marche sur Lexington avenue, émerveillé par les tours qui s'estompent sous les flocons. Suivent des jours fascinants de soleil et de neige. Lors d'un dîner, il rencontre Kevin Board. Kevin est maquilleur pour la presse de mode *(VOGUE)*, la télévision (NBC), le cinéma (Paramount). Mickaël s'installe à New York, perfectionne son anglais, étudie à la Parsons School of Design où il obtient un diplôme des Beaux-Arts.

« Killing me softly with his song », « God don't like ugly »... Avec Kevin Board il vit au rythme des chansons de la belle Roberta Flack, maman de Kevin, pianiste et chanteuse classique devenue lady de la soul music au début des années 70. Ils habitent à côté de Central Park, croisent Grace Jones, Yoko Ono. La vie s'accélère. Disco, paillettes et fêtes au Club 54, le grand night-club où dansent, posent, paradent les égéries de la mode et les inventeurs de looks les plus délirants.

L'époque est joyeuse, pétillante et libre. Art, mode, musique, la ville palpite d'énergies créatrices. Depuis sa «factory», Andy Warhol règne sur l'art et les noctambules mondains. Jean-Michel Basquiat, d'origine haïtienne et Keith Haring font entrer les graffitis dans l'histoire de la peinture. Robert Mapplethorpe photographie les orchidées et les Africains-américains avec la même délicatesse.

En ce début des années 80, Mickaël Kra rencontre Chris Seydou, LE grand couturier africain. Issu d'une famille de Bamako au Mali, Chris fait partie d'un groupe d'artistes qui ont réalisé l'importance de la tradition textile malienne. Il est inspiré par les bogolan, ces cotons épais aux motifs rares teints à la terre par des expertes dans les villages reculés du Mali et rassemblés par Kandiura Coulibaly. Chris Seydou y taille des tailleurs ultra sophistiqués avant de se passionner pour les broderies Dogon et les indigo. Il a compris les potentiels des textiles pour la naissance d'une mode africaine sur la scène internationale. Aussi, de passage à New York, il invite Mickaël Kra au SITHA, le premier Salon International du Textile Africain en 1984. Il détecte son talent pour les bijoux, l'incite à concentrer sa création. Il lui en commandera pour accessoiriser ses défilés. Ainsi Mickaël Kra commence une collaboration avec la couture africaine. Abidjan – New York, allers-retours inspirants, stimulants.

NEW YORK

Francine Vormese

At seventeen, he left Abidjan and arrived in New York on a night at Christmas time. Snow-covered, the city seemed like decoration between kitsch and dreamland. He walked down Lexington avenue, marvelling at the high-rise buildings, which were blurred by snowflakes. There followed some fascinating days of sun and snow. During a dinner party, he met Kevin Board. Kevin was a make-up artist for the fashion press *(VOGUE)*, television (NBC) and the cinema (Paramount). Mickaël settled in New York, perfected his English, studied at the Parsons School of Design, where he took a BA in Fine Art.

"Killing me softly with his song", "God don't like ugly"... With Kevin Board, he lived to the rhythm of the songs of the beautiful Roberta Flack, Kevin's mother, pianist and classical singer who had become the First Lady of Soul in the early 1970s. They lived alongside Central Park, met Grace Jones, Yoko Ono. Life speeded up. Disco, sequins and parties at Club 54, the famous night-club where the muses of fashion and the creators of the maddest looks danced, posed and showed off.

The era was joyful, sparkling and liberated. Art, fashion, music, the city throbbed with creative energies. Since "the Factory", Andy Warhol reigned supreme over art and chic nightlife. Jean-Michel Basquiat, Haitian by origin, and Keith Haring ensured that graffiti entered the annals of painting. Robert Mapplethorpe photographed orchids and African-Americans with the same exquisite tact.

In the early 1980s, Mickaël Kra met Chris Seydou, *the* great African couturier. The scion of a family from Bamako in Mali, Chris was a member of a group of artists who realised the importance of the Malian tradition of textiles. He was inspired by bogolans, thick cottons with sparse motifs painted with natural pigments by experts in the remote villages of Mali and collected by Kandiura Coulibaly. Chris Seydou made ultra-sophisticated suits of them before falling in love with Dogon embroideries and indigo cloth. He grasped the potential of textiles for regenerating African fashions on the international scene. So it came about that, passing through New York, he invited Mickaël Kra to SITHA, the first Salon International du Textile Africain in 1984. He spotted Mickaël's talent for jewellery, encouraged him to concentrate on creating it. He ordered it from Mickaël as accessories for his fashion shows. Thus Mickaël Kra embarked on a collaboration with African fashion. Abidjan – New York, inspiring, stimulating trips back

My First press clipping, 1985
Andy Warhol's Interview Magazine
M. Knu

17

Les lignes des architectures new yorkaises évoquent la structure des ors et des pagnes baoulé. « Baoulé »: l'ethnie qui descend de la reine Pokou, qui au XVIIIème siècle, guida son peuple menacé, depuis le royaume Ashanti au Ghana à l'actuelle Côte d'Ivoire. On dit que pour faire traverser tous ces sujets, elle offrit son unique enfant en sacrifice au génie de la rivière Comoé. La légende veut qu'après qu'elle eut jeté son fils en offrande dans l'eau, les hippopotames de la rivière s'alignèrent et firent avec leur dos, un gué qui permit à tous d'échapper aux poursuivants et de s'installer sur une terre paisible nommée par la reine Pokou ravagée de désespoir « Ba-ou-li », « l'enfant est mort ». Les orfèvres devenus « baoulé » perpétuèrent les savoir-faire de l'or Ashanti de leur Ghana originel.

C'est avec leurs descendants que Mickaël Kra entreprend à partir de 1986, de faire fabriquer à la cire perdue, les motifs de la ligne de bijoux qu'il appelle naturellement « Reine Pokou ». Il y interprète les parures traditionnelles. Mickaël et Kevin présentent la première collection à la galerie Kruger sur Madison Avenue. La culture ancestrale africaine s'affiche en broches, colliers, boucles d'oreilles sur les blondes américaines... Bientôt la production est réalisée à New York à partir des prototypes réalisés à Abidjan et Kevin Board distribue les modèles Reine Pokou. De Dallas à Beverly Hills en passant par San Francisco et New York, les grands magasins américains les plus prestigieux les diffusent: Neiman Marcus, Saks, Macy's ... La compagnie Air Afrique en vend sur ses lignes. De Paris à Dakar, d'Abidjan à New York, Reine Pokou, mot clé de l'élégance, achat coup de cœur, devient consommation identitaire. Le continent africain s'offrant un signe mode majeur, reconnaît la force esthétique de sa propre culture. Les belles de Cocody, quartier chic d'Abidjan, apprécient ces parures qui reflètent les fastes des cours ancestrales. Sans pour autant être des répliques de musée, car Mickaël Kra s'amuse à mêler les formes héritées des civilisations de l'or. La chanteuse Myriam Makeba, fidèle acheteuse, essaime leur renommée. Collier, boucles d'oreilles, bague, elle arbore Reine Pokou, notamment lorsqu'elle pose pour *ESSENCE* (le magazine mode des femmes africaines-américaines) qui lui décerne un Award en 1988.

Mickaël Kra comme Chris Seydou sont alors en phase avec Issey Miyake qui impose une mode non occidentale sur la scène internationale en réinterprétant les traditions stylistiques du costume et des textiles japonais. C'est ce que pratiquent alors Chris Seydou avec les bogolan ou Mickaël Kra avec les motifs des bijoux Reine Pokou.

and forth. The lines of New York buildings evoke the structure of gold jewellery and Baoulé rafia grass skirts. "Baoulé": the tribe descended from Reine Pokou (Queen Pokou), who, in the 18th century, led her people threatened with extinction from the kingdom of Ashanti in Ghana to what is now Ivory Coast. It is said that to ensure the passage of all her subjects, she offered up her only child to the spirit of the river Comoé. As the legend has it, no sooner had she cast her son as an offering into the water than the hippopotamuses in the river lined up and made a ford with their backs which permitted them all to escape their pursuers and to settle in a peaceful country named by Reine Pokou, devastated by despair at the loss of her son, "Ba-ou-li", "My child is dead". Goldsmiths who had become "Baoulé" perpetuated the Ashanti skill in making gold jewellery from their native Ghana. With their descendants, Mickaël Kra undertook from 1986 to make, using the lost-wax process of hollow-casting, motifs for the line in jewellery, which he, as a matter of course, called "Reine Pokou". In it he interpreted the traditional necklaces. Mickaël and Kevin presented the first collection at the Kruger Gallery on Madison Avenue. The ancestral African culture was showcased in brooches, necklaces, earrings on blonde American women ... Soon production was taking place in New York from prototypes realised in Abidjan and Kevin Board was marketing and distributing the Reine Pokou models. From Dallas to Beverly Hills, via San Francisco and New York, the most prestigious of the big American stores sold them: Neiman Marcus, Saks, Macy's ... The African airline Air Afrique sold them on its flights. From Paris to Dakar, from Abidjanto to New York, Reine Pokou, the buzzword for elegance, spontaneous purchases made because people simply fell in love with them, became the signature pattern of consumption. The African continent offering a major fashion signal, recognising the aesthetic power of its own culture. The beautiful women of Cocody, a chic section of Abidjan, appreciated those necklaces, which mirrored the ceremonial splendour of their forebears' courts. The singer Myriam Makeba, a faithful client, spread their fame. A necklace, earrings, a ring, she sported Reine Pokou, notably because she posed for *ESSENCE* (a fashion magazine for African-American women), which gave him an award in 1988.

Mickaël Kra and Chris Seydou were then in a phase like Issey Miyake, who was asserting non-occidental fashion by re-interpreting the stylistic traditions of Japanese textiles. That is what Chris Seydou was doing at the time with bogolans and what Mickaël Kra was doing with the motifs of his Reine Pokou jewellery.

REINEPOKOU

ABIDJAN · NEW YORK

AFRIC'ART.
rue Gourgas,
08 BP 1852 Abidjan 08
Tél : 22.57.82

AUX MASQUES D'OR.
av. Chardy,
01 BP 3298 Abidjan 01
Tél : 32.51.84

REINE POKOU.
08 BP 751 Abidjan 08
Tél : 41.30.03

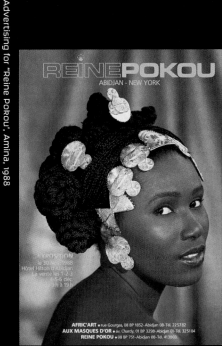

REINEPOKOU

ABIDJAN · NEW YORK

EXPOSITION
le 30 8 1988
Hôtel Hilton à Abidjan
La vente les 1-2-3
4-5-6 déc
9 h à 19 h

AFRIC'ART · rue Gourgas, 08 BP 1852-Abidjan 08-Tél. 225782
AUX MASQUES D'OR · av. Chardy, 01 BP 3298-Abidjan 01-Tél. 325184
REINE POKOU · 08 BP 751-Abidjan 08-Tél. 413003.

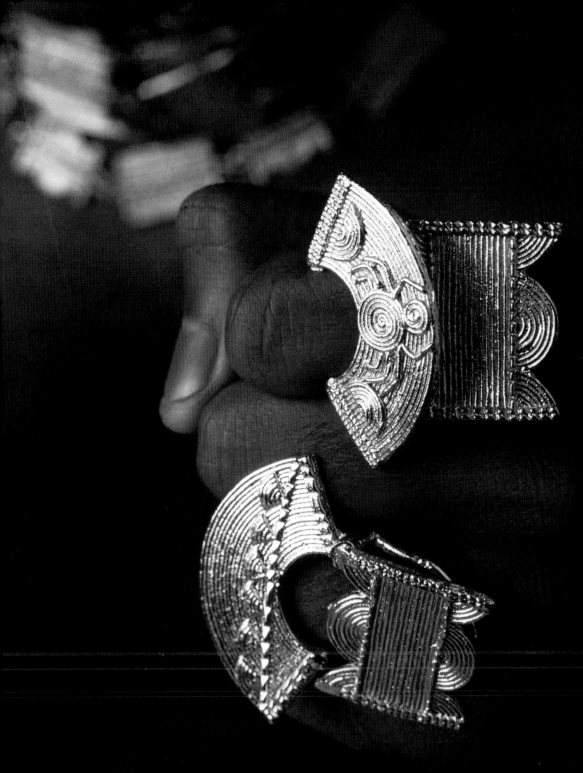

I owe everything to Kevin
He was the one who launched me
 into this profession.
Thanks to him that I am here
 Today.
What remains of him is a
wonderful memory,
a beautiful sunny day in my
 life.

N. KRA

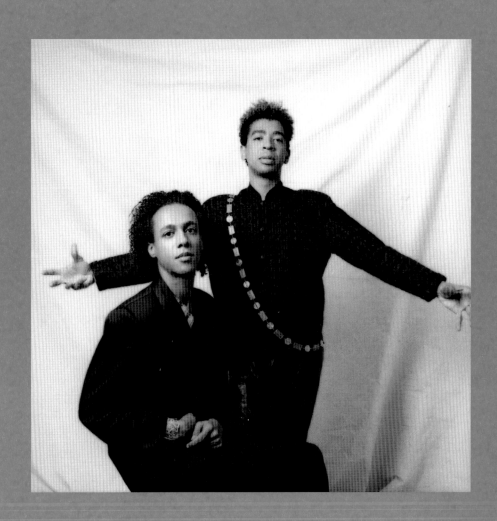

Baoulé weights on a dress worn by Kimi Khan. A tribute to Patrick Kelly. 1986

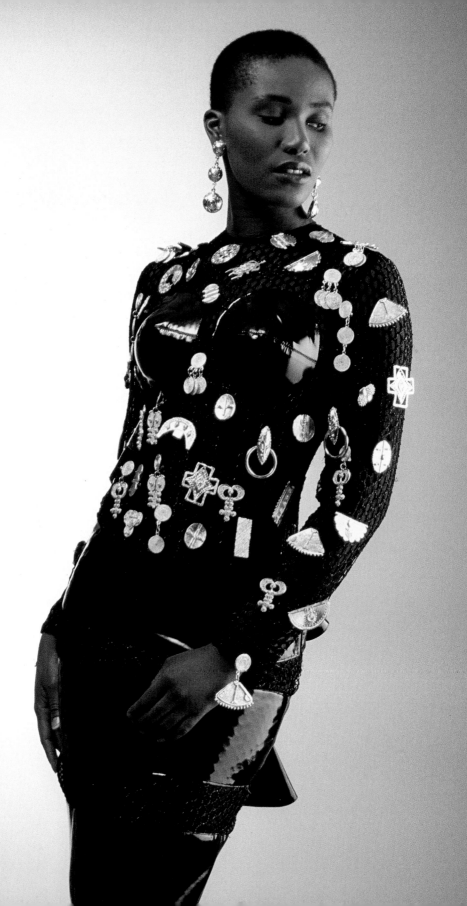

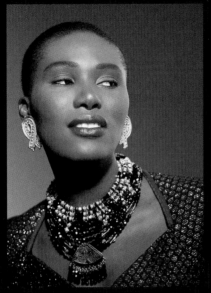

A choker of crystal beads, matching earrings, 1988

Kimi Khan
My First Muse.
My Reine Pokou.
My Ivorian Sister.

Л. Krat

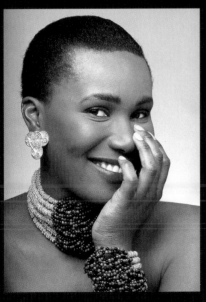

Necklace "Knots", malachite, lapis lazuli. Earrings "Club", 1987

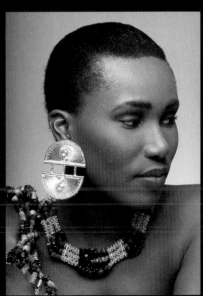

Tourmaline choker, earrings "Half-Moon", gold plated, 1987

25

Lapis 4MM Knot # 12
Malachite Necklace
onyx

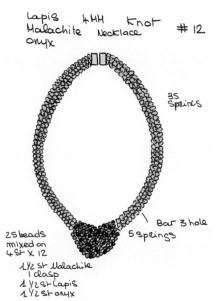

35
springs

Bar 3 hole
25 beads 5 springs
mixed on
4 St × 12

1½ St Malachite
 1 clasp
1½ St Lapis
1½ St onyx

Lapis · Malachite · Onyx 4MM
Masaï Collar ·
Pectoral ·

14

5 springs
1 spring
1 spring
1 spring
5 springs
1 spring

4 beads
5 "
6 "

w/ 12 strands ·

15 Bars 3 holes ·
1 clasp
3 St. springs ·
2 St Lapis
2 St Malachite
2 St onyx

Charm Necklace # 223
Mother of Pearl
w/ chain Triple

Mother of Pearl & Antique # 224
 Gold charm Bracelet
 w/ Triple chain

26

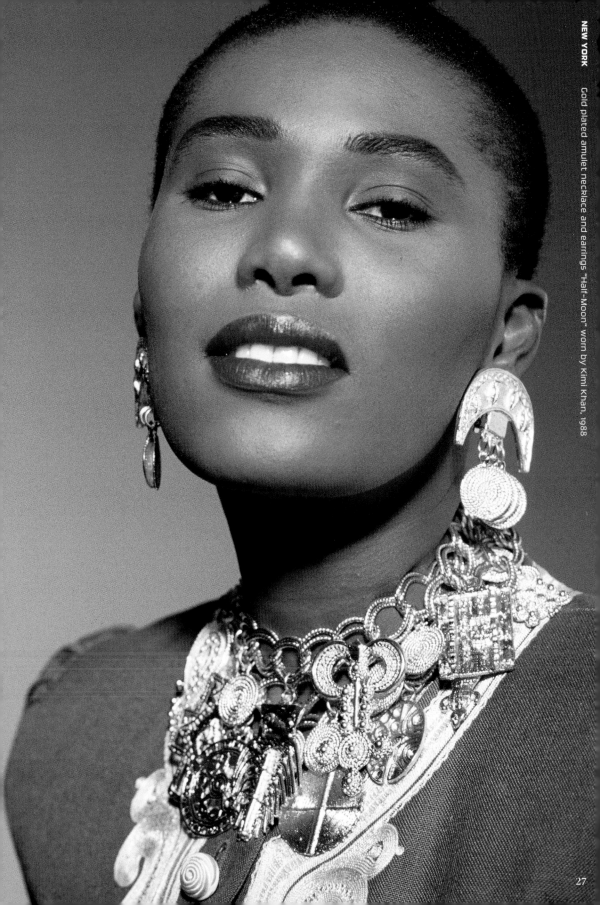

Gold plated amulet necklace and earrings "Half-Moon" worn by Kimi Khan, 1988

Patrick Kelly, the First
'Black Man at' the
Chambre Syndicale de la
couture " in France.
Patrick gave me my First
chance and choose
" Reine Pokou" to accessorise
his Panther collection. 1989
M. Kra

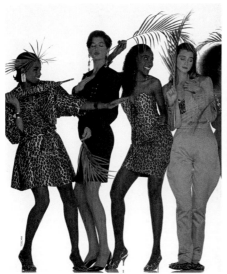

BLOOMINGDALE'S GRETA IF BOUTIQUE

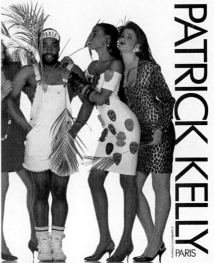

MACY'S NEW YORK NORDSTROM RUTH SHAW

PATRICK KELLY
PARIS

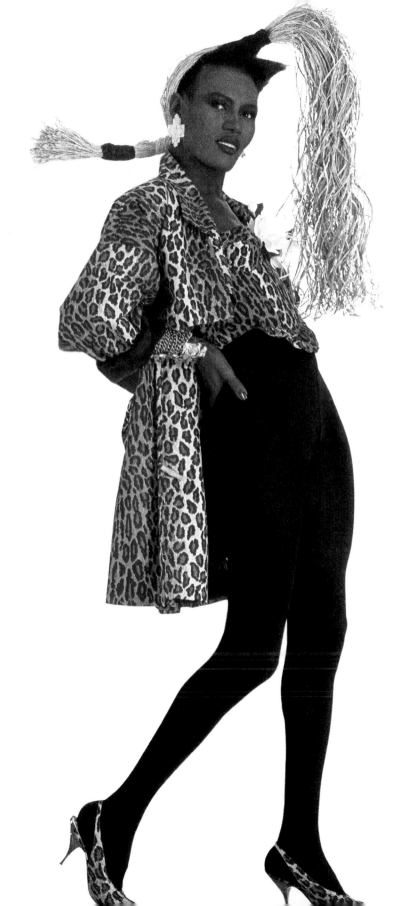

une pluie de Symboles
ruissolle sur la masselin
de condre et d'Indigo.
N.J.Sorbin Thomas

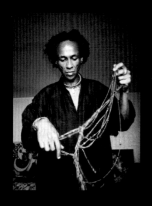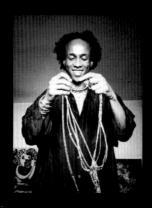

I am inhabited by beads.
N. KRA

30

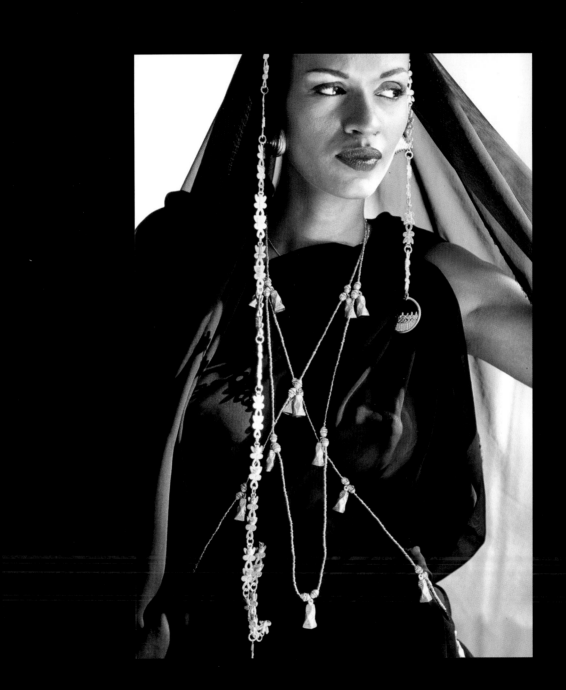

Ropes of beads "The knots of knowledge". Tuareg lead necklace and earrings "Cone", worn by Georgette Tra-Lou, 1997

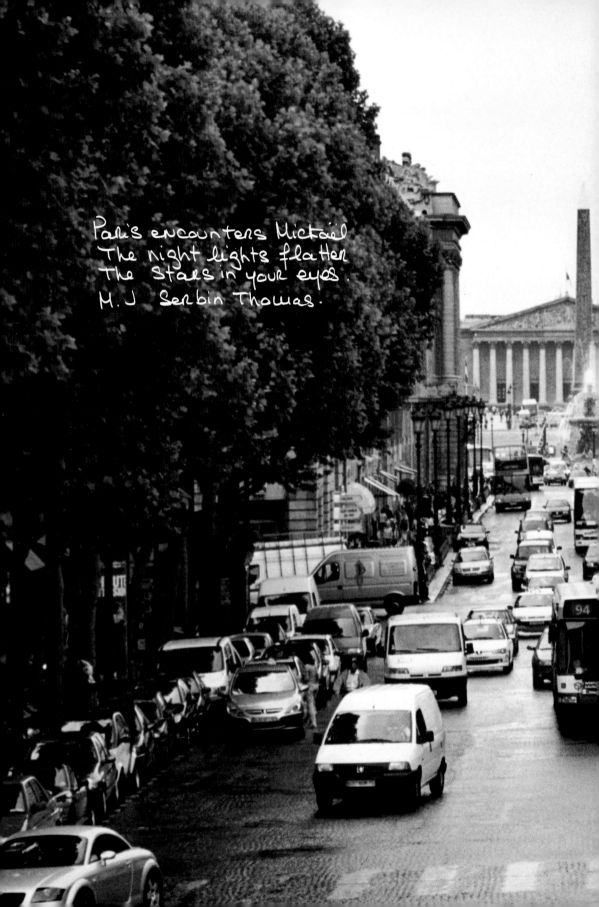

Paris encounters Mickaël
The night lights flatter
The stars in your eyes.
M.J Serbin Thomas.

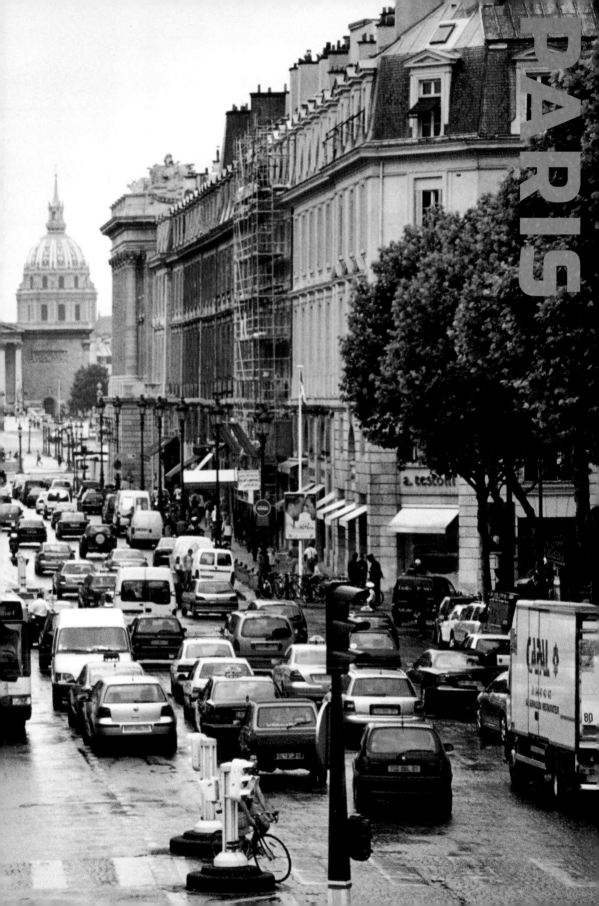

Necklace sauvage with hematite and lapis lazuli beads, matching earrings, salon Prêt à Porter, Porte de Versailles, Paris, with supermodel Debra Shaw, 1992

PARIS

Francine Vormese

Pendant les décennies 80–90, Paris s'entiche de mode ethnique. Une tendance black power culturelle dans la suite du «Black is beautiful» de l'Amérique contestataire des années 70. Elles sont lointaines désormais les réticences devant les premières mannequins noires engagées par Louis Féraud, Paco Rabanne et Courrèges dès les années 60. Donyale Luna pionnière, Mounia, Esther Kamatari, Pat Cleveland, Grace Jones, Tookie Smith, muses des seventies. Les années 80 voient Katoucha Niane et Khadidja chez Yves Saint Laurent et Kimi Khan, Iman, Veronica Webb, Roshumba, Waris Dirie avant le règne de Naomi Campbell.

En même temps que s'organisent les associations et actions humanitaires pour secourir l'Ethiopie frappée par la famine, un «besoin d'Afrique» s'affirme fortement. La jeunesse s'y reconnaît. Les branchés baptisent avec admiration les africains, «les blacks». S'adonnent au jungle-look. Adulent Yannick Noah vainqueur à Roland Garros en 1983. Frédéric Mitterrand écrit et filme ses belles «Lettres d'amour en Somalie». Bob Marley met les foules en transe. Kassav', Salif Keita, Mori Kante... Paris danse sur les rythmes zouk et soukouss. Les Touré Kunda sont au Zénith. Le Palace et les Bains Douches s'enorgueillissent de la présence des plus beaux mannequins blacks parisiens. Les néo-dandys griffés créateurs, se nomment les «sapeurs». Venus de Kinshasa, «Kin' la belle», ils paradent en boite de nuit. Gisèle Gomez sort première de l'école de stylisme Esmod et son mannequin est Kimi Khan qui de son côté incarne la «Mélissa métisse d'Ibiza», du clip de Julien Clerc. Le grand magasin du Printemps fait honneur au wax et montre en une expo ses usages en mode et en décoration. Le magazine *Actuel* réalise de nombreux reportages sur les musiciens du continent de Fela Kuti à Franco. Aux côtés de milliers de fans, Manu Dibango, Guy Cuevas, Jean-Paul Goude et Farida, assistant au concert de King Sunny Adé, consacrent l'idée d'une France riche de ses métissages.

Chris Seydou, après avoir travaillé deux ans chez Yves Saint Laurent, ouvre un show-room rue Lincoln. Les initiés découvrent dans son atelier l'interprétation des traditions, du tailleur bogolan à la petite veste du soir entièrement rebrodée à l'instar des plastrons de grands boubous. Mais ces broderies-là dessinent un néo-classicisme qui peut arpenter l'avenue Montaigne, Beverly Hills, la 5ème avenue à New York ou parader à Cocody avec la même superbe. Patrick Kelly est

PARIS

Francine Vormese

During the decades of the 1980s and 1990s, Paris was mad about ethnic fashions. A black power cultural trend as a follow-up to the "Black is beautiful" of conflict-riven 1970s America. From then on the ethnic fashions of those days would be a far cry from the restrained use of the first black models hired by Louis Féraud, Paco Rabanne and Courrèges in the 1960s. Donyale Luna was the pioneer, Mounia, Esther Kamatari, Pat Cleveland, Grace Jones, Tookie Smith, the muses of the '70s. The 1980s saw Katoucha Niane and Khadidja at Yves Saint Laurent and Kimi Khan, Iman, Veronica Webb, Roshumba and Waris Dirie before the reign of Naomi Campbell.

While associations and humanitarian campaigns were being organised to aid Ethiopia, stricken by famine, a "need for Africa" was taking on clear contours. Young people identified with it. Trendies christened Africans "Blacks" as a sign of admiration. Gave themselves up to the jungle look. Adored Yannick Noah, victorious over Roland Garros in 1983. Frédéric Mitterrand wrote and filmed his beautiful Lettres d'amour en Somalie. Bob Marley entranced crowds. Kassav', Salif Keita, Mori Kante ... Paris danced to the rhythms of Zouk and the souk. The Touré Kunda were at the Zénith. Le Palace and the Bains Douches took pride in the presence of the most beatiful black Parisian models. Slick neo-dandy designers styled themselves "sappers". Just arrived from Kinshasa, "Kin' the Beautiful", they strutted their stuff at night-clubs. Gisèle Gomez emerged as the star of the Esmod school of style and its model was Kimi Khan, who, for her part, was the "Half-Blood Queen Bee of Ibiza", from the Julien Clerc clip. *Actuel* magazine published a great many reports on musicians from the African continent, ranging from Fela Kuti to Franco. Alongside thousands of fans, Manu Dibango, Guy Cuevas, Jean-Paul Goude and Farida attended the concert given by King Sunny Adé, consecrating the idea of a France enriched by beings of mixed racial origin. After working for Yves Saint Laurent for two years, Chris Seydou opened a show-room in the rue Lincoln. The initiated discovered in his studio an interpretation of tradition, from the bogolan suit to the little evening jacket stiff with embroidery after the fashion of the front panels of the formal boubou (the robe worn by African men and women). But those embroideries marked a Neo-Classicism that could keep pace with avenue Montaigne, Beverly Hills, 5th Avenue

Mille et une nuit
Scherazade fascinée par
les feux de la ville des
lumières.

Une rencontre improbable
mais un rêve sans cesse
renouvelé.

M.J. Serbin Thomas.

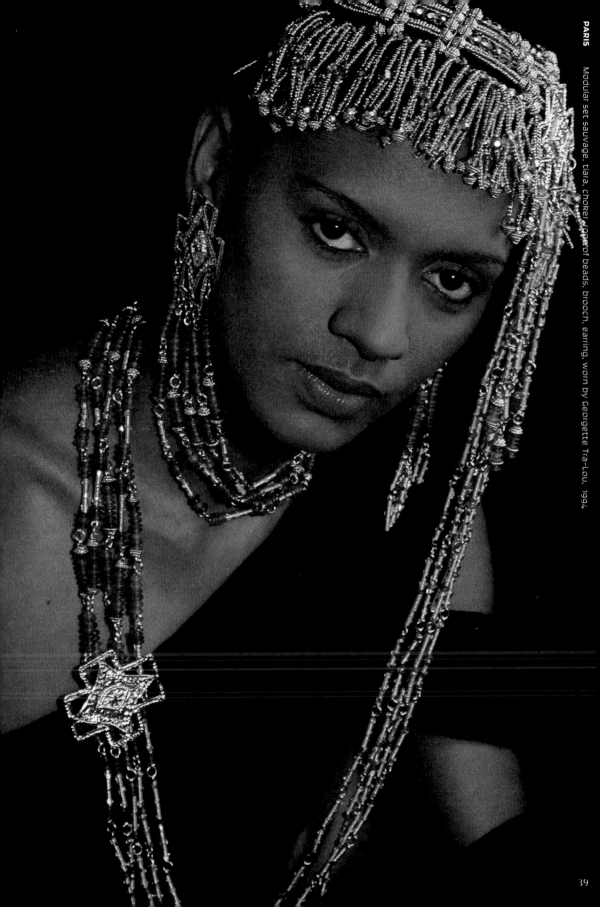

Modular set sauvage; tiara, choker, rope of beads, brooch, earring, worn by Georgette Tra-Lou, 1994

le premier «black», africain-américain, intégré à la Fédération des créateurs de mode. Il a les honneurs de la presse de mode. Le magazine *ELLE* plébiscite ses robes «tubes» qu'il a concocté avec du jersey de coton de La Soie de Paris, où viennent s'approvisionner les créateurs de mode. Lorsque Patrick Kelly confie sa pub au photographe Oliviero Toscani (qui sera ensuite le directeur artistique de Benetton), il demandera à Mickaël Kra d'accessoiriser les mannequins avec ses bijoux. Le magazine *AMINA* multiplie les couvertures avec les bijoux de Reine Pokou.

La situation, si propice au développement des bijoux de Mickaël, se trouve bouleversée par le décès de Kevin Board. Deuil au seuil de l'été. Une si belle amitié foudroyée en plein développement des idées, des projets, des joies à venir. Kevin disparu, Mickaël Kra traverse une période de chagrin immense. Katoucha Niane, égérie d'Yves Saint Laurent l'invite à Paris. «Katoucha, confie Mickaël, m'a réconforté, accueilli, en sœur». Fille de l'historien guinéen Djibril Tamsir Niane, Katoucha traverse les podiums parisiens avec une grâce altière. Paco Rabanne, Christian Lacroix, Yves Saint Laurent la font défiler comme une reine. Imprégnée de l'élégance de la Haute Couture et de ses audaces, elle encourage Mickaël à créer ses propres bijoux. «Katoucha m'a incité à présenter mes créations aux maisons de Haute Couture», explique-t-il, «et j'ai eu la chance de travailler avec des gens qui m'ont fait confiance».

Ainsi il va collaborer avec Oscar de la Renta qui signe les collections Balmain puis Louis Féraud pour neuf saisons. Leurs goûts pour l'exotisme luxuriant permet des bijoux importants. Ce ne sont pas pour autant des harnachements clinquants. Ecole de la rigueur érigée en sacerdoce, la Haute Couture impose le défi du travail le plus fabuleux et le plus subtil à réaliser en quelques jours et nuits. Mickaël Kra y prend ses marques, transfigure la disparition de Kevin en production incessante de splendeur, affine son style.

«J'aime que l'on ressente le poids d'un bijou, le contact, la fluidité», explique-t-il, «les formes fixes ne me suffisent pas, j'aime ce qui bouge, la notion de danse du bijou sur la peau. Un bijou qui fait corps sur soi, prend différentes formes, provoque des effets différents».

Décembre 93, Accra au Ghana. Chris Seydou fonde la Fédération Africaine des Créateurs de mode, la FAC, avec Collé Sow Ardo qui est sénégalaise, Alphadi du Niger, Pathé O' le styliste du Burkina installé en Côte d'Ivoire, Koffi Ansah du Ghana et Mickaël Kra bien sûr.

or display itself at Cocody with the same pride. Patrick Kelly was the first "black", an African-American, to be integrated in the French fashion federation. He was honoured by the fashion press. *ELLE* magazine voted for the "tube" dresses he concocted of cotton jersey from La Soie de Paris, where fashion designers came to stock up. When Patrick Kelly entrusted the photographer Oliviero Toscani (who would subsequently become artistic director at Benetton) with handling his publicity, he asked Mickaël Kra to provide his models with jewellery accessories. *AMINA* magazine multiplied its sales with the Reine Pokou jewellery.

This situation, so propitious for the development of Mickaël's jewellery, was suddenly shattered by the death of Kevin Board. Mourning at the threshold of summer. Such a beautiful friendship blasted in the midst of developing ideas, projects, joys to come. With Kevin gone, Mickaël Kra went through a period of acute distress. Katoucha Niane, Yves Saint Laurent's muse, invited him to Paris. "Katoucha", confides Mickaël, "comforted me, welcomed me like a sister." The daughter of the Guinean historian Djibril Tamsir Niane, Katoucha crossed Parisian catwalks with a haughty grace. Paco Rabanne, Christian Lacroix, Yves Saint Laurent had her show fashions like a queen. Imbued with the elegance of haute couture and its daring, she encouraged Mickaël to create jewellery that was really his own. "Katoucha encouraged me to present my creations to the bastions of haute couture," he explains, "and I had the good fortune to work with people who gave me self-confidence."

Thus he came to collaborate with Oscar de la Renta, who was responsible for the Balmain collections and then Louis Féraud for nine seasons. Their taste for the sumptuously exotic allowed for important jewellery. Nevertheless, those pieces were not clinking harnesses. A strict school elevated to high-priest status, haute couture imposed the challenge of realising the most fabulous and subtle work within the space of just a few days and nights. Mickaël Kra found his bearings there, came to terms with the loss of Kevin by working incessantly on producing splendid things, refining his style. "I like it when the weight of a piece of jewellery is felt, the contact with it, its fluidity," he explains, "rigid forms aren't enough for me, I like what moves, the idea of jewellery dancing on the skin. A piece of jewellery which is at one with the body, assumes different forms, creates different effects."

December '93, Accra in Ghana. Chris Seydou co-founded the FAC (Federation of African Fashion Designers) with Collé Sow Ardo, a Senegalese, Alphadi from Niger,

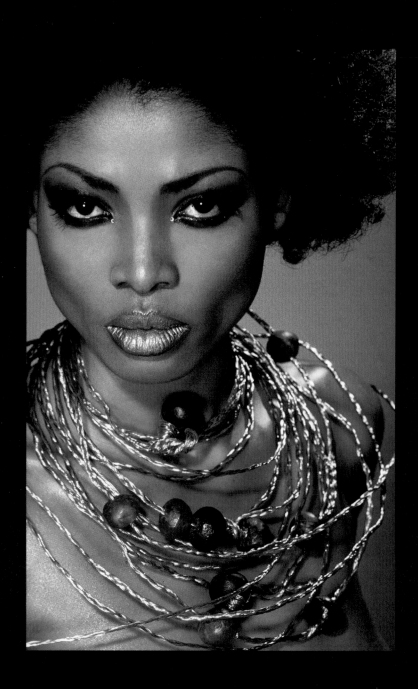

Necklace made of plated orange copper wire and glass beads, worn by Sylvie, 2000

Necklace shower of jet and belt of Baoulé weights worn by Raili. Tribute to Claire Kane, 1997

Les espoirs fondés sur le lancement de la FAC se trouvent freinés en 1994, année de tous les bouleversements. Le 11 janvier la dévaluation du franc CFA permet cependant d'envisager de multiplier les exportations. Mais Chris Seydou s'éteint à Bamako le 4 mars et laisse la FAC à elle-même. Le 8 avril, le génocide rwandais plonge la communauté internationale dans l'horreur. Le 27 avril, l'élection magnifique du président Nelson Mandela, rétablit la dignité de la communauté noire du monde entier.

En septembre de cette même année, les instances économiques européennes invitent les stylistes à participer au salon du prêt-à-porter à Paris. La couture africaine affronte un salon régi par des habitudes industrielles, un marketing implacable, des délais de livraisons sous pression. Qu'à cela ne tienne! Accompagnés par «Seven seconds» le hit qui consacre Youssou Ndour superstar de la musique africaine, Alphadi, Koffi Ansah, Collé Sow Ardo et Mickaël Kra font leurs défilés, avec superbe et enthousiasme. Ils feront l'ouverture du magazine *ELLE* deux semaines plus tard et les bijoux Reine Pokou que Mickaël Kra a accroché en constellation sur un turban et une crinoline en toile de jute, se retrouveront en pleine page. Ainsi les deux millions et demi de lecteurs de *ELLE*, découvriront l'existence d'une couture africaine. Ce n'est pas pour autant que celle-ci va trouver des appuis financiers immédiatement. L'incrédulité subsiste, héritée d'anciens préjugés coloniaux quand la question de la mise en place d'une véritable industrie de la mode est posée. Pourtant, l'Afrique n'a-t-elle pas une puissance créatrice telle qu'elle a inspiré le mouvement cubiste? N'est-elle pas aux sources de l'abstraction? N'a-t-elle pas généré des formes du design contemporain?

Toujours cool, Mickaël Kra décide de se concentrer sur la production de pièces uniques, entre ses collections pour Louis Féraud.

Créer est une démarche artistique. A Paris, il travaille chez lui, la nuit avec de musique, entouré de quelques objets africains classiques. Face à lui, un stockman et ses matériaux de prédilection: perles d'argile ou de verre recyclé, cuivre, poids baoulé, motifs dorés. Au cours des nuits, surgissent des bijoux qu'il pense comme des vêtements à part entière.

Il inverse ainsi la fonction du bijou: de simple accessoirisation d'une robe, le bijou selon Mickaël Kra devient élément central. Le vêtement qu'il conçoit pour ses défilés est un drapé qui tourne autour du bijou, devient sa toile de fond.

Pathé O', a stylist from Burkina Faso who had settled in Ivory Coast, Koffi Ansah from Ghana and, of course, Mickaël Kra.

The hopes based on the launch of the FAC were nipped in the bud in 1994, the year of so many upheavals. The devaluation of the CFA franc on 11 January, however, made a growth in exports foreseeable. However, Chris Seydou died at Bamako on 4 March, leaving the FAC to its own devices. On 8 April, genocide in Ruanda horrified the international community. On 27 April, the magnificent election of Nelson Mandela as president re-established the dignity of the black community throughout the world.

In September that same year, European big business invited designers to take part in the off-the-rack salon in Paris. African fashion design was an affront to a salon under the sway of industrial habits, implacable marketing, strictly enforced delivery timetables. No problem! To the accompaniment of "Seven seconds", the hit song which made Youssou Ndour a superstar of African music, Alphadi, Koffi Ansah, Collé Sow Ardo, and Mickaël Kra held their fashion show proudly and enthusiastically. Two weeks later they featured as the cover story in *ELLE,* and the Reine Pokou jewellery which Mickaël Kra had clustered on a turban and a hessian crinoline were given the full-spread treatment. Thus the two and a half million readership of *ELLE* discovered the existence of African fashion. Unsurprisingly, it immediately found financial backing. Incredulity persisted, however, inherited from ancient colonial prejudices when the question of establishing a real fashion industry arose. However, didn't Africa have creative powers which had inspired the Cubist movement? Wasn't it the wellspring of abstraction? Hadn't it generated forms of contemporary design?

Without ever losing his cool, Mickaël Kra decided to concentrate on producing one-off pieces between his collections for Louis Féraud.

Designing is a creative undertaking. In Paris, he worked at home, at night to music, surrounded by some classic African objects. Across from him, a stockist and his materials of choice: beads of clay or recycled glass, copper, Baoulé weights, gold motifs. During those nights, pieces of jewellery emerged which he thought of as separate pieces of clothing.

Thus he reversed the function of jewellery: from simple accessory to be worn with a dress, a piece of jewellery became a pivotal element of dress according to Mickaël Kra. The dress he conceived for his fashion shows is drapery which revolves around a piece of jewellery, becoming its support.

Ascot necklace of curly copper beads and beads of hematite and aquamarine, worn by Victoria, 1999

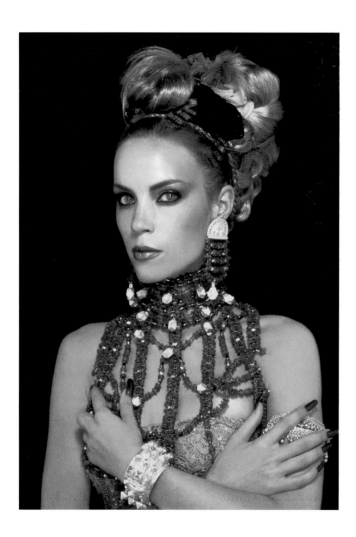

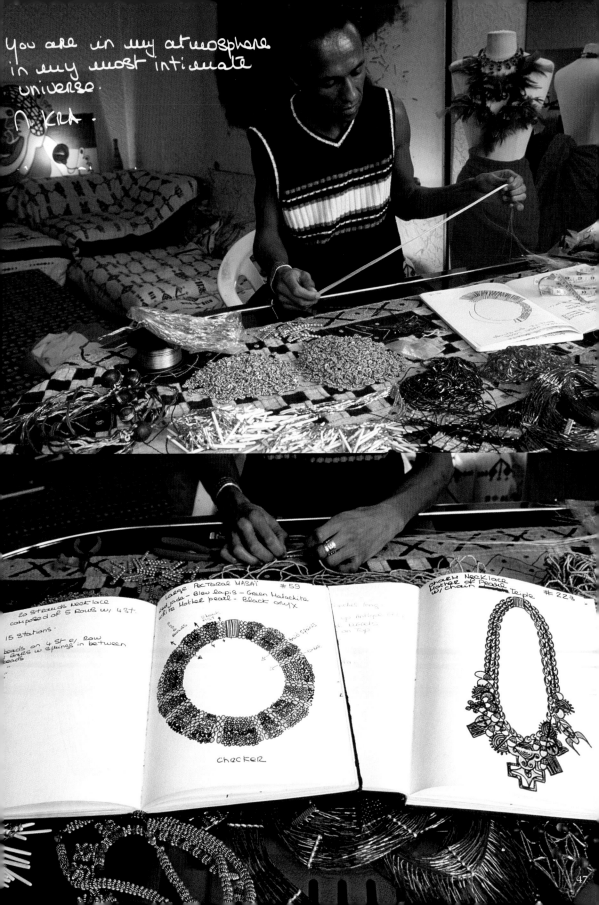

You are in my atmosphere
in my most intimate
universe.
AKRA.

Large Pectoral MASAI #59
Red Jade - Bleu lapis - Green Malachite
White Mother pearl - Black onyx

CHECKER

GREEN Necklace
Mother of Pearl
w/ chain Triple #223

20 Strands Necklace
composed of 5 Rows w/ 4 St.

15 stations:

beads on 4 St e/ Row
3 Brass w 4 mings in between
beads

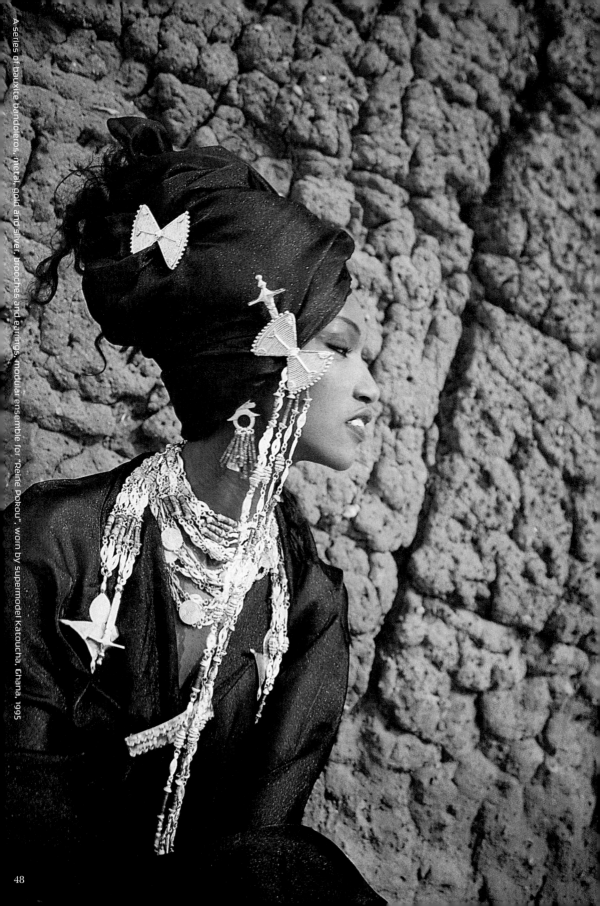

A series of bauxite bandoleros, metal, gold and silver, brooches and earrings, modular ensemble for "Reine Pokou", worn by supermodel Katoucha, Ghana, 1995

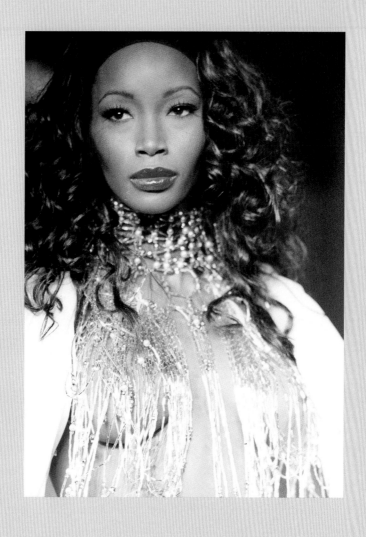

Katoucha Forever
our Collaboration has been
a Revelation to me.

N. KЯA

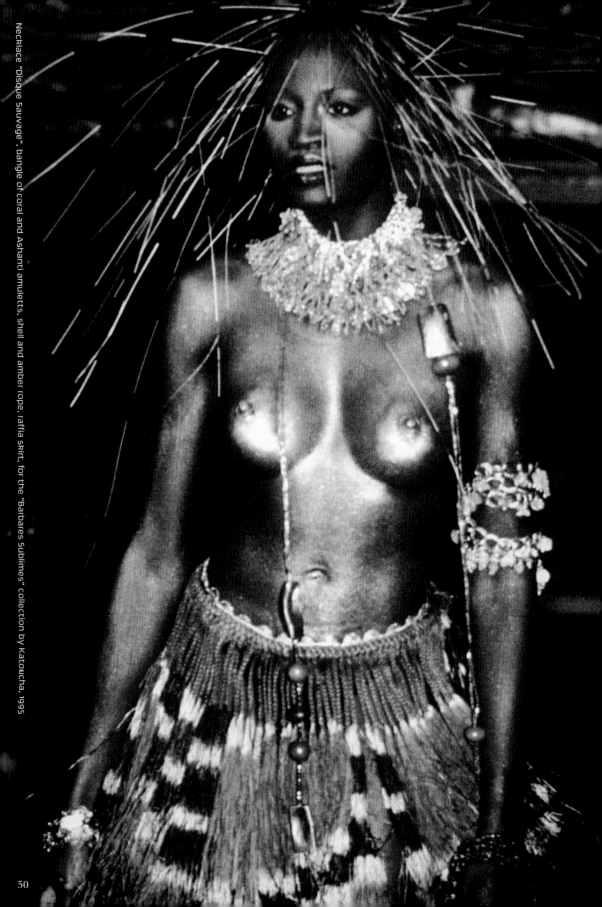

Necklace "Disque Sauvage", bangle of coral and Ashanti amuletts, shell and amber rope, raffia skirt, for the "Barbares Sublimes" collection by Katoucha, 1995

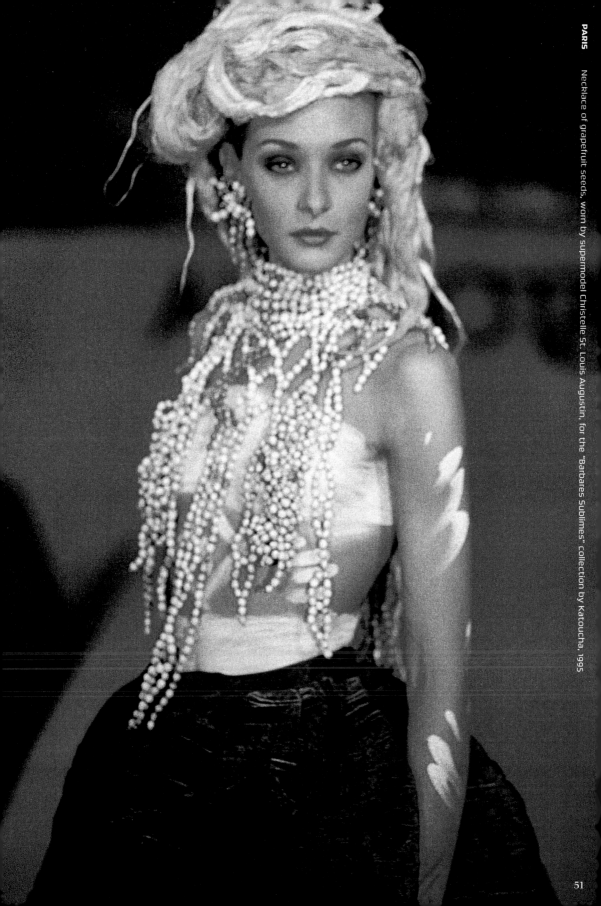

Earrings worn by supermodel Anna Getaneh, for Katoucha, 1994

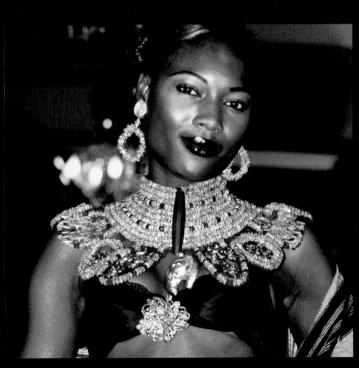

Necklace and creols, worn by supermodel Mekissi, for Katoucha, 1997

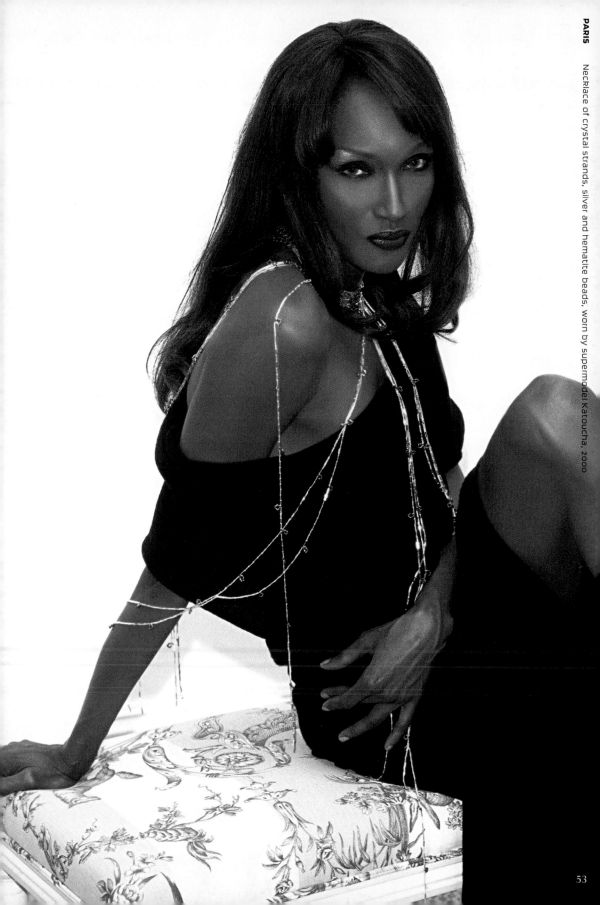

Necklace of crystal strands, silver and hematite beads, worn by supermodel Katoucha, 2000

53

Necklace of hematite and glass beads and oxidised silver-plated springs, gunmetal, for Alphadi, "Opal", Carrousel du Louvre, Paris, 2001

54

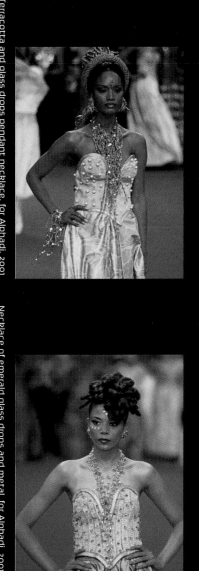

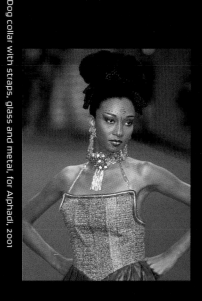

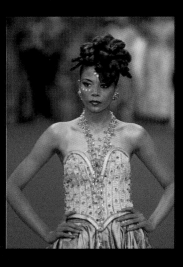

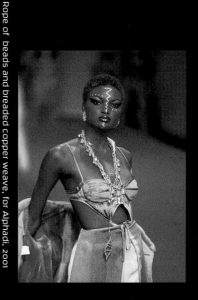

Alphadi is a magician. His work is over the top !!!

He let me add the finishing touch to his clothes.

It's great to meet and to enter into the soul of a designer.

N. KRA

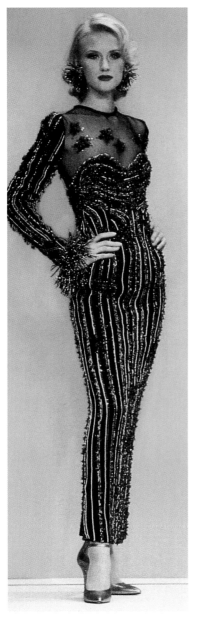

Necklaces "Fiery Orange". Necklace and bracelets in organic forms, glass beads, for Louis Féraud, haute couture, autumn/winter 1995/96

Necklaces "Midnight Blue". Bracelets sauvages, fringed with glass cylinder beads and drops, for Louis Féraud, haute couture, autumn/winter 1995/96

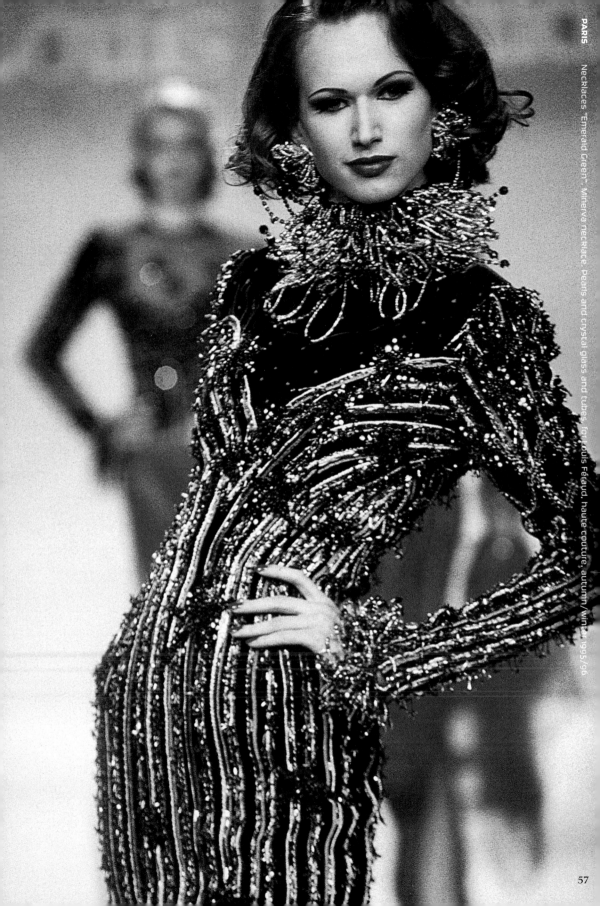

Necklaces "Emerald Green". Minerva necklace. Pearls and crystal glass and tubes, for Louis Féraud, haute couture, autumn/winter 1995/96

MR Louis Féraud was the one
who opened his arms, his house
to me.
He expecTed me To Keep an eye
on Myself, on Africa.
The one that we love : fluid
magic, hot, black, lit by
the Sun of a thousand fire
Noble, Supple or exuberant.
Louis Féraud and his Team
(Elga, Ki Ki, Astrid)
Represented to me a time when
I built up myself.
Imagine trying on jewelry
with Top models in the Salons
Rue du Faubourg St Honoré.
What a joy !

CM KAA.

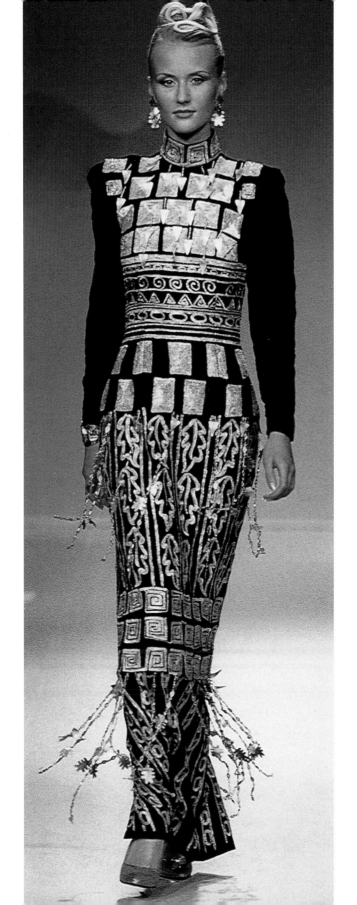

Dress embroidered with Ashanti filigree pendant chains, for Louis Féraud, haute couture, autumn/winter 1997/98

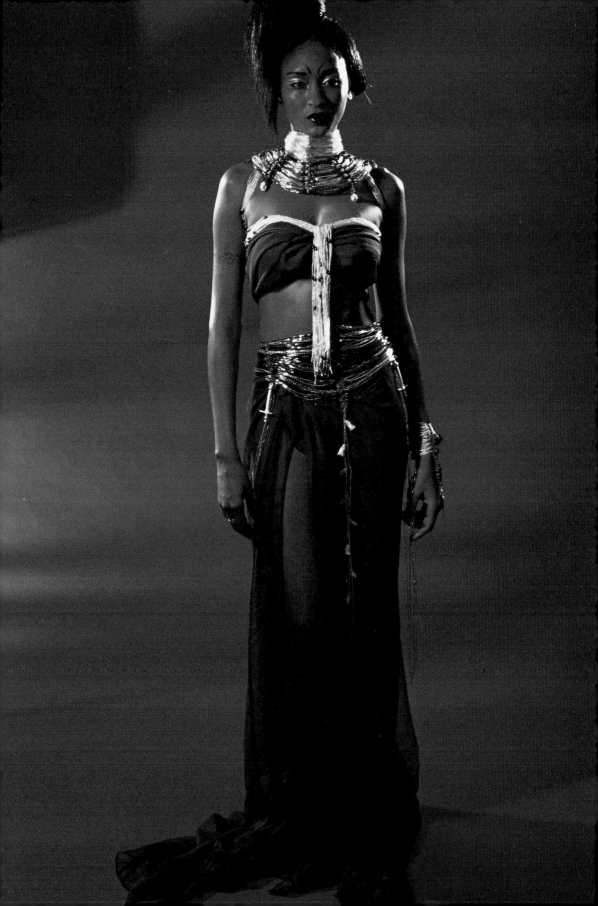

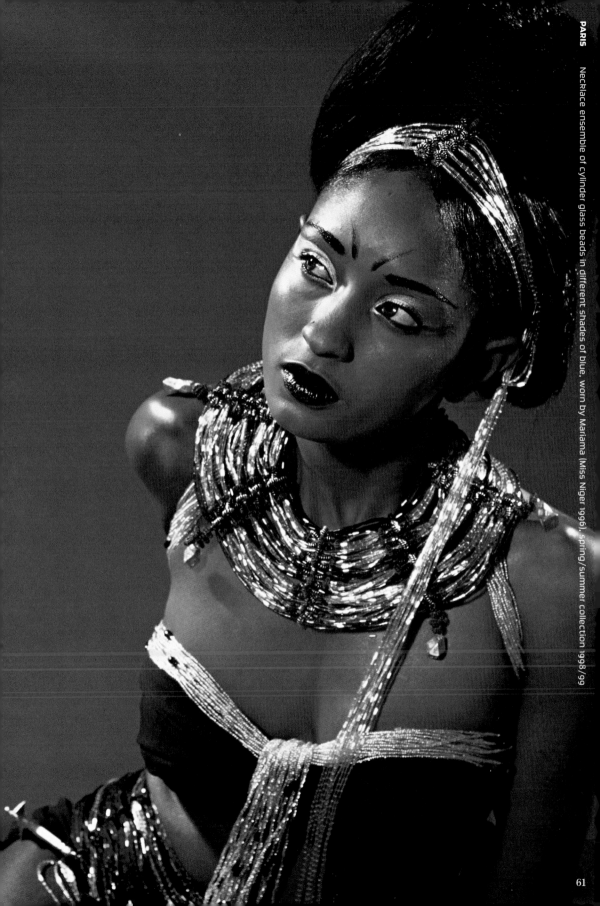

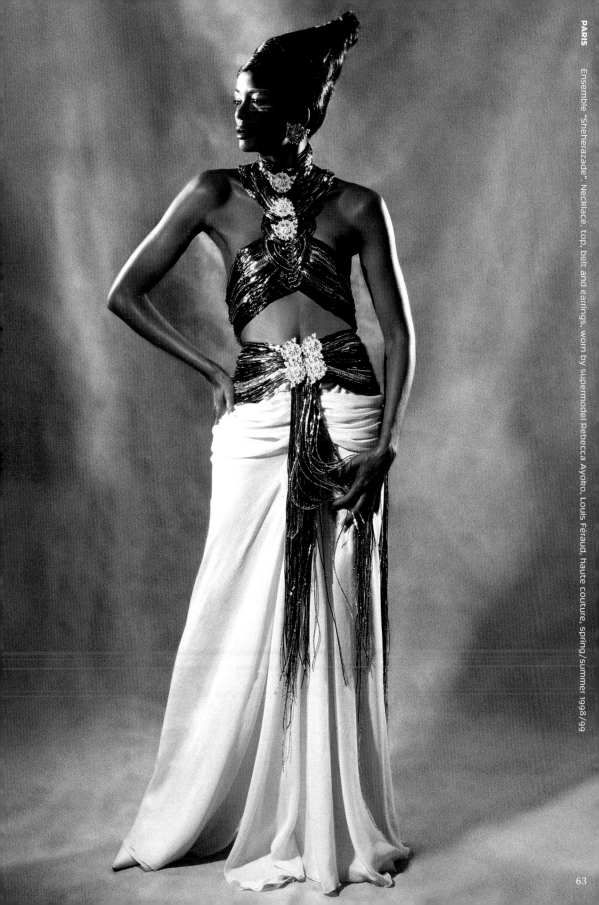

PARIS

Ensemble "Sheherazade". Necklace, top, belt and earrings, worn by supermodel Rebecca Ayoko, Louis Féraud, haute couture, spring/summer 1998/99

Necklace of curly beads, silver and oxidised silver with an Agadez cross, ready-to-wear version, 1999

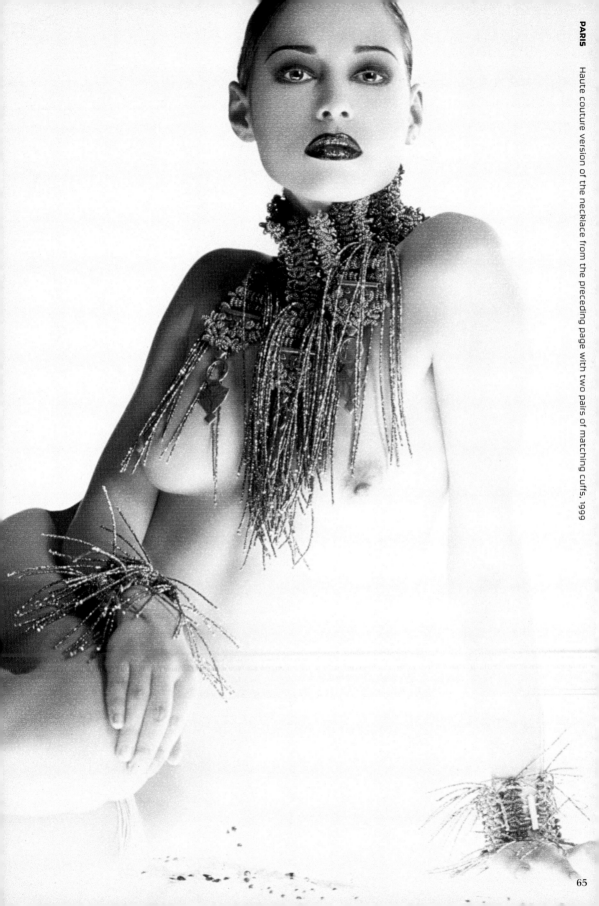

ffic

Haute couture version of the necklace from the preceding page with two pairs of matching cuffs, 1999

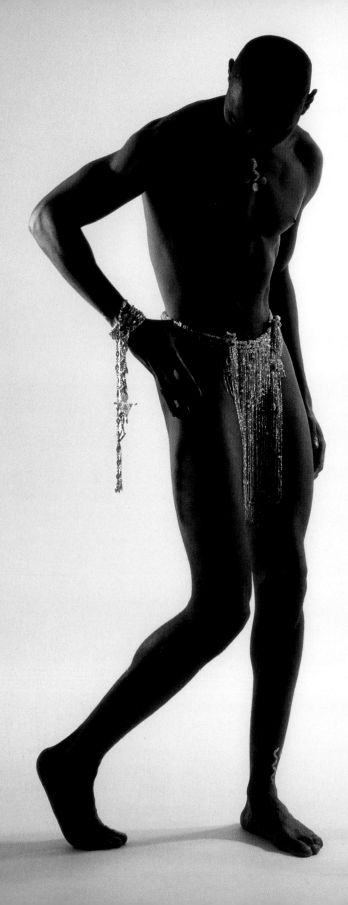

Haute couture loincloth of glass, crystal and metallic beads with a bandolero bracelet and a Tuareg hammer pendant, worn by Eric Enyenque, 1998

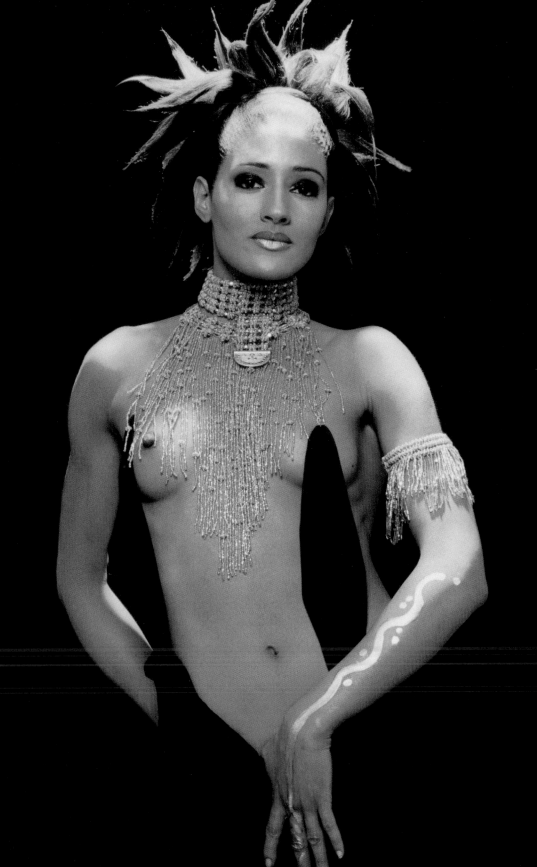

PARIS

Ensemble, dog collar "Half-Moon" with Baoulé weights in gold with glass beads and matching flowing necklace and bracelet, 1998

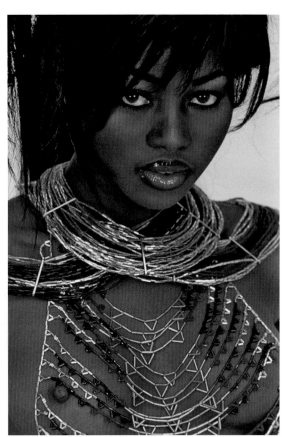

Set of Masai disc necklaces in multicolour glass beads with a net collar, worn by Valérie K., 1998

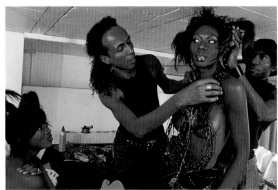

Preparation with models and Eddie Kapesa, 1998

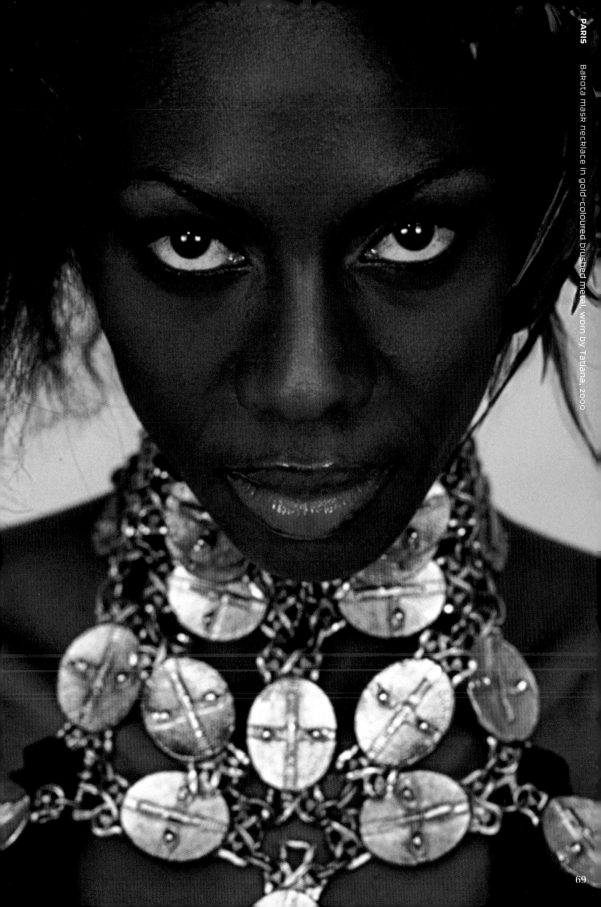

Barota mask necklace in gold-coloured brushed metal, worn by Tatiana, 2000

69

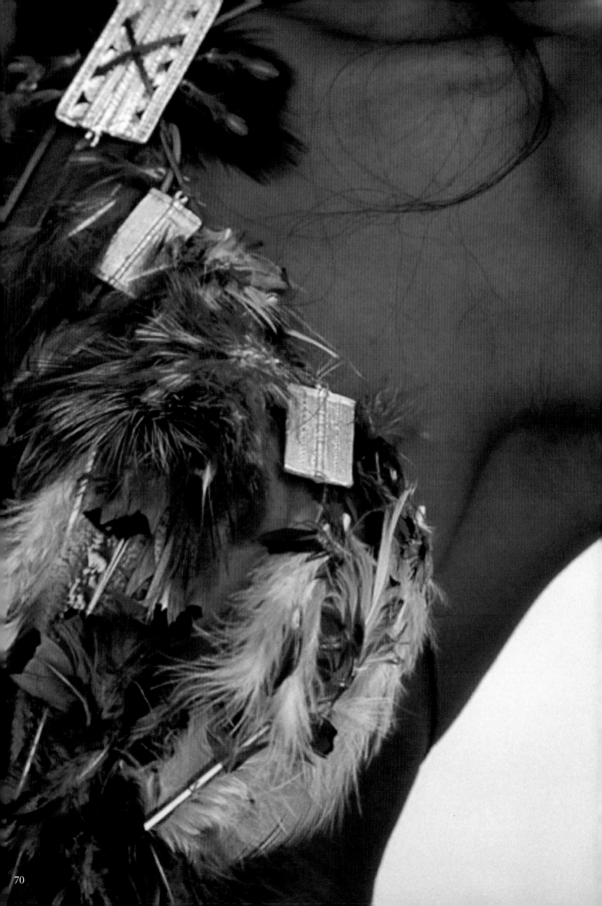

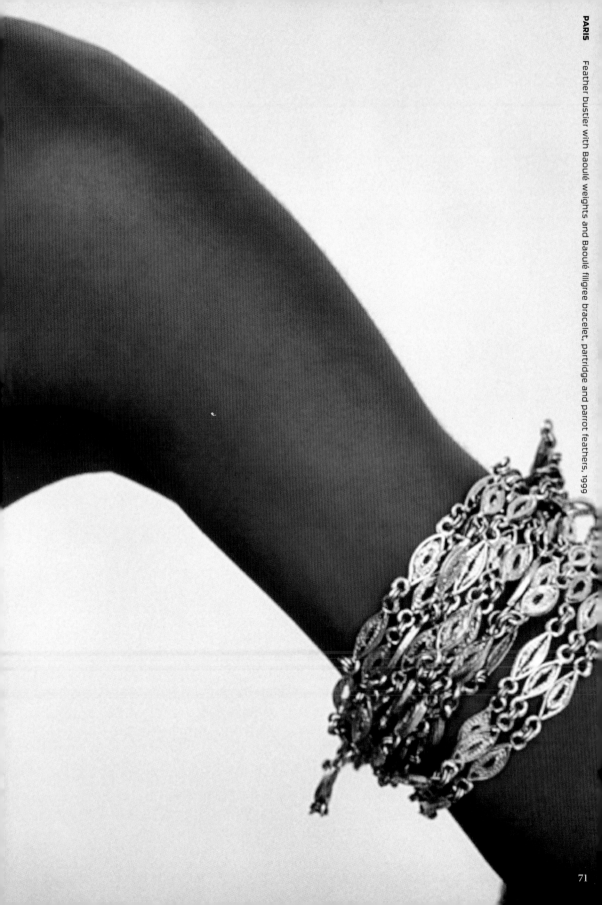

Feather bustier with Baoulé weights and Baoulé filigree bracelet, partridge and parrot feathers, 1999

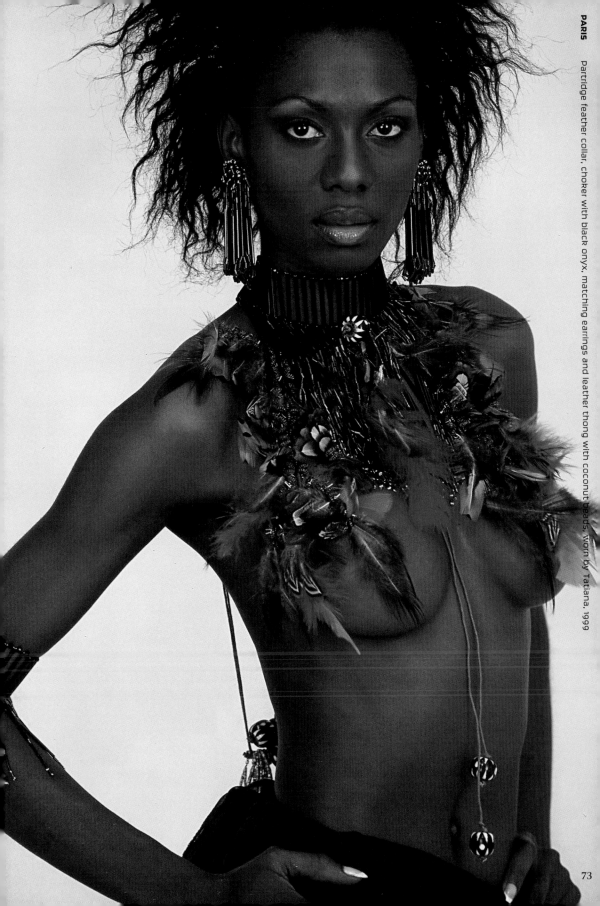

partridge feather collar, choker with black onyx, matching earrings and leather thong with coconut beads, worn by Tatiana, 1999

Margareth is one of my
favorite models.

"Black Venus de Milo"
Ul. Kra

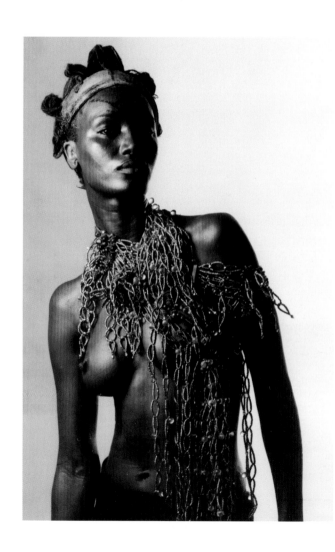

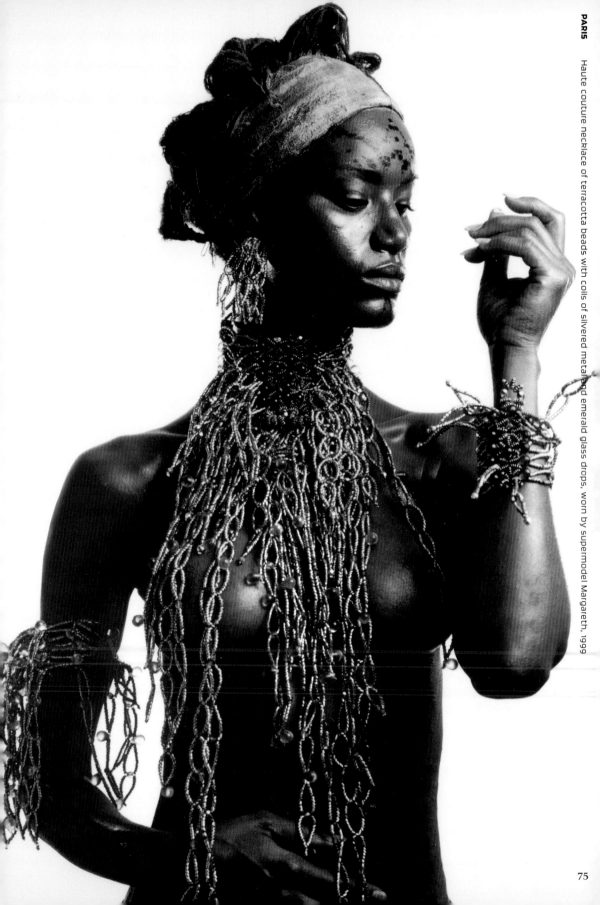

Haute couture necklace of terracotta beads with coils of silvered metal and emerald glass drops, worn by supermodel Margareth, 1999

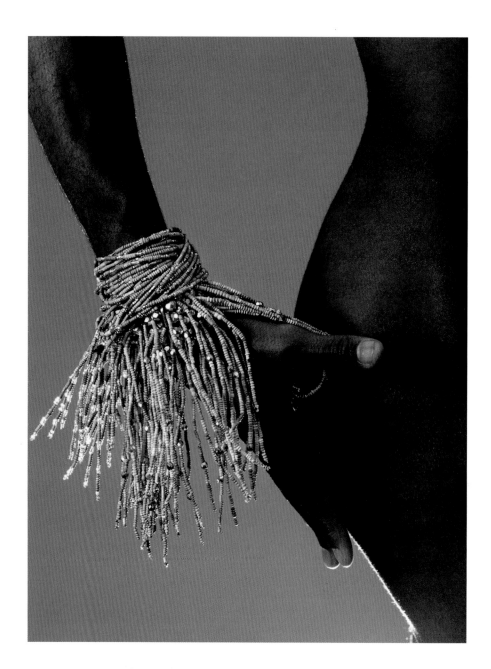

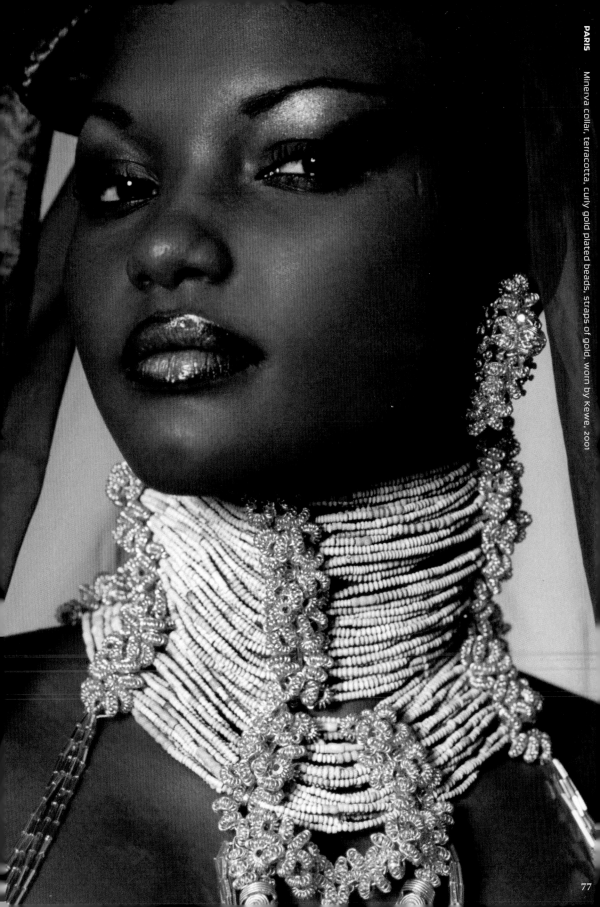

Minerva collar, terracotta, curly gold plated beads, straps of gold, worn by Kewe, 2001

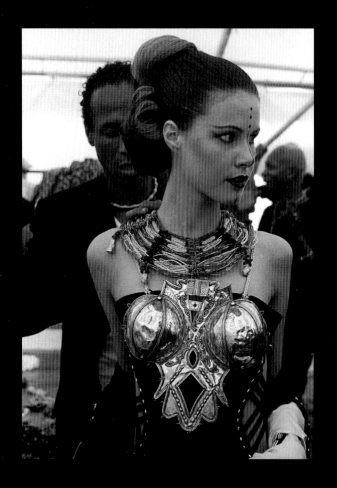

Garo was the FiRST major hair Stylist to encourage me by buing Some of my pieces in Ivory coast, publicising me and ordering Jewelry For The "Mondial de la coiffure".

N. KRA

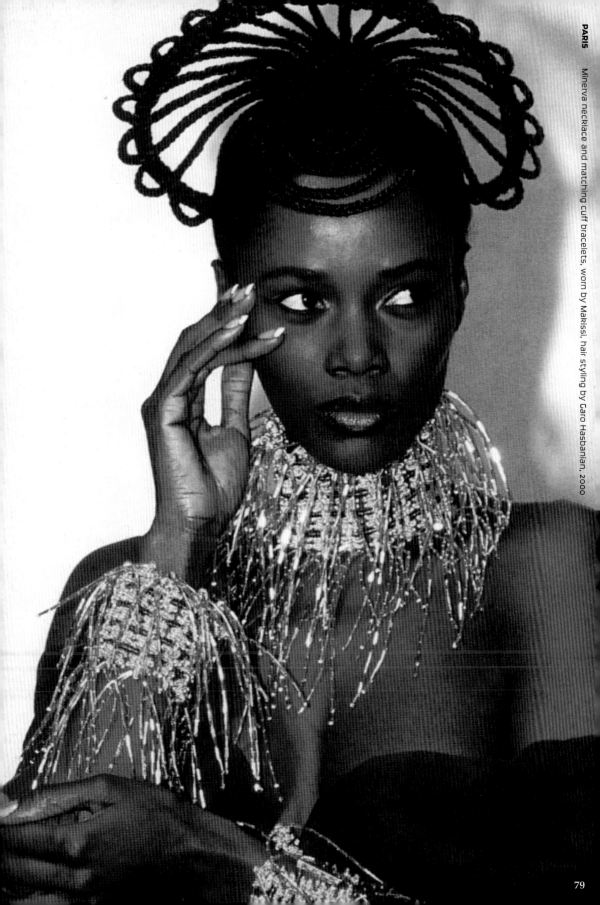

Minerva necklace and matching cuff bracelets, worn by Marissi, hair styling by Caro Hasbanian, 2000

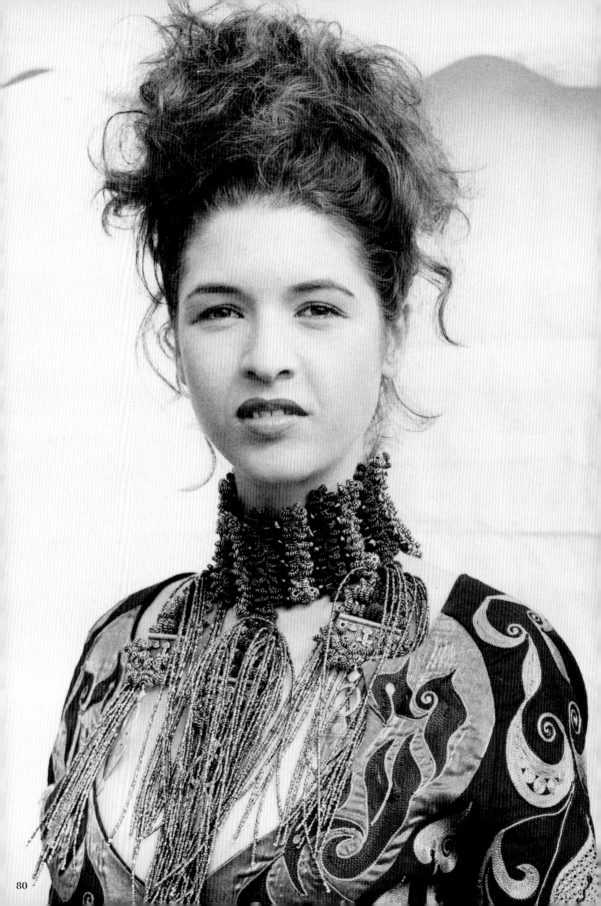

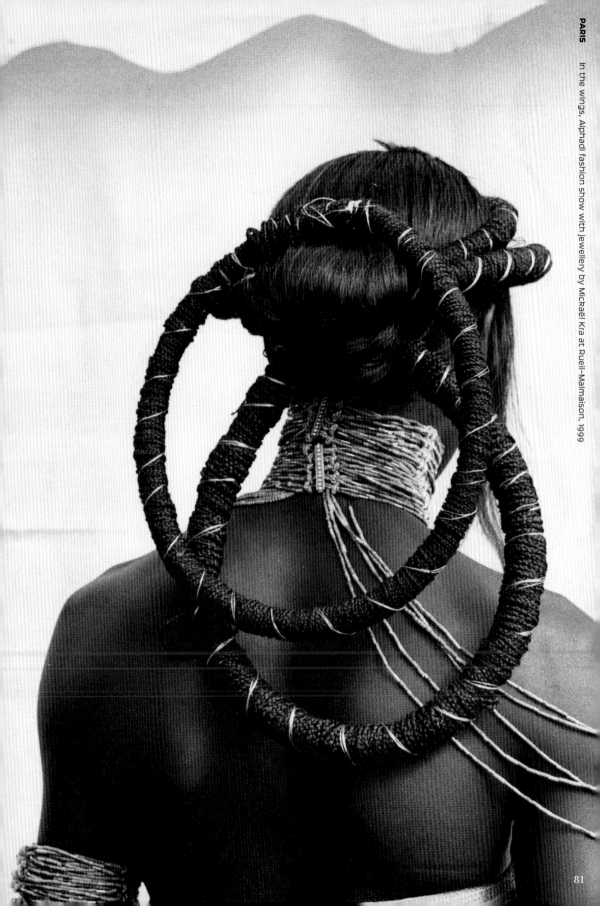

Anne Vidal, a very dear friend
gave me the opportunity to
make a jewel dress for
advertising the swedish vodka
brand "ABSOLUT", which
sponsors artists in Design.
More than 300 hours of work
to realise this ensemble.

[signature]

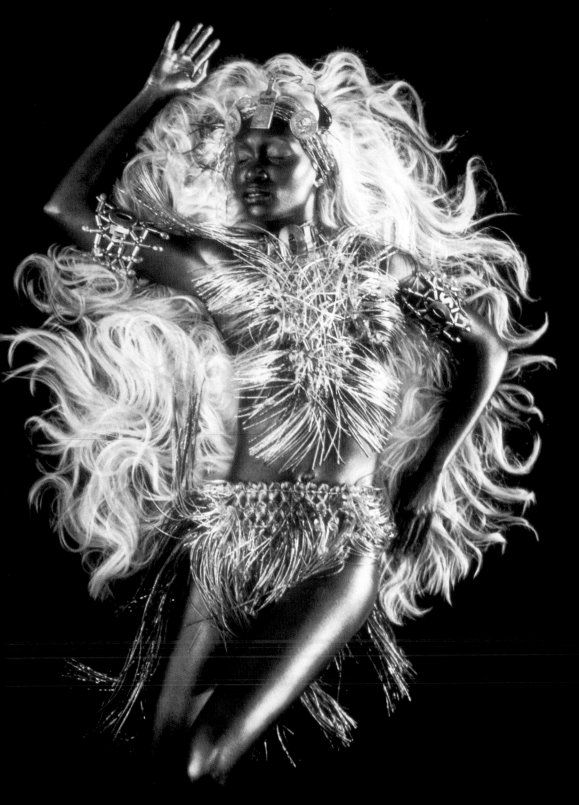

"Absolut Michaël Kra", ensemble comprising a tiara, pectoral necklace, two bracelets and a skirt, worn by Dawn, 1999

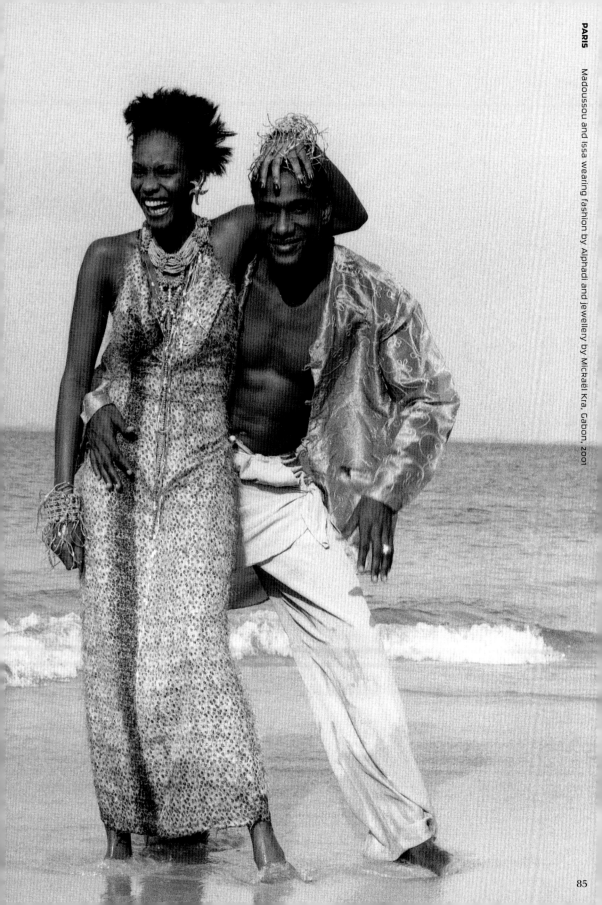

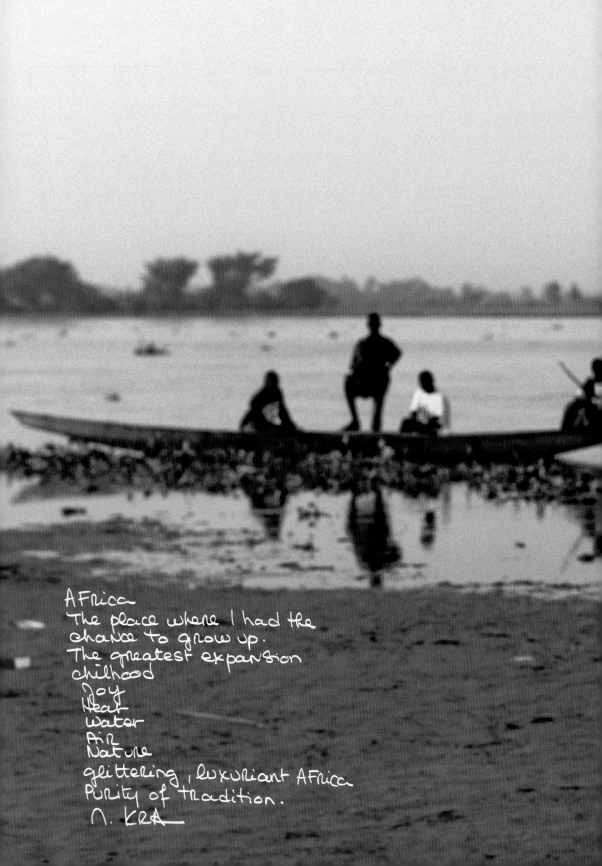

AFrica
The place where I had the
chance to grow up.
The greatest expansion
childhood
Joy
Heat
water
AiR
Nature
glittering, luxuriant Africa
Purity of tradition.
∧. KRA

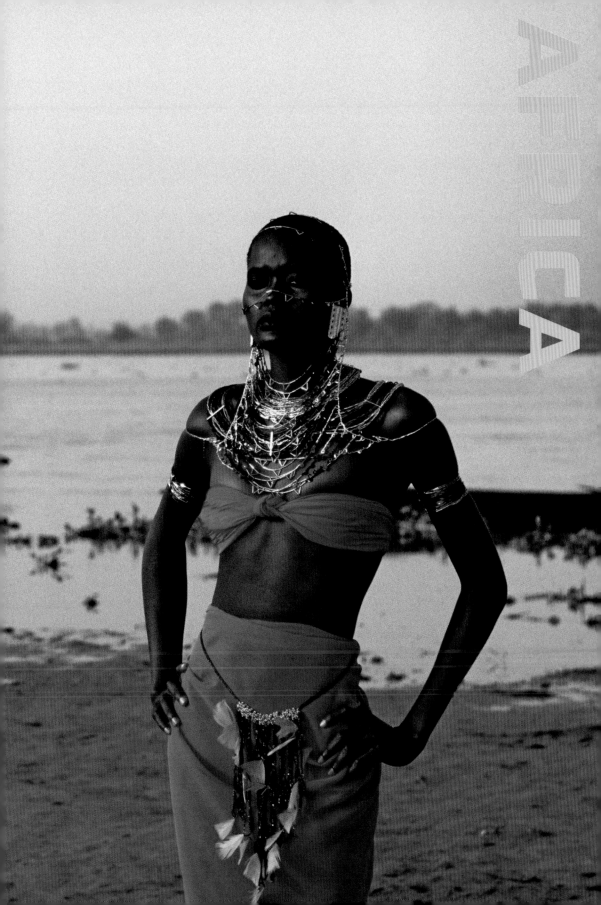

AFRIQUES

Francine Vormese

Abidjan, Dakar, Douala, Johannesburg, Niamey, Paris... Mickaël Kra fait découvrir ses bijoux, au rythme d'environ dix défilés par an. Artistes, femmes de goût ou de pouvoir les adorent. Il continue à signer les bijoux des défilés d'Alphadi. Il en a concocté pour les shows de Katoucha Niane et c'est elle qui l'a incité à défiler sous son propre nom. Sur le fond mélodieux de musiques world et soul, au Carrousel du Louvre pour Opal's (au profit des malades du sida), ou sous les étoiles d'une nuit au Sahara pour le FIMA, le Festival international de la mode africaine, surgissent les mannequins.

Femmes-joyaux, hommes-statues, sur les corps lianes et les muscles forgés, s'entrecroisent fleuves dorés et rivières de perles. Jaillissements qui suivent les courbes des chairs, palpitent et tintinabulent en rythme. Autour des reins, sur les cheveux, des drapés de mousselines sombres et mates sont écrins-écrans des cascades, envolées, vagues, des colliers, sautoirs, bracelets qui s'enroulent et caressent seins nus fardés d'or, épaules d'athlètes, chevilles graciles. Chaque détail des corps s'enivre de ces coulées lumineuses, dorées, laiteuses ou cuivrées qui virevoltent à chaque pas. «Ce monde rayonnant de métal et de pierre ... où le son se mêle à la lumière» («Les bijoux», Baudelaire), ne va pas sans choquer ceux qui voient dans le corps dévoilé une atteinte aux mœurs prescrites. Des mains feignent de couvrir les yeux pour cacher ces seins qu'ils ne sauraient voir, puis s'ouvrent subrepticement, vérifiant la pure beauté.

Le décalage entre les podiums internationaux où la nudité est devenue naturelle (même si elle est mise en scène) et ces podiums d'Afrique encore soucieux de pudeurs, entretient la confusion.

Cependant, il y a une élégance et un impact chez Kra qui tiennent des audaces de la Haute-Couture parisienne et n'ont rien à voir avec la provocation gratuite. Il n'y a rien de vulgaire à exalter un corps par les traits lumineux d'un bijou. Il y a un travail de sculpture vivante, d'installation artistique sur le corps. Cette tournure singulière de Mickaël Kra à montrer un bijou qui n'est pas toujours dévolu à une place fixe. Si cela peut sembler déroutant, les collectionneuses de bijoux ne s'y trompent pas. Pour lui, la mode est une expression culturelle qui éclaire l'Afrique d'un nouveau regard, débarrassé des méconnaissances qui ne considèrent le continent qu'à travers ses désespoirs: conflits armés, misère, sida.

AFRICA

Francine Vormese

Abidjan, Dakar, Douala, Johannesburg, Niamey, Paris ... Mickaël Kra allowed his jewellery to be discovered at a rate of some ten fashion shows a year. Artists, women with good taste or means adored it. He continued to be responsible for the jewellery worn at the Alphadi fashion shows. He concocted some for Katoucha Niane's shows and it was Katoucha who would encourage him to show under his own name. Models appeared against a melodic background of world and soul at the Carrousel du Louvre for Opal's (for the benefit of people suffering from AIDS) or beneath the stars of a night in the Sahara for FIMA, the Festival international de la mode africaine.

Women as jewels, men as statues, on bodies supple as lianes and muscles like forged steel, gold necklaces met fluid rivers of pearl. Bursts and flashes following the curves of the flesh, rhythmically pulsing and jingling. Around the hips, in the hair, on drapery of dark, matt muslin, cascades, flights, waves, necklaces, long ropes of beads, bracelets that coiled up to caress nude breasts dusted with gold, athletic shoulders, graceful ankles as screens and showcases. Every part of the body was intoxicated by luminous, golden, milky, or coppery streams which twirled and twinkled at each step. "This world gleaming with metal and stones ... where sound mingles with light" ("Les bijoux", Baudelaire) could not get away without shocking those who see in the unveiled body an assault on prescribed mores. Hands pretended to cover eyes to conceal those breasts which they did not want to see but they opened surreptitiously, to disclose sheer beauty.

The discrepancy between international catwalks where nudity has become entirely natural (even if it is staged) and the catwalks of Africa still concerned with modesty maintained the confusion. Nevertheless, there is an elegance about Kra, an impact which withstands the effrontery of Parisian haute couture and has nothing to do with gratuitous provocation.

There is nothing vulgar about enhancing a body with the luminous glint of a jewel. There is a work of living sculpture, an artistic installation on the body. The singular mindset revealed by Mickaël Kra in showing a jewel which is not always designed for a particular place. Although that may seem disturbing, the women who collect his jewellery know what they are about. To him, fashion is a cultural mode of expression which illumines Africa from a new standpoint, free

Pre fima , 1998
We did a Fashion Show with
Alphadi at the Sultan's house in
the city of agadez - Niger.
It caused a Scandal when the
models draped in black
arrived on the catwalk as
if wearing chadors

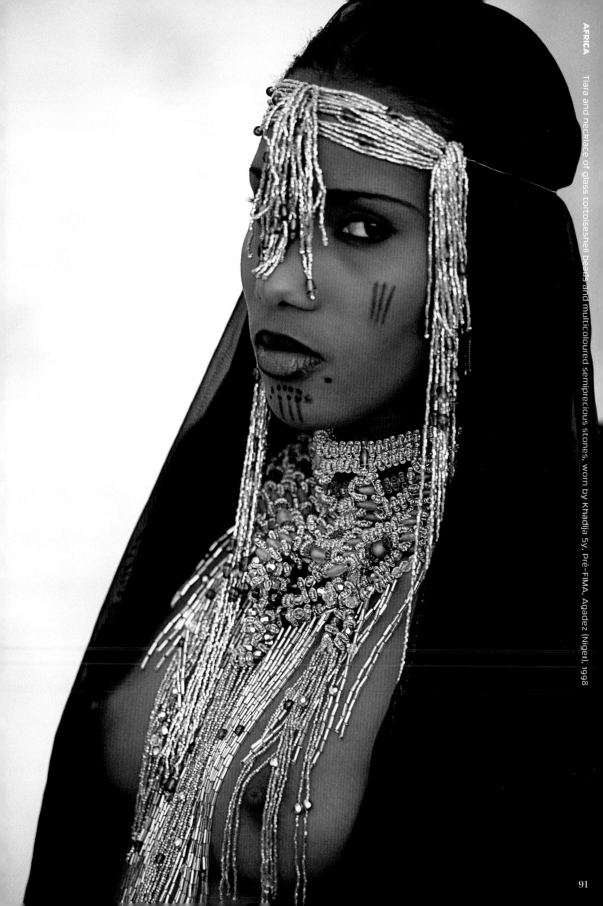

Tiara and necklace of glass tortoiseshell beads and multicoloured semiprecious stones, worn by Khadija Sy. Pré-FIMA, Agadez (Niger), 1998

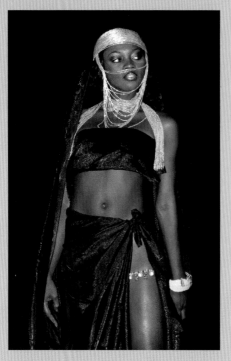

... and then proceeded to
remove layer by layer,
to reveal the jewelry ...

n. KRA

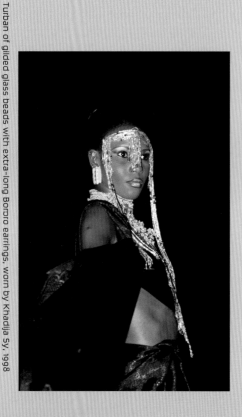

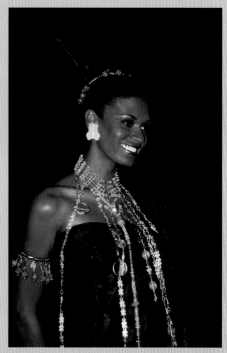

92

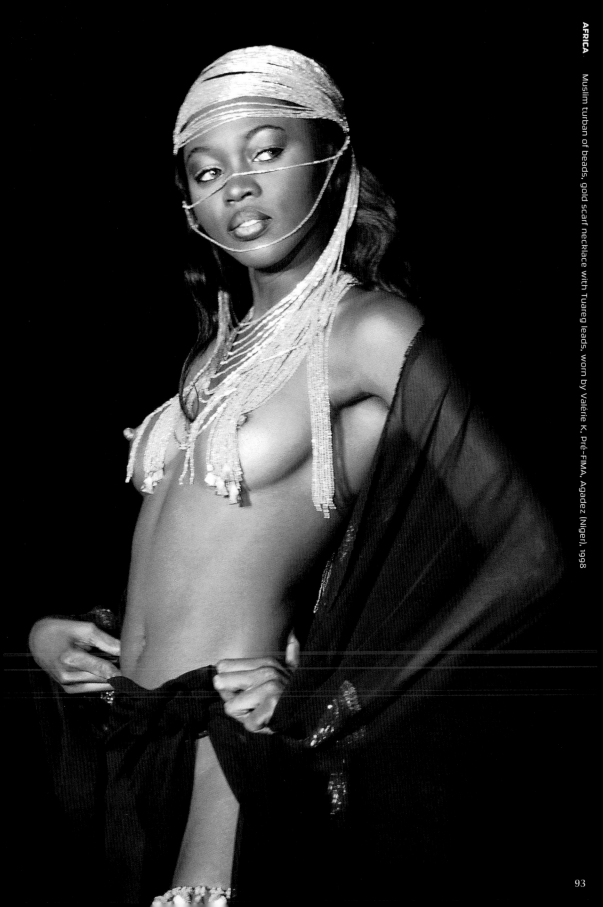

Muslim turban of beads, gold scarf necklace with Tuareg leads, worn by Valérie K. pré-FIMA, Agadez (Niger), 1998

En Afrique, on ne s'attarde pas à l'affliction d'être marginalisé par ces désastres. On continue. Et avec vivacité. Question d'honneur. Tête haute, tailleur impeccable et bijoux choc. Yako, qui est fou? The show must go on!

Les défilés de mode font désormais partie de l'agenda des grandes villes africaines. Le K'Palezo à Abidjan fut un coup de maître en novembre 1997 organisé par Khady Diallo, secrétaire générale de la FAC, Fédération africaine des créateurs. En 1998, Alphadi, styliste, président de la FAC et grand communicateur de la mode africaine, crée le FIMA, Festival international de la mode africaine et cela, malgré un contexte qui ne destine pas à priori Niamey à devenir capitale de mode. A Dakar les manifestations se multiplient: le SIMOD, la Semaine Internationale de la mode de Dakar est lancé par Oumou Sy en 1997; le SIRA VISION, créé par Collé Sow Ardo en est a sa troisième édition. D'un Bio-Top de Dasha, à une Fashion Week, Dakar démontre ses appétits en matière de mode. A Johannesburg, la South African Fashion Week se veut ultra professionnelle, la presse de mode locale existe et les industriels sont attentifs ... Et à Paris en 2002, le grand concert de Youssou Ndour à Bercy, a été précédé d'un défilé de mode avec deux stylistes: Claire Kane, française et sénégalaise et Mickaël Kra.

Aidées par les gouvernants, bailleurs de fonds internationaux, grandes institutions et sponsors privés, les manifestations culturelles se sont multipliées depuis 1994. Ainsi prend forme un grand mouvement artistique africain contemporain. Bamako accueille les Rencontres photographiques, Ouagadougou, l'artisanat (SIAO) et le cinéma (Fespaco). Dakar résonne de sa Biennale des Arts ... Des défilés de mode donnent la touche de glamour à chaque manifestation.

C'est à Dakar au SIMOD en 2000 que Mickaël Kra rencontre Annette Braun, coordinatrice culturelle de EED. Elle est a la recherche d'un professionnel de bijoux pour animer des ateliers d'artisanat en Namibie, dans le désert du Kalahari au sein d'une communauté San, ethnie en danger d'extinction.

Depuis des temps ancestraux, les San utilisent les coquilles d'œufs d'autruche dans leur quotidien, par exemple pour des gourdes servant à transporter l'eau qu'ils pompent dans les profondeurs du sable avec un bambou, chacune d'entre elles pouvant contenir jusqu'à deux litres d'eau. Les San devenus semi-nomades travaillent les coquilles en bijoux ou accessoires d'artisanat vendus aux touristes. L'enjeu pour Mickaël Kra est d'accompagner les San pour les amener à réaliser des bijoux de très haute qualité du point de vue créatif. Puisque les savoir-faire des femmes San sont extrêmement sophistiqués, il se tourne vers des formes

of misconceptions which only see the continent through a veil of hopelessness: armed conflicts, AIDS.

In Africa, no one is being slowed down by the affliction of being marginalised by disaster. People just keep going. And with vitality. A question of honour. Head high, impeccable dress and wow-factor jewellery. Yako, who's nuts? The show must go on!

Fashion shows have since become part of the agenda of big African cities. The K'Palezo at Abidjan was a masterstroke organised in November 1997 by Khady Diallo, secretary-general of the FAC, the African Federation of Designers. In 1998, Alphadi, stylist, president of the FAC and great communicator of African fashion, created FIMA, the Festival international de la mode africaine, and that, despite a context which did not à priori predestine Niamey to become a fashion capital. At Dakar, the show events have multiplied: SIMOD, la Semaine Internationale de la mode de Dakar, was launched by Oumou Sy in 1997; SIRA VISION, created by Collé Sow Ardo, is by now in its third season. From a Bio-Top at Dasha to Fashion Week, Dakar flaunts its fashion urges. At Johannesburg, the South African Fashion Week strives to be ultra-professional; there is a local fashion press and industrialists are paying attention ... And in Paris in 2002, the big Youssou Ndour concert at Bercy was preceded by a fashion show featuring two designers: Claire Kane, French and Senegalese, and Mickaël Kra.

Aided by governments, international funding, large institutions and private sponsors, the number of cultural events has grown by leaps and bounds since 1994. Thus a vast contemporary African art movement is taking shape.

Bamako hosts African Photographic Exhibit, Ouagadougou, craftsmanship (SIAO) and cinema (Fespaco). Dakar resonates with its Arts Biennale ... Fashion shows give the finishing touch of glamour to each event.

It was at the 2000 SIMOD in Dakar that Mickaël Kra met Annette Braun, cultural co-ordinator of the EED. She was looking for a jewellery professional to breathe life into craft workshops in Namibia, in the Kalahari Desert at the heart of a San community, an ethnic group threatened with extinction.

Since the days of their ancestors, the San have used ostrich eggshells in daily life, for example as gourds for transporting the water they pump from the depths of the sand with bamboo pipes. Each ostrich eggshell can hold up to two litres of water. The San, having become semi-nomadic, work the eggshells into jewellery or craft accessories for sale to tourists.

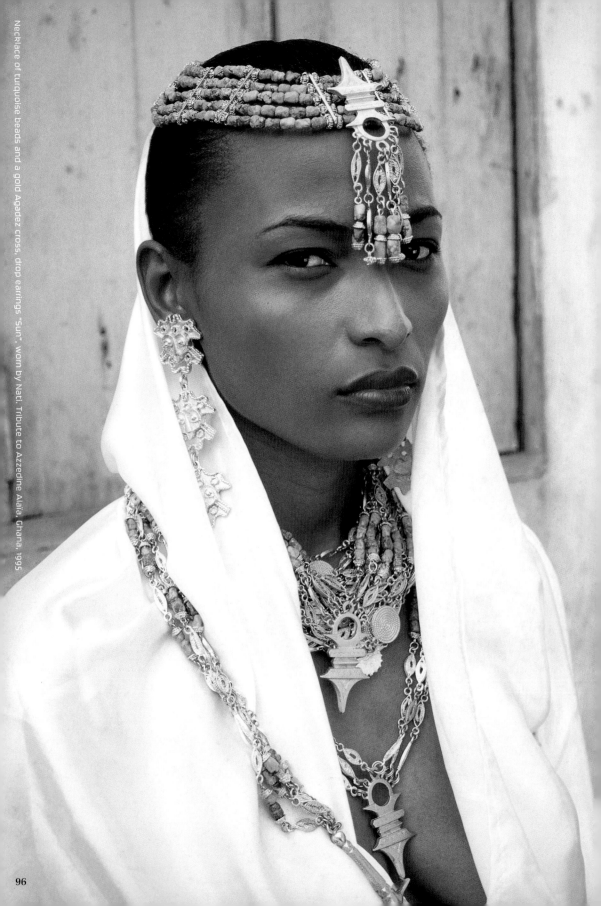

Hommage à MR
Azzedine Alaïa

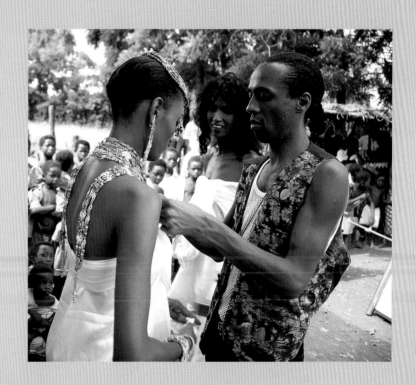

97

archétypales à la fois proches de l'Art Déco et pétries de la mémoire des bijoux antiques. Ainsi, ces bijoux issus de ressources recyclées affichent un style destiné à perdurer. A porter autant avec un jean, une robe du soir, un tailleur ou bien un grand boubou.

Quelques participantes qui avaient affiché une certaine réserve lors du premier atelier, commencent à sourire quand elles s'aperçoivent que Mickaël Kra revient travailler avec elles, que la presse s'intéresse à leur travail, que cette matière, l'œuf d'autruche, devient un matériau noble.

Quant à Mickaël cette expérience le transforme; l'illumine. Il est à la fois passionné et irradie une force spirituelle. Il trouve chez les femmes San des complices de travail exigeantes et encore secrètes. Il ressent cela comme une bénédiction, qu'il reçoit simplement, avec humilité. Sa ligne de bijoux couture est baptisée «Pearls of the Kalahari with Mickaël Kra» – «with», c'est-à-dire «avec» et non pas «by» ou «for», «par» ou «pour» qui signerait une appropriation du produit comme on le voit couramment dans le milieu de la mode internationale. De fait, il applique le point de vue exprimé par l'historien Joseph Ki-Zerbo: «L'économie solidaire telle qu'elle existe actuellement en Afrique est une économie de partage basée sur l'humanisme (mogoya en bambara, l' «humanitude» en somme).»

Le langage fashionista, traduit cela par «l'éthique c'est chic». Mickaël Kra a participé en 2004 et 2005 aux deux premières éditions du salon de mode éthique, «The Fashion Ethical Show» organisé par Isabelle Quéhé à Paris. La mode éthique est destinée à rassembler les générations et Mickaël Kra y participe pleinement. Il confirme ainsi une culture métissée, qui s'enrichit en permanence de rencontres, d'ouvertures, de ponts traversés entre les savoir-faire, des formes qui en naissent, des bijoux qui témoignent un amour et un respect entre des gens qui étaient éloignés dans l'espace et se rejoignent par l'élaboration du beau.

What is involved for Mickaël Kra is to accompany the San to guide them in creating jewellery of very high quality from the creative standpoint. Since the skills of San women are extremely sophisticated, he has turned towards archetypal forms that are both close to Art Déco and steeped in the memory of ancient jewellery. Consequently, these pieces of jewellery made from recycled resources proclaim a style destined to last. To be worn with jeans, an evening dress, a suit or indeed the full boubou.

Some participating women who had evinced a certain amount of reservation during the first workshop, were all smiles when they saw that Mickaël Kra returned to work with them, that the press was interested in their work, that the raw material, ostrich eggshells, had become a precious material.

As for Mickaël, this experience has transformed him, has lit him from within. He is at once impassioned and illumined by a spiritual power. In the San women, he has found working colleagues who are both exacting and still know how to keep a secret. He feels that this is a blessing, one which he receives simply and with humility. His line in high-fashion jewellery has been christened "Pearls of the Kalahari with Mickaël Kra" – "with" means what it says and not "by" or "for", which would signify expropriating a product as is continually seen in the context of international fashion. Indeed, he is putting into practice the point of view expounded by the historian Joseph Ki-Zerbo: "The economy of solidarity as it currently exists in Africa is a sharing economy based on humanism" (mogoya en bambara; in brief, 'humanity')."

Fashionistas translate this as "the ethic of chic". In 2004 and 2005, Mickaël Kra participated in the two first seasons of the ethical fashion salon, "The Ethical Fashion Show", organised by Isabelle Quéhé in Paris. Ethical fashion is destined to span the generations and Mickaël Kra is right in the thick of it.

Thus he confirms a hybrid culture, which has been lastingly enriched by encounters, openings, bridges crossed by skills, forms growing out of it, pieces of jewellery which attest to a love and respect among peoples who had grown apart in space and have come together again through the cultivation of the beautiful.

"Masai Woman", disc necklace of multicoloured glass bugle beads, belt of glass bugle beads and feathers, worn by Diane B, Niger, 2001

Necklace "Butterfly", Baoulé weights with feathers and twisted leather fringe, worn by Anra and Diane B, Niger, 2001

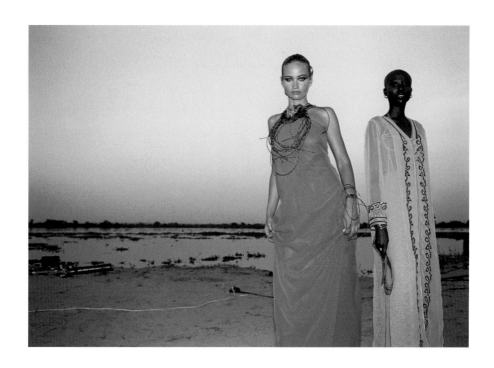

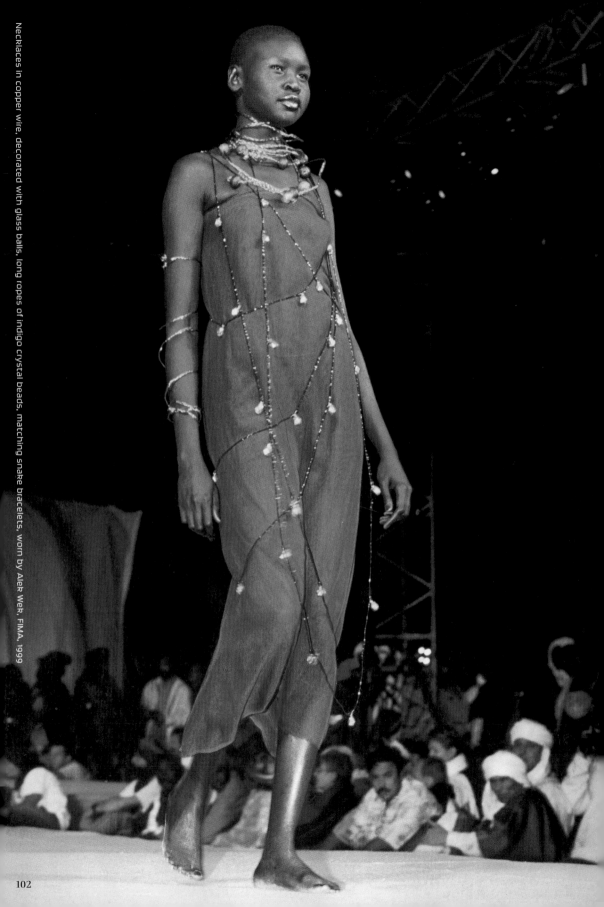

Necklaces in copper wire, decorated with glass balls, long ropes of indigo crystal beads, matching snake bracelets, worn by Aier Wek, FIMA, 1999

alek wek gave me the
pleasure to open my Fashion
Show (Fima).
Unforgettable!
M. KRA.

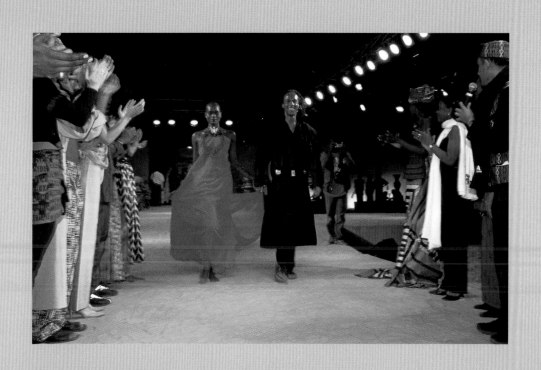

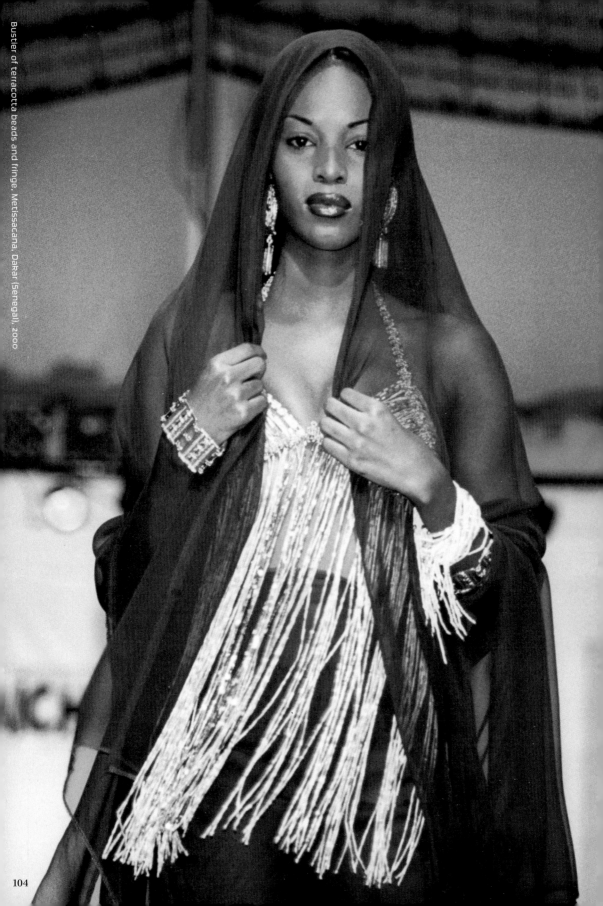

Bustier of terracotta beads and fringe, Metissacana, Dakar (Senegal), 2000

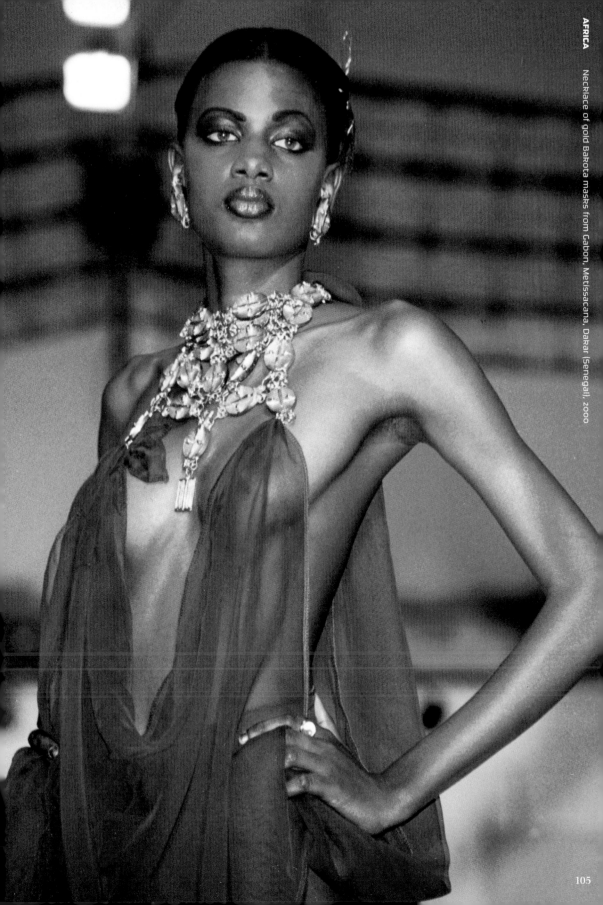

Tradition ancestrale et innovation –
Les San et le projet « Les Perles du Kalahari »

Le WIMSA et Annette Braun

Depuis des millénaires, les bijoux en coquille d'œuf d'autruche – la « Perle du Kalahari » – sont chez les San d'Afrique du Sud une parure traditionnelle de la vie de tous les jours. Mais ces bijoux, depuis toujours considérés comme des objets d'une grande beauté, ne servaient pas seulement de parure quotidienne mais devaient être portés par toute la communauté lors de la célébration des divers rites de passage : rituels d'initiation, de fiançailles, danses cérémonielles de guérison, rites de mariage. Aujourd'hui, le port de bijoux en coquille d'œuf par les San eux-mêmes mais aussi par d'autres groupes ethniques, voire par les touristes étrangers, est un rappel du riche patrimoine culturel de cette population. Etant donné que les groupes San, appelés encore « Bushmen » (ce terme étant de nouveau admis) étaient les habitants d'origine de la région, il est probable qu'ils furent aussi les premiers à découvrir, à côté de leur valeur symbolique et de leur usage pratique comme jarres, la beauté et la résistance des coquilles d'œuf d'autruche. Au cours des siècles, avec l'arrivée massive de groupes bantous puis, en 1652, de colons européens dans la région, les San découvrirent la valeur commerciale des coquilles d'œufs. Aussi, les perles étaient-elles souvent utilisées dans les échanges commerciaux.

Mais avec le temps les colons et les populations bantoues Héréro et Tswana envahirent les territoires de chasse ancestraux des San et les dirigeants politiques les destituèrent de leurs terres avec leurs ressources naturelles, faisant des San un peuple déshérité et marginalisé. La politique de réimplantation forcée menée jusqu'à ce jour fait que les San vivent, dans une abjecte pauvreté, de l'aide sociale ou qu'ils gagnent leur maigre pitance comme travailleurs agricoles ou aides ménagères. Avec la perte de leurs terres ils ont perdu une grande partie de leurs traditions et de leur identité. Pour eux, l'artisanat et les perles ne sont pas seulement un lien culturel avec leur passé mais aussi, pour beaucoup d'entre eux, aujourd'hui la seule source de revenus.

Le travail accompli par le EED (Le Service des Eglises Evangéliques en Allemagne pour le Dévelopment) et le WIMSA (Groupe d'aide aux minorités indigènes d'Afrique du Sud) et son réseau régional au cours des dix dernières années

From Grassroots to Glamour –
The San and the "Pearls of the Kalahari" Project

The WIMSA Team and Annette Braun

For thousands of years, the San of Southern Africa have worn jewellery made from ostrich eggshell – the "Pearl of the Kalahari" – as part of their traditions and everyday life. The San have always viewed the eggshell beads as items of great beauty which, in addition to "everyday" adornment, were also designed as special pieces to wear by all members of the community during various rites of passage – such as initiation, courtship, healing dances and marriage. The wearing of eggshell, by the San themselves, by other ethnic groups and foreign tourists – even when combined with modern clothing – is an ever-present reminder of the rich cultural heritage of the San.

As the San groups (the term "Bushmen" is again in accepted use) were the original inhabitants of the region, it is likely that they also were the first people to discover the attractive and durable properties of the ostrich eggshell, besides the symbolical meaning and practical value of the egg as water bottle. Over the centuries when different Bantu groups and in 1652 European settlers moved into the region in larger numbers, the San began to realise the commercial value of eggshell and the beads were often used for trade.

However, the settlers and Bantu groups like Hereros and Tswanas invaded their ancestral hunting grounds and politicians seized their land and natural resources, leaving the San to become a disinherited and marginalised people. Forced resettlements have continued up to today and most of the San live in abject poverty, on welfare or eke out a meagre living as farm workers or housemaids. With the loss of their land they lost most of their tradition and identity. The craft and bead work for them is not only a cultural link with their past but also in many areas the only source of income for the San today.

During the last ten years, the work of EED (Church Development Service – An Association of the Protestant Churches in Germany) and WIMSA (Working Group of Indigenous Minorities in Southern Africa) and its regional network has done much to highlight the injustices suffered by the San. The San have worked with WIMSA to vigorously defend their intellectual property (such as their intimate knowledge of the indigenous flora) against commercial exploitation in

a beaucoup contribué à révéler les injustices subies par les San. Ceux-ci s'emploient avec le WIMSA à défendre leur propriété intellectuelle (par exemple leur connaissance intime de la flore indigène) contre l'exploitation commerciale, afin de sauvegarder le peu qui leur reste de leur héritage culturel.

Le projet intitulé «Pearls of the Kalahari» (POK) fournit un excellent exemple de l'idée que se font les San de la coopération: la fidélité au savoir traditionnel alliée à la volonté d'assimiler de nouvelles idées. Les meilleurs artisans de perles de la région, un groupe sélectionné constitué d'environ vingt-cinq femmes et de quelques hommes, ont participé aux trois workshops organisés en Botswana (2002) et en Namibie (2003 et 2004) sous la direction d'un grand designer de bijoux résidant à Paris, Mickaël Kra. Les participants provenaient des communautés San en provenance de Nyae Nyae, Tsumkwe West et de la région du Omaheke en Namibie ainsi que des districts de Ghanzi et de Kgalagadi au Botswana. Les artisans de perles étaient heureux de cette occasion qui leur était offerte. L'idée directrice était de conserver la tradition et les anciennes techniques de leur art, sa qualité et sa beauté archaïque, tout en lui insufflant une touche de cosmopolitisme, de chic parisien. Mickaël Kra voulait obtenir un produit répondant aux plus hautes exigences de l'élite européenne du monde de la mode. Comme il aime à le dire: «Un produit fait main de A à Z, c'est de la haute couture!» Les femmes San se révélèrent de bonnes et habiles élèves. Utilisant leur savoir-faire traditionnel dans la production de bijoux en coquille d'œuf, elles surent adopter, adapter et intégrer l'expérience internationale du designer Mickaël Kra ainsi que l'utilisation d'autres matériaux tels que perles de verre, cuir et pierres semi-précieuses, et accomplir des variations personnelles de haut niveau : une re-création moderne de l'ancien.

La collection POK qui sortit des ateliers dirigés par Mickaël Kra est une série d'un goût exquis de vingt colliers et quelques bracelets finement ouvragés qui portent la signature de chacune des femmes de Namibie et du Botswana qui les ont réalisés. La beauté et la qualité des produits finis parlent pour elles. Toutes les femmes engagées dans ce projet ont exprimé leur plaisir et leur satisfaction d'apprendre de nouvelles techniques pour pouvoir les enseigner, à leur retour, au sein de leurs communautés. La compréhension des attentes des consommateurs, le respect des délais, l'estimation des quantités et du rendement ainsi que l'application d'un contrôle de qualité strict furent pour ces femmes une expérience nouvelle et précieuse. Quant à Mickaël Kra, cette rencontre fut pour lui

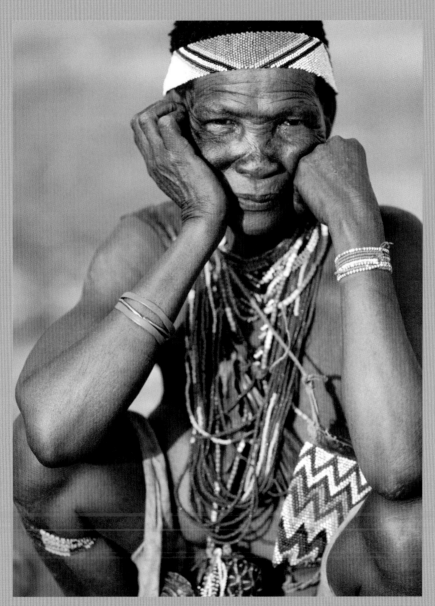

Beads - the ancient adornment of the San

aussi une expérience extraordinaire – son histoire d'amour personnelle avec les San, comme il l'appelle, et un apprentissage mutuel, car il acquit aussi un profond respect pour le savoir-faire et l'habileté de ces femmes.

Le Service des Églises Évangéliques en Allemagne pour le Développement (EED), et le WIMSA ont été, dès le départ, les acteurs-clés du projet POK et ont aidé les communautés San à commercialiser leurs produits. Ce projet s'inscrit dans un projet plus vaste destiné à soutenir l'autodétermination économique, sociale et culturelle des communautés San d'Afrique du Sud. L'EED et le WIMSA avec son réseau régional soutiennent le projet POK pour de multiples raisons. En premier lieu, ils espèrent que le projet contribuera à donner une autre image des San dans le reste du monde. Au lieu d'accréditer l'image de communautés spoliées de leurs biens et de tout pouvoir, le projet POK prouve qu'un peuple, même réduit à la misère, est capable d'inscrire sa culture ancestrale dans la modernité. Deuxièmement, l'EED et le WIMSA pensent que ce projet peut servir de levier au progrès socio-économique des San. Les femmes San ont considérablement amélioré leurs techniques de production. Aussi, des centaines de communautés dispersées dans le désert du Kalahari et au-delà ont-elles pu bénéficier des ateliers, car la vente de leurs produits artisanaux est l'unique moyen d'améliorer le niveau de vie des communautés. Enfin, s'adressant essentiellement aux femmes, le projet POK contribue à aborder la question de l'inégalité des sexes au sein des communautés San et à sortir les femmes de leur marginalité. La formation et le soutien apportés aux femmes San par Mickaël Kra et le projet POK durant deux ans ont donné à celles-ci une autre image d'elles-mêmes et une plus grande indépendance.

La collection POK a été présentée avec un énorme succès sous la direction de Mickaël Kra dans des défilés à Windhoek, Niamey, Dakar, Douala, Johannesburg, Paris et aux Caraïbes. Elle est présentée aujourd'hui encore dans diverses foires commerciales en Europe et a suscité un vaste écho dans des revues internationales de mode. Ce succès d'une re-création artistique d'un art ancestral a redonné aux San un peu de leur fierté perdue. Ainsi, ce projet est aussi un exemple vivant du rôle qu'assume l'EED pour la protection de la dignité humaine, de la justice sociale et de la diversité culturelle en collaboration avec ses partenaires du Sud. Les organisations de soutien aux San ont créé des structures régionales pour la production et la vente des bijoux en coquille d'œuf d'autruche en Afrique du Sud et l'EED a facilité leur commercialisation en Europe (adresse page 4).

order to protect what little remains left of their heritage. The "Pearls of the Kalahari" (POK) project provides a beautiful contemporary example of the partnership approach of the San, utilising their excellent traditional skills.

The best bead artisans of the region, a selected group of about twenty five women and some men, participated in the three workshops held with the Paris based top jewellery designer Mickaël Kra in Botswana in 2002 and in Namibia in 2003 and 2004. The participants came from San communities in Nyae Nyae, Tsumkwe West and the Omaheke Region in Namibia, from the Ghanzi and Kgalagadi Districts in Botswana.

The bead workers highly appreciated this opportunity of artistic empowerment. The idea was to keep the tradition and the ancient craft, its serene quality and archaic beauty, but to fuse it with a cosmopolitan touch, with Parisian flair. Kra wanted to make sure that the final product meets the tough standards of Europe's fashion elite. As Mickaël Kra says: "A product made from A to Z by hand is haute couture!" The women proved themselves to be skilful and fast learners, utilising their traditional knowledge in relation to the production of eggshell jewellery, whilst adopting, adapting and incorporating Mickaël Kra's international experience of different cultural approaches to jewellery design and the use of additional materials such as glass beads, leather and semi-precious stones. Thus, they developed their personal variations of the design range: their modern recreation of the ancient.

The POK collection that resulted from the workshops under the guidance of Mickaël Kra is an exquisite range of about 20 necklaces and some bracelets bearing the name of each of the women producers from Namibia and Botswana.

The beauty and quality of the finished products speak for themselves. All of the women involved expressed their enjoyment and satisfaction at learning new skills and imparting their knowledge as trainers upon return to their communities. "Working in a team" was not new for the women, as most San communities rely heavily on the interdependence and their ability to work together. However, gaining an understanding of meeting the fashion demands of the consumer, working to deadlines, estimating quantities and output levels and applying strict quality control were all new and valuable learning experiences for the women.

And for Mickaël Kra, too, this encounter was an extraordinary experience – his personal love affair with the San, as he would say, and a mutual learning process as he also developed great respect for the skilful expertise of the women.

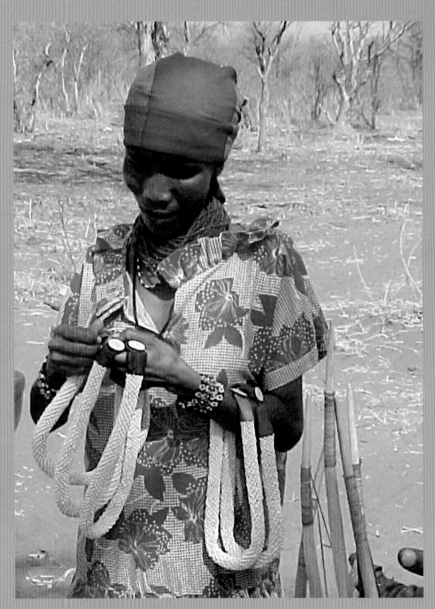

The "Botswana Snake" necklace - an ostrich eggshell beads bestseller

The Church Development Service – An Association of the Protestant Churches in Germany (EED) and WIMSA have been key players in establishing the POK project from its outset and have helped San communities market their crafts. The project is part of a major programme to secure sustainable economic, social and cultural self-determination of the San in Southern Africa. EED, WIMSA and the regional network support the POK project for a number of reasons. Firstly, they hope that the project will assist with presenting a new image of the San to the rest of the world. Rather than constantly portraying the San as a dispossessed and disempowered people, the POK project demonstrates that a small group of – albeit poverty-stricken – people can lead the way in terms of mixing ancient culture and modernity. Secondly, EED and WIMSA believe that the project also provides a lever towards socio-economic advancement for the San. The ability of San women to produce stunning and high quality designs for sale has been vastly improved. Thus hundreds of craft producers in the far-out scattered settlements in the Kalahari and beyond have also been benefitting from the jewellery workshops, as the sale of their crafts is the only means to improve life in the communities. The focus on women within the project contributes to addressing gender imbalance and marginalisation within San communities.

The training and support which San women received from the POK project over two years contributed to enhancing their self-esteem and self-reliance. The jewellery shows, which were curated by Mickaël Kra and featured the POK collection, have been presented very successfully on the catwalks of fashion fairs in Windhoek, Niamey, Dakar, Douala, Johannesburg, Paris and the Caribbean. They are currently shown at various trade fairs for marketing in Europe and have received wonderful coverage in international fashion magazines.

This glamour, in turn, has a positive impact on the "grassroots" where the artistic recreation of an ancient craft gave back to the San some of their lost pride. Thus the project has also become a vivid example of EED's mandate to secure human dignity, social justice and cultural diversity together with their partners in the South. The San support organisations have established regional structures for the production and marketing of the ostrich bead jewellery in Southern Africa and EED has facilitated marketing in Europe (addresses on page 4).

"Pearls of the Kalahari" workshop in Botswana with a team of 23 San women, 2002

I was in need of inspiration
and new colours on my palette.
By the grace of God I met
Annette Braun in Dakar.
She is actively involved in
cultural development projects
with disadvantaged
minorities.
When she saw my work she
immediately thought I was
the right person to contribute
and add my expertise in
order to uplift the level of
the local craft of the SAN
in southern Africa...

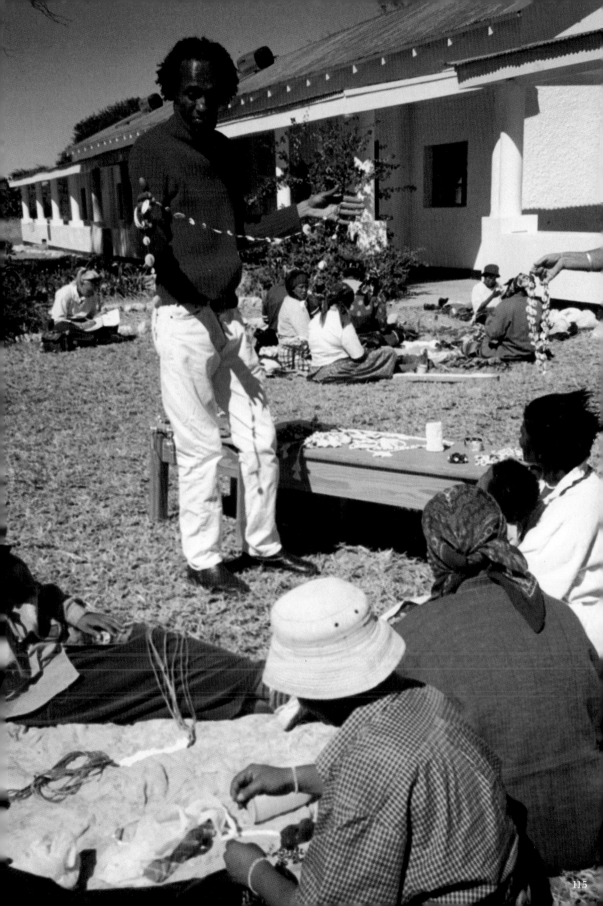

Trying on with Namasha during the "Pearls of the Kalahari"
workshop, Botswana 2002

Dora, one of the participants, modelling
for Mickaël Kra, Botswana 2002

...From the First workshop I
understood that Giving &
Receiving - Sharing &
exchanging the ritual of
knowledge was the key
to open the Heart.

MKra

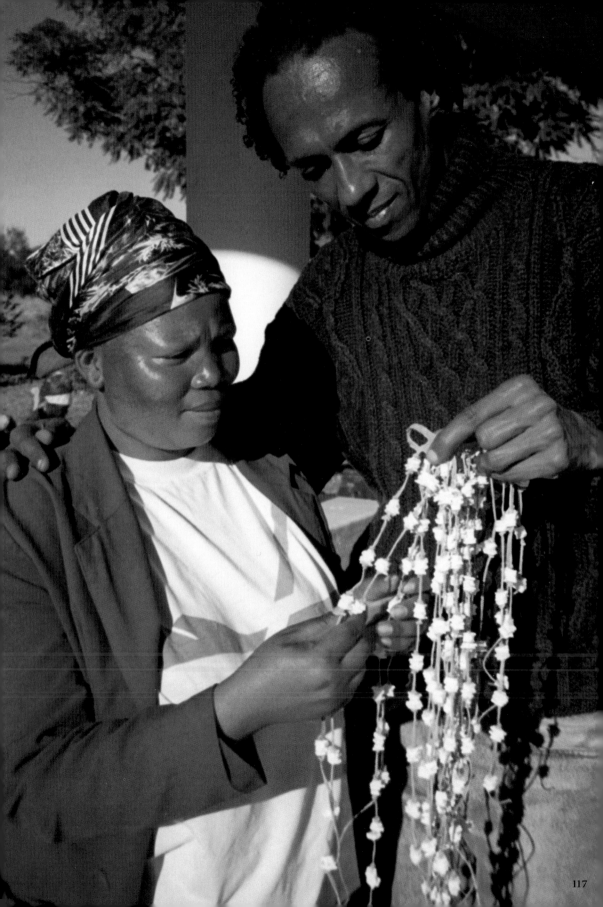

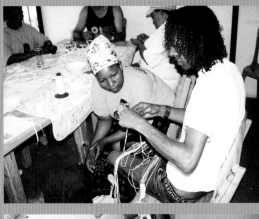
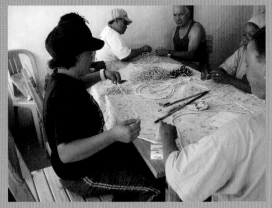
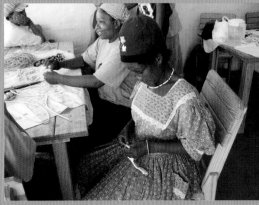
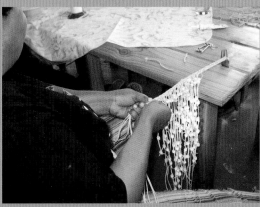

Namasha watching and applying Mickaël Kra's expertise, Micki working on her bracelet,
Maria weaving the "Waterfall", Namibia 2004

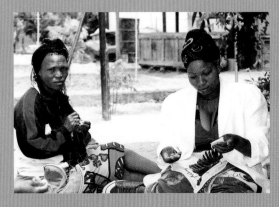
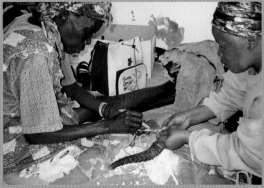

"Pearls of the Kalahari" workshop, Namibia 2004

> Making beads from ostrich eggshells requires a lot of patience and precision

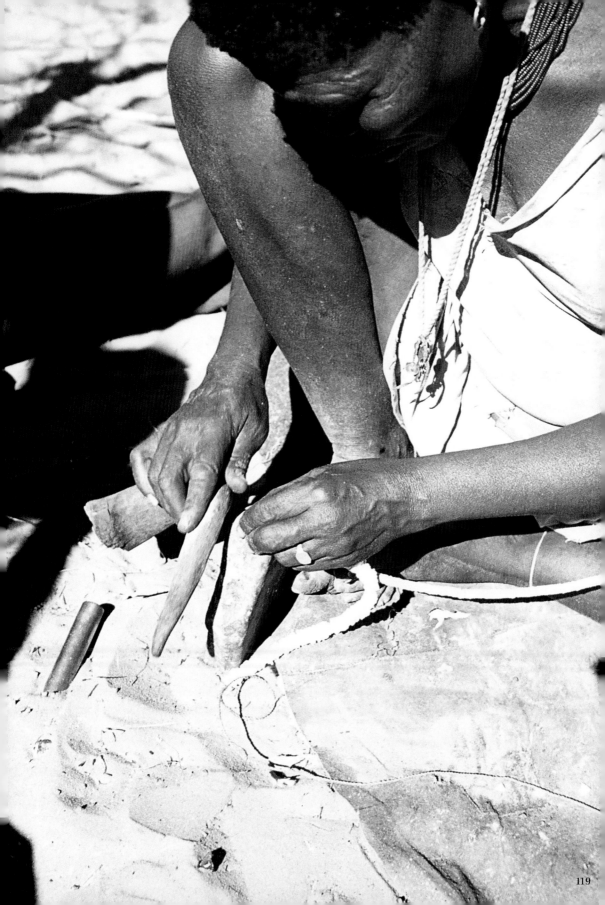

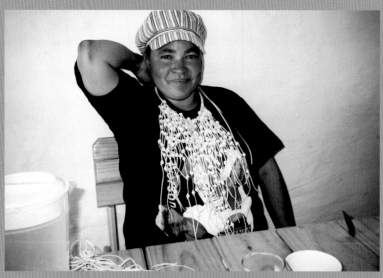

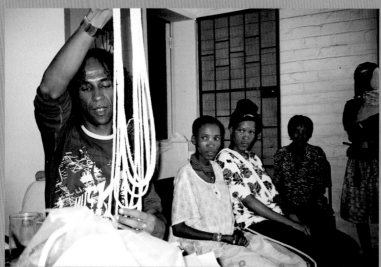

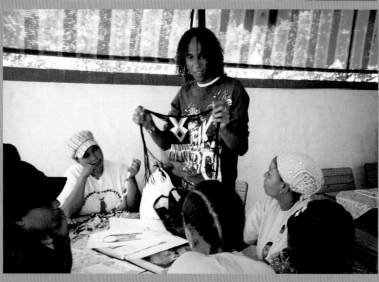

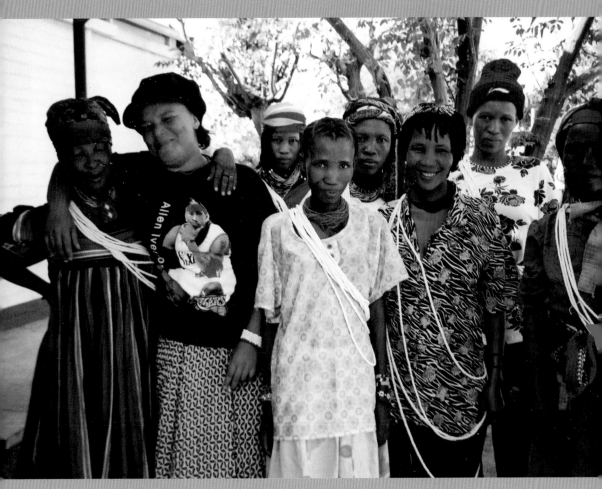

Participants of the "Pearls of the Kalahari" workshop, Namibia 2004

< The women have come from far bringing their strands of ostrich eggshell beads to the workshop, Namibia 2004

we don't speak the same
language.
Design is a universal language
N. KRA

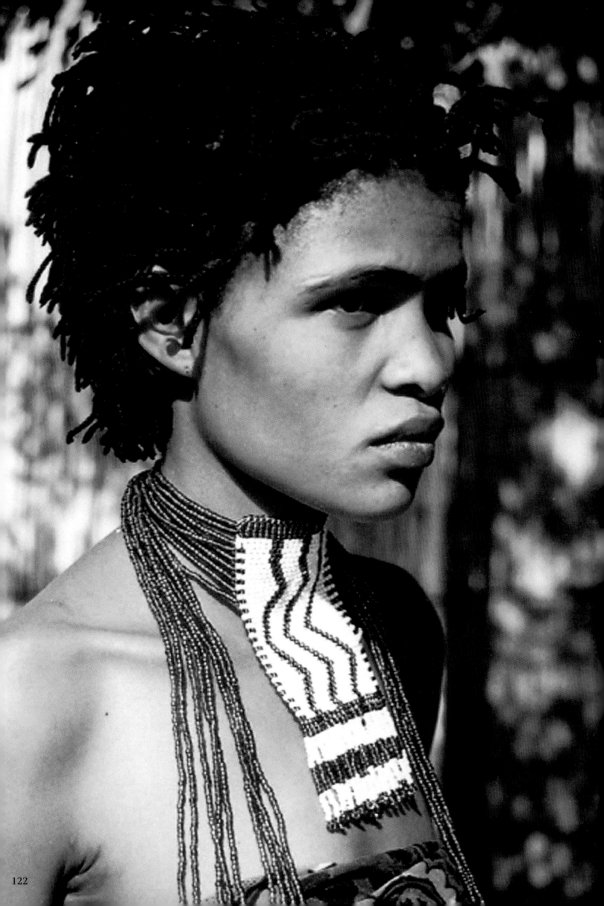

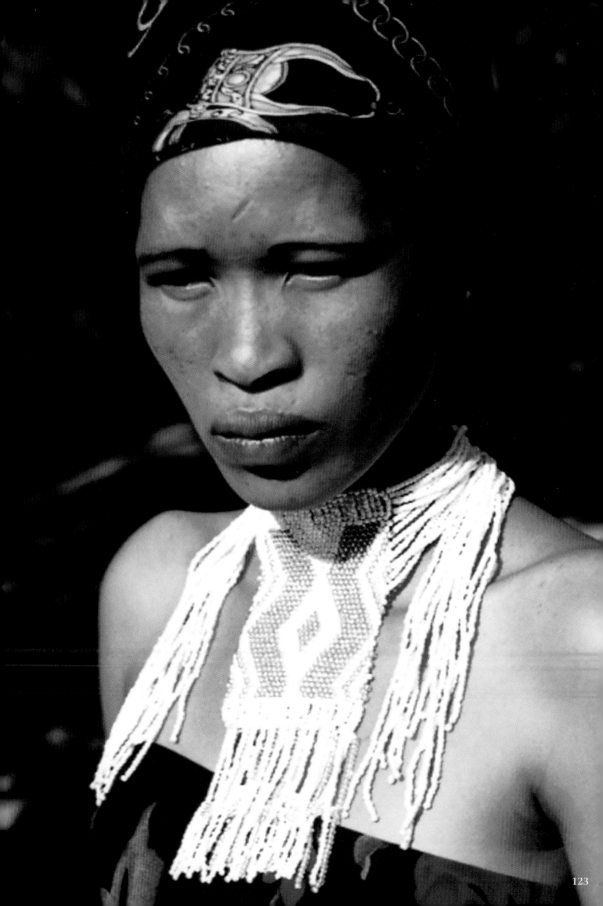

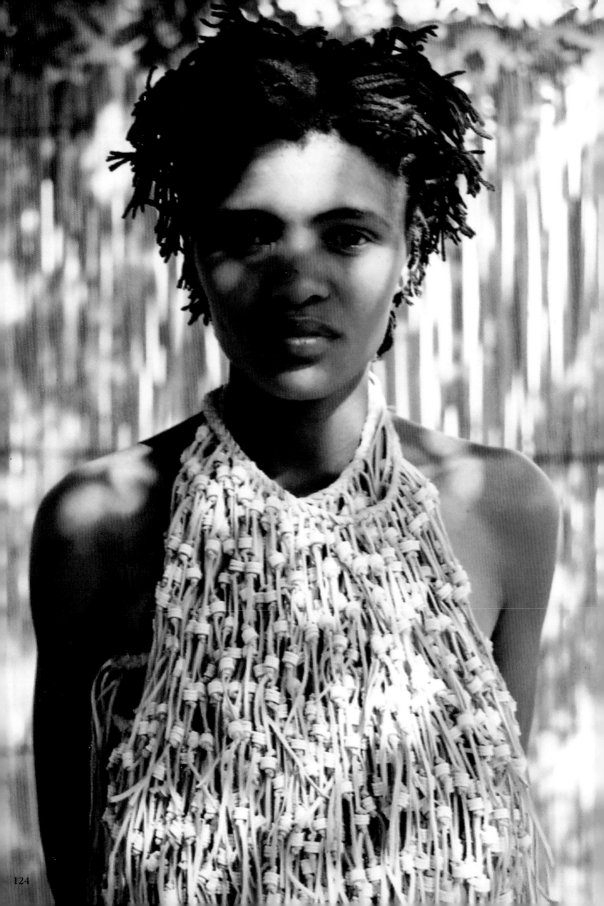

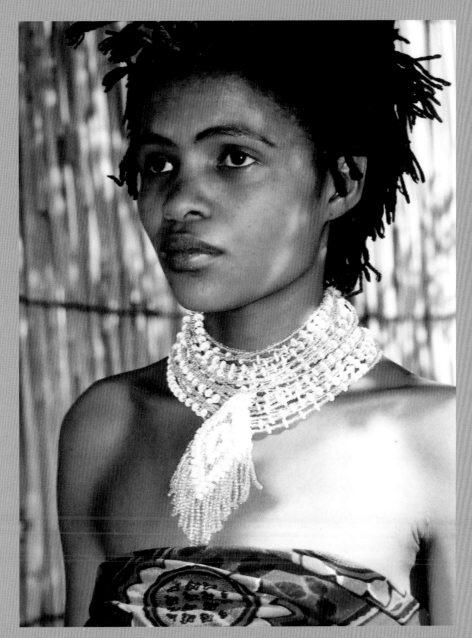

Multistrand necklace of ostrich eggshell beads and silver glass beads inspired by San symbols, 2004

< "Waterfall", flowing necklace of ostrich eggshell strung on leather lanyards, 2004

<< "Namibian Wrap", scarf necklace of ivory and bronze glass beads, 2004
<< "Namibian Wrap", scarf necklace of glass beads, worn by X'oan, 2004

Mickaël Kra et la « Perle du Kalahari »

Sandra P. Tjitendero

Les San, comme ils se nomment eux-mêmes et sont nommés en Afrique australe, sont malheureusement mieux connus du reste du monde sous le nom de Bushmen. Mais, en Namibie, le terme «Bushmen» a une connotation péjorative; aussi pardonnez-moi si le nom de San vous est peu familier. Mais, la suite de l'histoire vous récompensera de votre effort.

La culture de ce peuple ancien, pacifiste et ingénieux est en voie de disparition et sa population en voie d'extinction par suite de la misère et des maladies qui déciment ses communautés. Les San sont souvent appelés «primitifs» par nos sociétés technologiques. Néanmoins, au moment où la peur d'un réchauffement global ne cesse de grandir et alors que l'on commence à prendre conscience de la fragilité de notre environnement, les San sont, parmi tous les groupes ethniques vivant sur cette planète, celui dont le style de vie traditionnel est probablement le plus écologiste! Bon nombre d'entre nous pourraient se mettre à leur école.

Les gouvernements d'Afrique australe, dont les maigres ressources doivent être réparties entre de nombreux postes budgétaires, font de valeureux efforts pour prévenir le déclin qui menace ce peuple vulnérable et marginalisé. Mais le destin d'un peuple n'est pas scellé par la seule volonté des gouvernements. La société civile et la population concernée y jouent aussi un rôle important. L'humanité toute entière sera moins riche si les San sont oubliés et relégués dans les pages annexes de l'histoire de la culture. Leur sagacité face au désert rude et impitoyable et leur manière de coopérer avec cet environnement contiennent des leçons qui peuvent profiter à toutes les sociétés vivant sur la planète terre.

Le Service des Églises Évangéliques en Allemagne pour le Développement, l'EED, travaille avec les communautés San de l'Afrique australe. C'est l'EED qui est à l'origine du projet qui amena Mickaël Kra en Namibie. Même si les San sont contraints à vivre dans un environnement extrêmement hostile, il est faux de s'imaginer qu'ils sont dépourvus d'expression artistique. Mickaël Kra a pu se rendre compte combien cette idée, perpétuée par une histoire coloniale désastreuse, est loin d'être vraie.

J'ai rencontré Mickaël Kra lors de son premier projet de coopération avec des membres des communautés San du Botswana et de Namibie. Son dessein était

Mickaël Kra and the "Pearl of the Kalahari"

Sandra P. Tjitendero

The San, as they call themselves and as they are known in Southern Africa, are unfortunately better known to the rest of the world as Bushmen. In Namibia this is a derogatory term, so please bear with me if you are a little unfamiliar or uncomfortable with the name San. You will be proud of yourself a little later for making this effort!

The culture of these ancient, peaceful and knowledgeable people is rapidly disappearing. It can even be argued that the people themselves are decreasing in numbers as a result of poverty and disease that can afflict their communities. They are often called stone-aged by our more technologically based cultures. However, in this era when fear of global warming is increasing and the fragility of our environment is starting to be recognised and dealt with, the San are a people whose traditional life style is probably the most "environment-friendly" of any group of people anywhere on the planet! There is a lot many of us need to learn from them.

The governments of Southern Africa, whose meagre resources must be spread across many budget lines, make valiant efforts to prevent decline among the vulnerable and unfortunately marginalised San. However, governments alone are usually never solely responsible for the success or demise of any group of people. Civil society and the people themselves also have major roles to play. Humanity itself will be less rich if the San are ignored and relegated to the back pages of culture and history. Their insights regarding a harsh and unforgiving desert environment and how to co-operate with that environment contain lessons that can benefit every society on this planet earth.

Consequently, the German Church Development Service EED (Evangelischer Entwicklungsdienst), among others, is doing socio-economic development work in San communities of Southern Africa. It is the German EED that created the project that brought Mickaël Kra to Namibia. Even though the San have to live in an environment which is extremly hostile, it does not mean that they cannot express themselves artistically! Oh no! Mickaël Kra has come to personally experience how far this notion perpetuated by an ill-fated colonial history is from the truth.

d'explorer les possibilités d'utilisation de leurs techniques de fabrication de bijoux en perles de coquille d'œuf d'autruche pour la haute couture. Il était enthousiaste à l'idée de travailler avec ces femmes simples mais talentueuses. Ma famille, nos amis et moi-même étions enchantés quand il nous racontait combien ces femmes étaient désireuses d'apprendre ainsi que de partager leur savoir. Son respect et sa passion pour ce qu'elles représentaient, à savoir le lien entre une culture ancestrale et le monde moderne, était extraordinairement contagieux. Avec Mickaël Kra je peux parler des heures entières sur l'importance du travail réalisé en collaboration avec ce groupe particulier de femmes : nous voyons déjà l'impact que ce travail aura sur leurs propres communautés en particulier, sur la Namibie et le Botswana plus spécialement, sur le monde entier d'une manière générale.

Mon amour et mon respect pour le travail de Mickaël Kra sont infinis. Car, en fin de compte, nous voyons ici, dans cette partie du monde, un grand nombre de bijoux en coquille d'œuf d'autruche. Je ne m'enthousiasme pas aussi facilement que cela. Je pense que ce qui caractérise avant tout l'innovation, c'est la capacité de faire d'une chose ordinaire et courante quelque chose de beau – une œuvre d'art. Les créations de Mickaël Kra ont su inspirer un groupe de femmes San et transformer un produit artisanal traditionnel en œuvres d'art – plus précisément des œuvres d'art à porter.

J'adore le travail réalisé par Mickaël Kra dans le cadre de notre projet appelé "Perles du Kalahari". Certains penseront que nous exagérons beaucoup en appelant une coquille d'œuf une perle. Toutefois, il convient de rappeler qu'une huître forme une perle de nacre à la suite d'une irritation produite par un simple grain de sable. Dans le cas des "Perles du Kalahari", des mains humaines ont formé chaque éclat, chaque coquille d'œuf dans une intention bien précise. Quand je pense à ces femmes, à leurs mains, à leur patience et à leur dévouement, à leurs chants ou aux pensées qui les habitent quand elles entrelacent des coquilles d'œuf pour en faire un bijou dont vous et moi pouvons nous parer, alors ce sont vraiment des perles que nous portons, les Perles du Kalahari.

Un article de haute couture, c'est un article admirablement exécuté à la main. Ces bijoux répondent à cette définition ainsi qu'aux normes imposées par les plus grandes maisons de haute couture de Paris, telles Louis Féraud et Yves Saint Laurent. Célébrons et fêtons cette fusion de l'ancien et du moderne, cette collection de bijoux d'art qui s'appelle aujourd'hui les « Perles du Kalahari ».

I met Mickaël during his first undertaking with members of the San community of Botswana and Namibia. It was his aim to explore the possible use of their craft of ostrich eggshell beadwork in haute couture design. He was aflame with enthusiasm about the opportunity to work with this group of unassuming but talented women! He delighted me, my family and friends with stories about the desire of these women to learn from as well as share their knowledge with him! His respect and passion for what this group of women represented as a link between their culture and the world of modernity was extraordinarily contagious! Mickaël and I can sit together for hours discussing the implications of his work with this particular group of women, extrapolating as to how this work will impact their community in particular, Namibia and Botswana specifically and the world in general!

My love and regard for Mickaël's work is boundless and that is saying something. After all, in this part of the world, we see a lot of ostrich eggshell jewellery. I am not so easily impressed. For me, a major factor of innovation is the ability to take something common or ordinary, and then transform it into something astonishingly beautiful – a work of art. That he has been able to create designs that inspire this group of San women to raise the level of their work from craft to art, is truly a breath-taking and ground-breaking vocation. The results must correctly be called wearable art.

I love Mickaël's work with our "Pearl of the Kalahari". Some of you may think that we are overstating the issue to call an eggshell a pearl. However, we must remember that a simple oyster makes a lustrous pearl because of the irritation of a single grain of sand. In the case of the "Pearl of the Kalahari", we must realise that human hands have shaped each and every sliver or chip of shell with purpose and intent. If I think of the hands of those women, their patient endeavour, the songs they sing together, and the thoughts they have individually, as they lace each bead into jewellery that you and I can adorn ourselves with, then I am sure that we are wearing "Pearls of the Kalahari".

Finally, haute couture is about exquisitely executed handmade items. This jewellery meets the definition and standards set by major design houses of Paris, namely Louis Féraud and Yves Saint Laurent. Let us celebrate and enjoy this fusion of the ancient and the modern, this artistic jewellery collection that is now called "Pearls of the Kalahari".

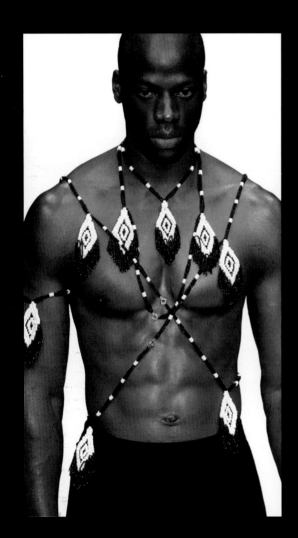

A series of necklaces of ostrich eggshell beads with black onyx beads and San weaving. SAFW Johannesburg (South Africa), 2005

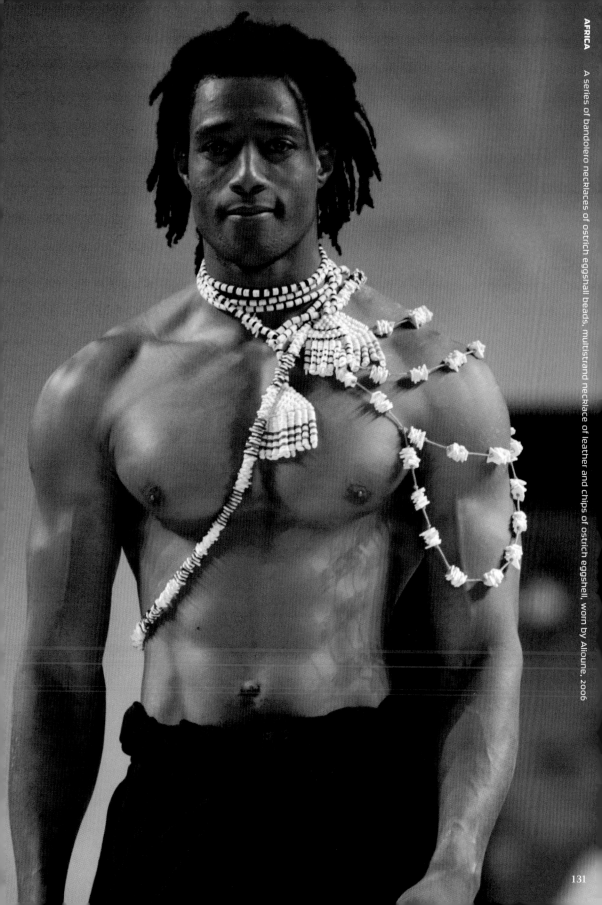

A series of bandolero necklaces of ostrich eggshell beads, multistrand necklace of leather and chips of ostrich eggshell, worn by Alioune, 2006

132

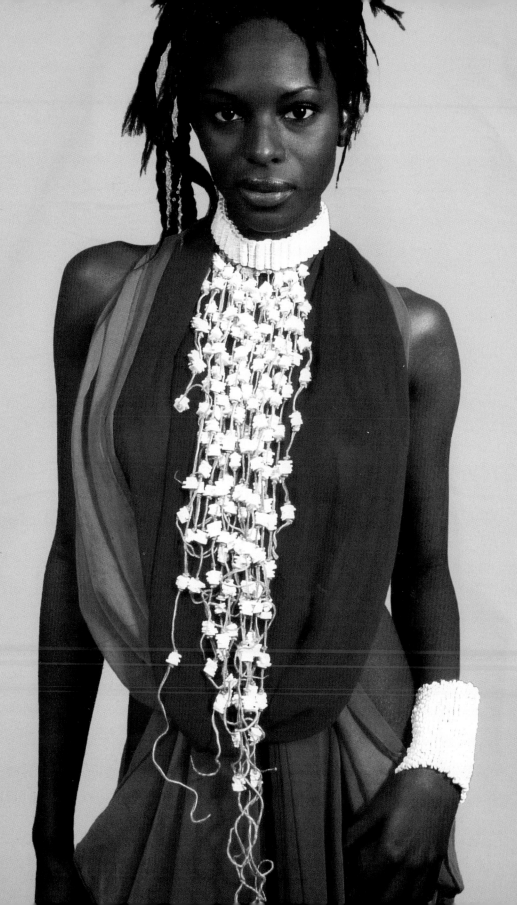

AFRICA

Long necklace "Wild Rain", chips of ostrich eggshell mounted on a leather lanyard and matching cuff, worn by Madoussou, 2003

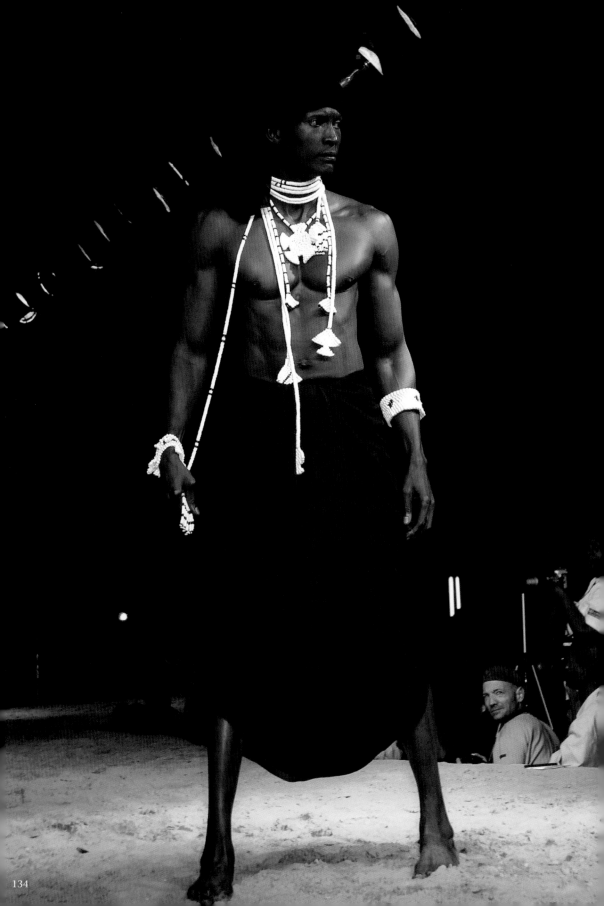

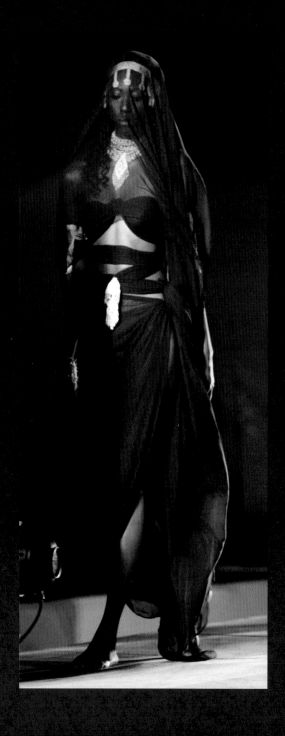

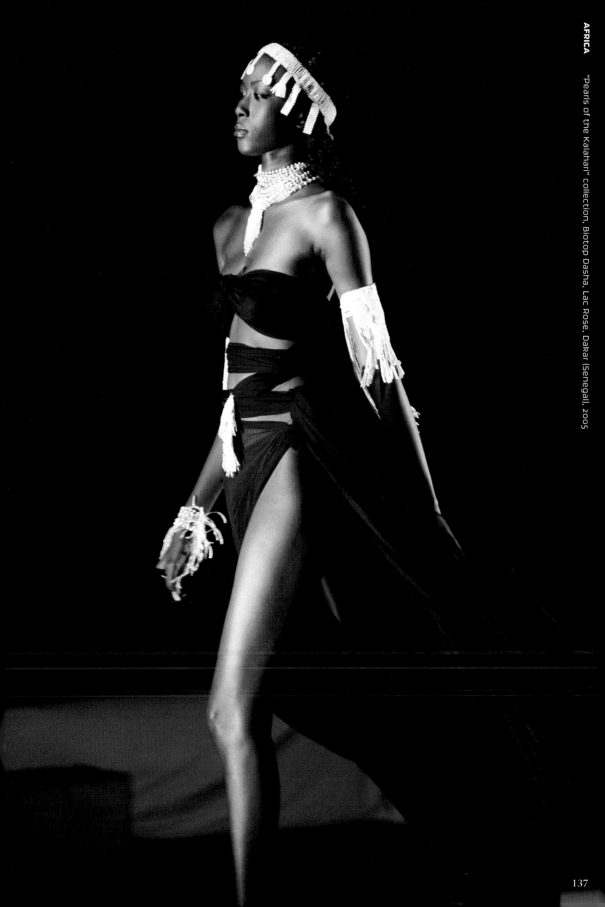

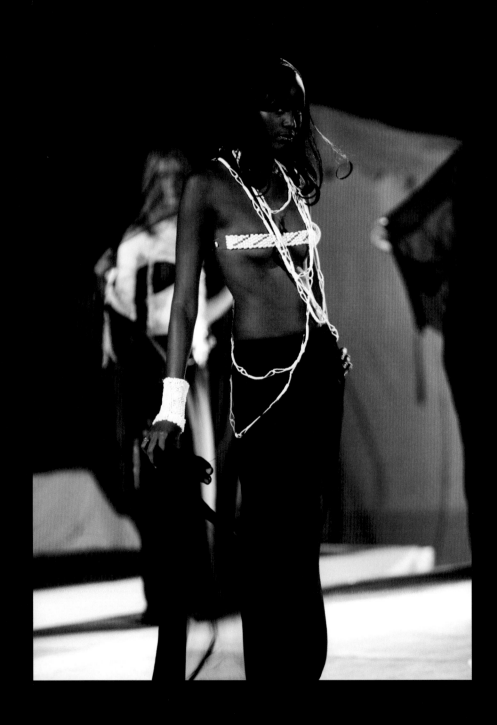

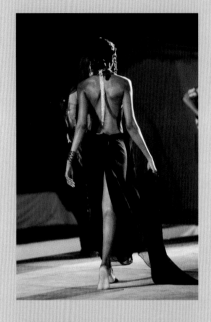
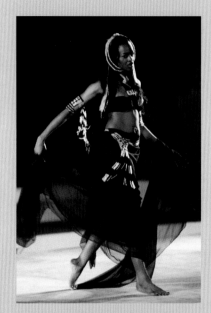
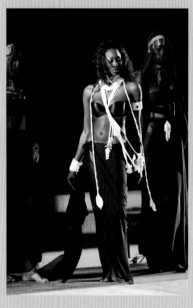
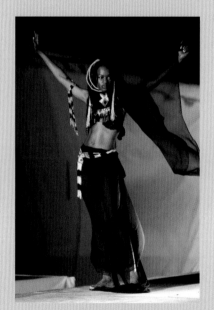

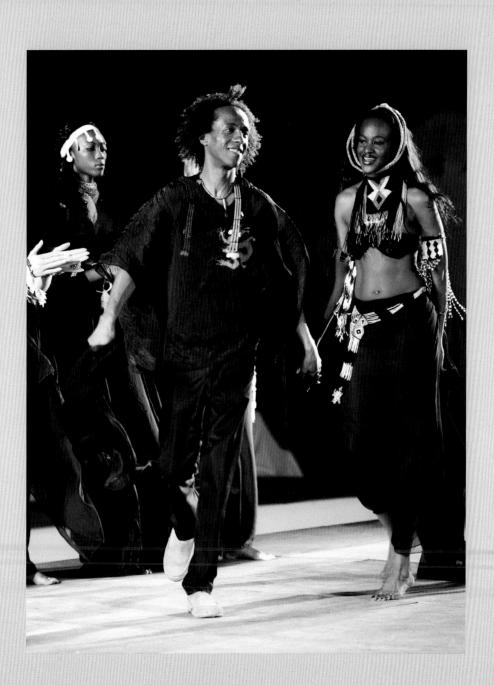

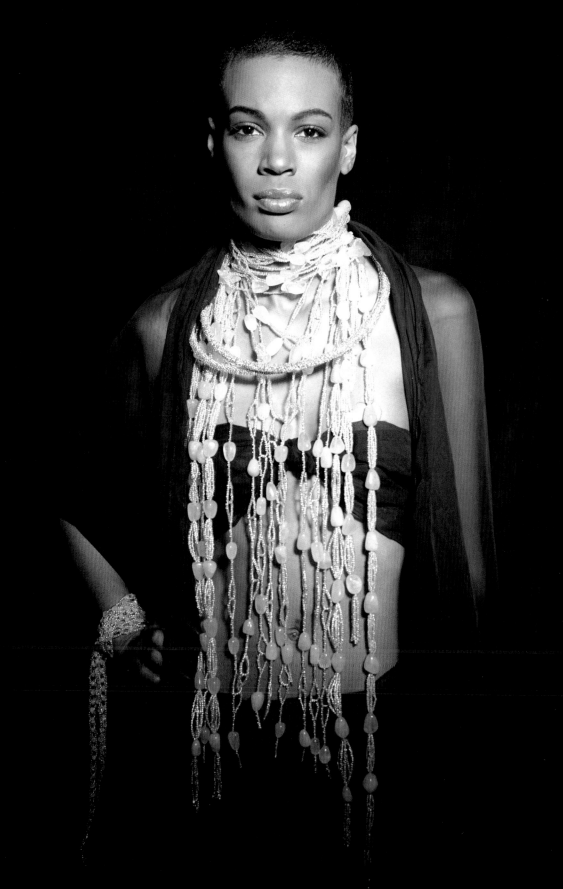

Series of flowing necklaces of rose quartz and silver glass beads, silver hoop, matching bracelet of rose quartz chunks, worn by supermodel Shirley, 2004

Une rencontre sous les étoiles

Esther Kamatari

Ma rencontre avec Mickaël Kra est une très belle histoire. Il était une fois, à la fin du dernier millénaire lors du premier Festival International de la Mode Africaine, imaginé par le couturier Alphadi, dans le somptueux désert du Ténéré …

Sous les tentes confectionnées par les femmes Touaregs, palpitait une effervescente ruche de mannequins, stylistes, coiffeurs, maquilleurs, journalistes, venus d'Europe, à la rencontre d'une Afrique qui les émerveillait.

Au crépuscule, l'atmosphère du désert était si prenante que l'harmonie s'emparait de tout. Il y avait comme une légèreté nouvelle de l'espace et du temps.

Le sable chaud semblait aller à la rencontre du ciel qui apportait la pureté et la fraîcheur de la nuit. Il faisait tellement sombre que le ciel semblait toucher la terre.

Pour présenter la soirée, je portais une robe d'Alphadi. Perfectionniste, j'étais, à la recherche d'un je ne sais quoi pour magnifier ma tenue. Je me suis dirigée vers une table où était assis un jeune homme et où il avait disposé devant lui différentes parures. Mes yeux se sont arrêtés subitement sur un magnifique collier d'agates si claires que je me croyais tout à coup dans la voie lactée. Mickaël prit le collier sans hésiter et le posa autour de mon cou. Un frisson me parcourut. J'avais l'impression que ma tête, altière, portait le collier ou bien est-ce le collier qui me portait ? Symbiose totale !

Sur la scène les Touaregs et les Peulhs Wodaabe apparurent dans leurs beaux costumes. Sous la voûte étoilée, je fis mon discours d'inauguration du festival. Je parlais des enfants d'Afrique, de la mode. On aurait dit que les mots qui sortaient de ma bouche tels des météores célestes atteignaient leurs buts. Par ce collier ma rencontre avec Mickaël s'accomplit. Le collier d'agate fit corps avec moi. Je ressentis toutes les énergies accumulées des siècles durant par ces pierres sur mon cou. C'était comme si elles allaient chercher en moi profondément un autre moi en devenir.

Je ressentais une ferveur, le créateur, Mickaël Kra laissa éclater sa joie de voir sa parure si fièrement portée. Et c'est ainsi qu'une étoile vibrante est née. Amitié. Elle est il en fut ainsi fait.

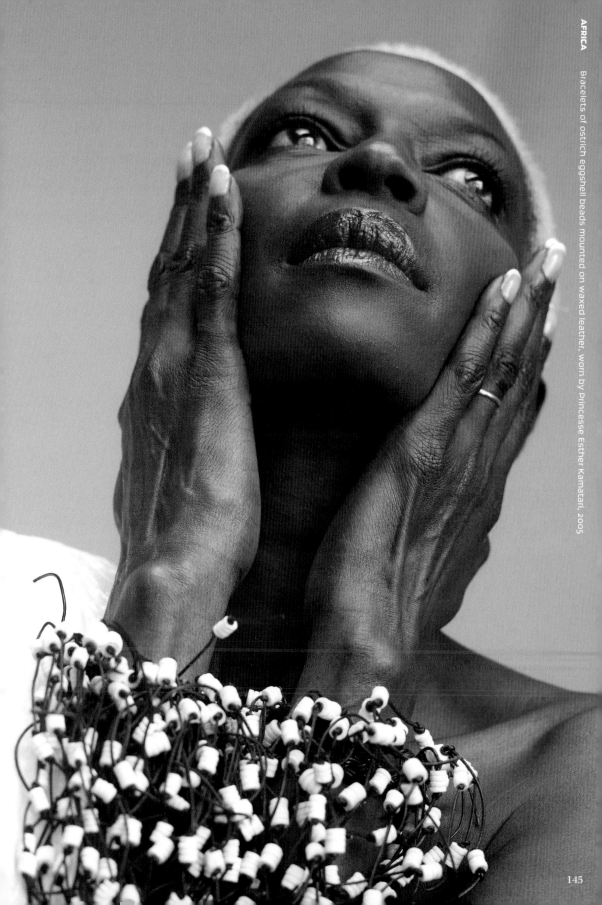

Bracelets of ostrich eggshell beads mounted on waxed leather, worn by Princesse Esther Kamatari, 2005

145

AFRICA

Head jewellery of ostrich eggshell beads mounted on waxed leather, worn by Princesse Esther Kamatari, 2005

Encounter under the Stars

Esther Kamatari

My first encounter with Mickaël Kra is a very beautiful story. It was once upon a time at the close of the last millennium on the occasion of the first Festival International de la Mode Africaine, designed by the couturier Alphadi, in the gorgeous desert of Ténéré...

Under tents sewn by Tuareg women throbbed an bubbly swarm of models, stylists, hairdressers, make-up artists, journalists, all of them having arrived from Europe to encounter an Africa which filled them with awe.

At dusk, the atmosphere of the desert was so pervasive that harmony took hold of everything. There was a new lightness, as it were, of space and time.

The warm sand seemed to rise up to meet the sky, which brought the purity and coolness of night. It was so dark that the sky seemed to touch the earth.

To present the evening festivities, I was wearing a dress by Alphadi. Perfectionist as I am, I was on the look-out for something or other to put the finishing touch to my appearance. I headed towards a table where a young man was sitting, on which he had laid out various necklaces in front of him. My glance was suddenly arrested by a magnificent necklace of agate so clear that I felt as if I was all of a sudden in the Milky Way. Mickaël picked up the necklace without hesitation and put it round my neck. A shiver ran through me. I had the impression that my head, held high, was wearing the necklace, or was the necklace wearing me? A total symbiosis!

Tuaregs and Peulhs Wodaabe appeared on stage in their beautiful costumes. Beneath the starry vault of heaven, I gave my speech to inaugurate the festival. I spoke of African children, of fashion. One might have said that the words that shot from my mouth like celestial meteorites attained their goal. My meeting with Mickaël was brought about by this necklace. The agate necklace became one with my body. I felt all the energy that had been accumulated for aeons by those stones now on my neck. It was as if they were seeking in me the profoundly different me that I was about to become.

I felt a passion; the creator of the piece, Mickaël Kra burst with joy at seeing his necklace worn so proudly. And thus it was that a vibrant star was born. Friendship.

That is how it was meant to be.

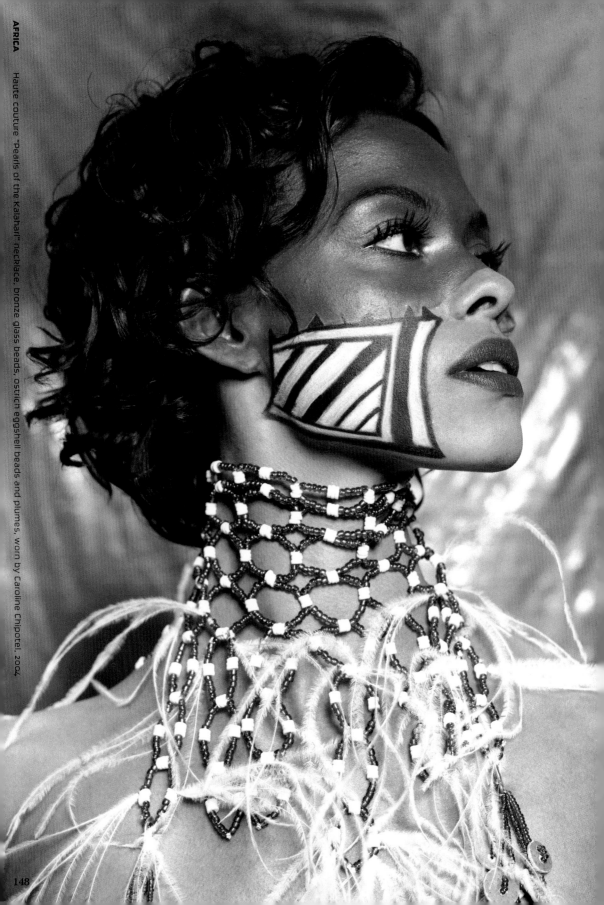

Haute couture "Pearls of the Kalahari" necklace, bronze glass beads, ostrich eggshell beads and plumes, worn by Caroline Chipotel, 2004.

Bracelet of glass beads, inspired by the Zulus of South Africa, SAFW Johannesburg (South Africa), 2005

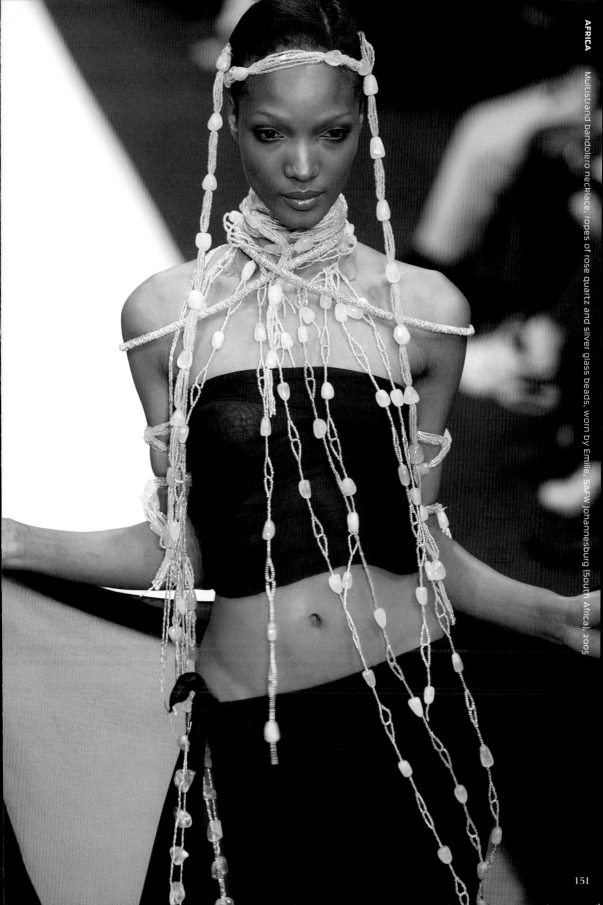

Multistrand bandolero necklace, ropes of rose quartz and silver glass beads, worn by Emilie, SAFW Johannesburg (South Africa) 2005

always
with Katoucha
final Touch

Sandi is ready

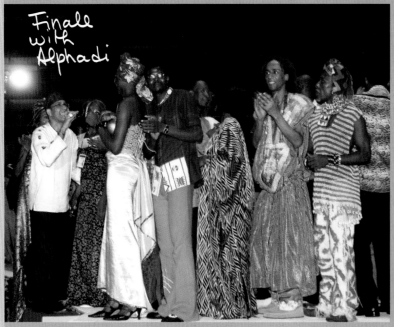

Finale
with
Alphadi

with Sekou
it's perfect

glamour
caroline

Fittings and Rehersals continue !!!
one after the others

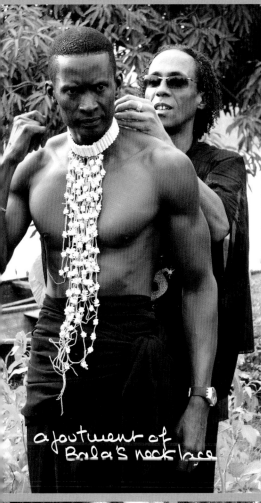

a joutwent of
Bala's necklace

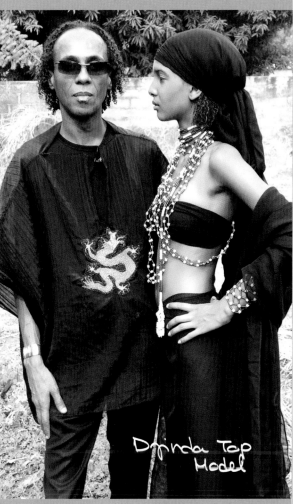

Djinda Top
Model

preparing
shooting

Claire Kane is
helping

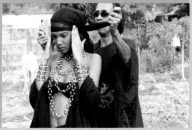

Djinda
Kane

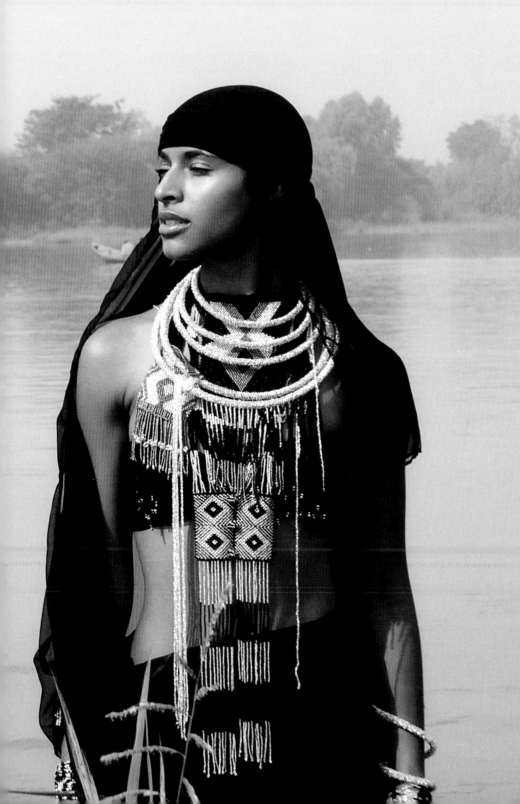

155

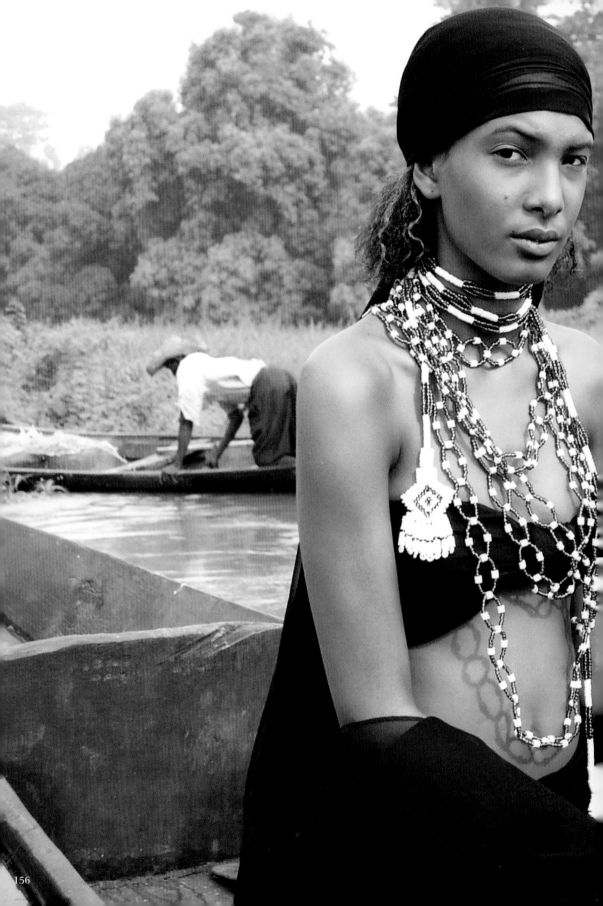

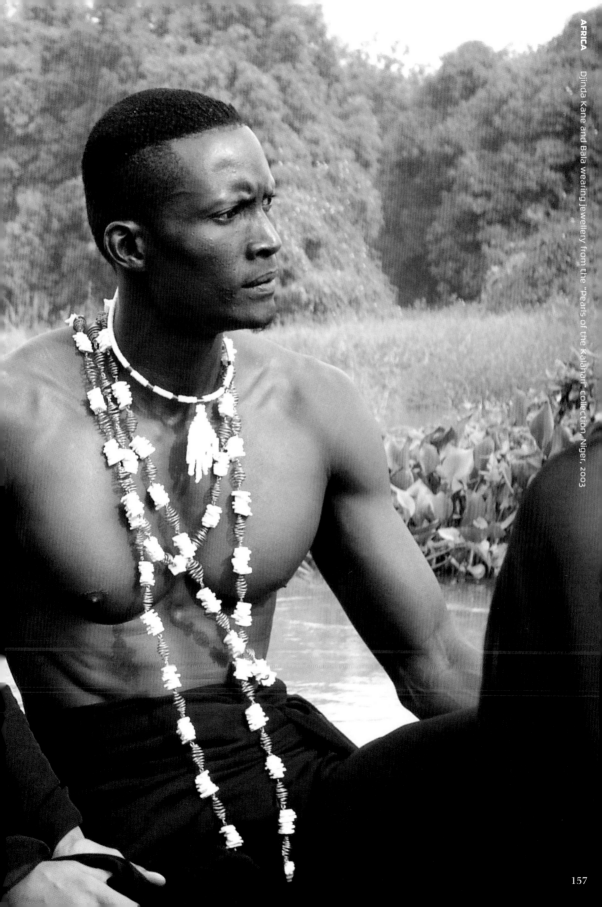

Djinda Kane and Bala wearing jewellery from the 'Pearls of the Kalahari' collection, Niger, 2003

157

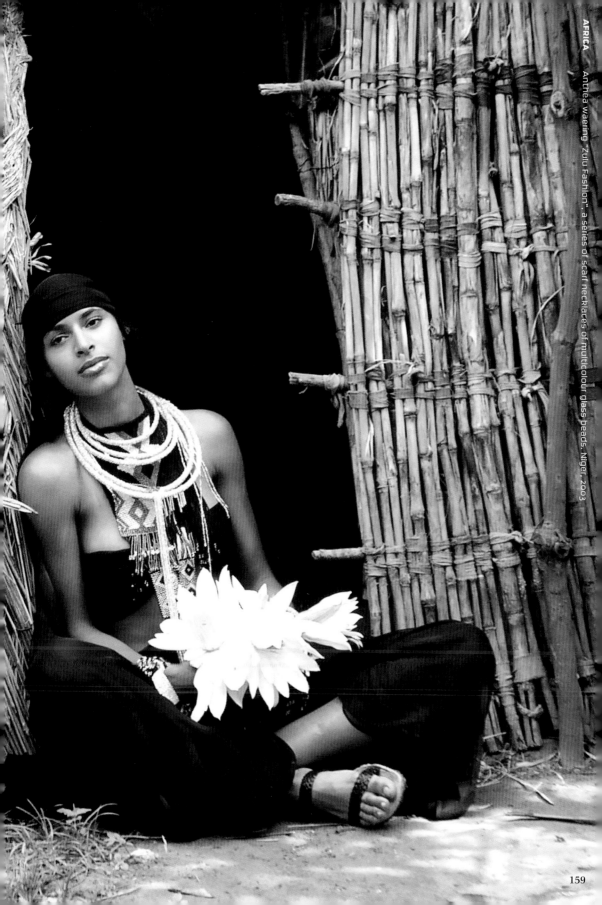

Anthea waering "Zulu Fashion", a series of scarf necklaces of multicolour glass beads, Niger, 2003

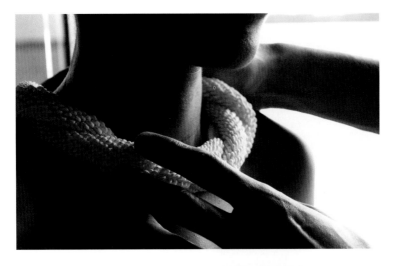

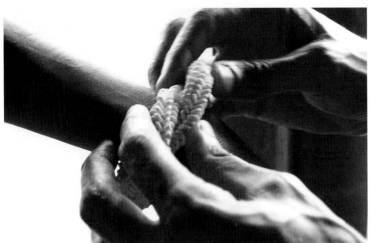

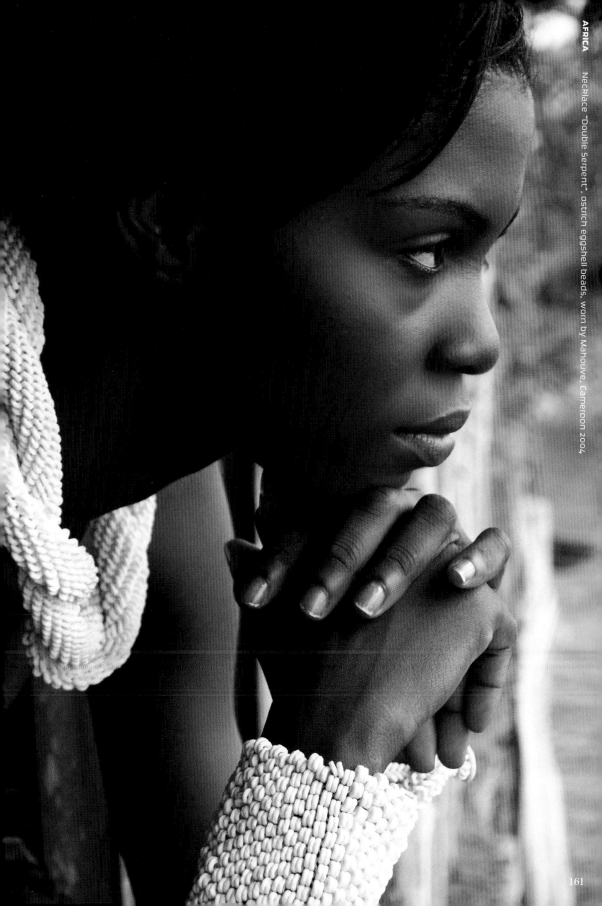

Necklace "Double Serpent", ostrich eggshell beads, worn by Mahouve, Cameroon 2004.

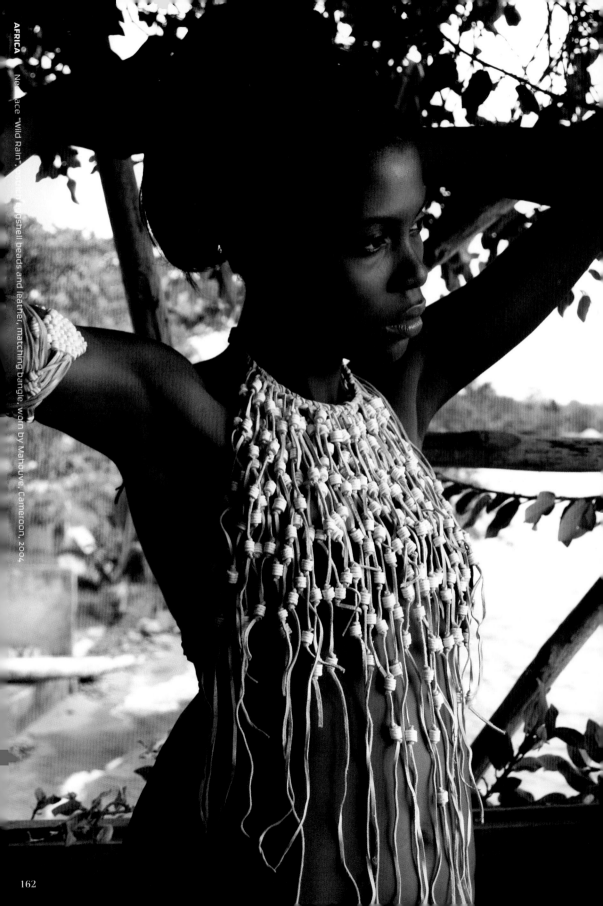

Necklace "Wild Rain", ostrich eggshell beads and leather, matching bangle, worn by Mahouve, Cameroon, 2004.

Acknowledgements
Remerciements

My thanks to:
Mr de Breteuil (Amina)
Christiane Pierre
Renée Mendy
Maude Kwarta and Alain Herman
Saydou Bernard Tall
Christophe Lepetit
Nadine O. Boucher
Eddie Kapesa
Morgan Bala
Karin Leroux
Jean Pierre Aujoulet
Pierre Hoffmann and Britta Lorch
Gigi Vadeleux and Cati Jean Louis at Paco Rabanne
All the models who have worked with us
All those who made this book possible

My special thanks to:
Annette Braun (EED) for her support and for having never lost faith in me –
 que Dieu la bénisse et protège
Axel Thoma (WIMSA) for his support and all the positive energy he is dedicating
 to the San of the Kalahari
Sandra Tjitendero, who welcomed me like a sister to Namibia
Francine Vormese for her support for this project and her involvement
Marie Jeanne Serbin Thomas who from the outset has discovered me and for
 her poetic pen
Winfried Stürzl at Arnoldsche for his unswerving commitment to this book
Princesse Esther Kamatari for her charisma and for always being available
Jaime Ocampo, Stéphane Tourné, Oliviero Toscani and Dennis Williford for their
 superlative pictures and their generosity
Elga at Louis Féraud for her beauty and sincerity
Katoucha Niane, my sister
Kimi Khan, my Reine Pokou
Alphadi who has always supported me
Khady Diallo for all her good advices
Anne Vidal and Renaud
Ma Maman Danielle, mon Papa Amany for their love and their eternal support
Thierry, Odette and Karen
Eugène Kadet

Je dédie ce livre à ma mère, à toutes les femmes de la terre
et en particulier aux femmes San.

Mickaël Kra

Légendes

Tous les bijoux montrés dans ce livre ont été créés par Mickaël Kra, Paris.

2 Mickaël Kra portant un collier en pierres sémi-précieuses (agate blanche, jade jaune et cornaline) avec fil de cuir et perles de cuivre et coquilles d'oeufs d'autruche. 2006. Photo: Alain Herman

NEW YORK

10/11 Times Square, New York. Photo: Winfried Stürzl
12 Médaillon Touareg plaqué or avec chaîne filigrane Baoulé. (Série de sautoirs fabriqués à partir de poids Baoulés à peser l'or. Métaux mélangés). «Le métissage de l'Afrique» (MK). 1992. Photo: Alain Herman. Mannequin: P.L. Ndiaye
13 Chrysler Building, New York. Photo: Winfried Stürzl
16 Traffic à New York. Photo: Winfried Stürzl
17 Bracelet clochettes de danse Ashanti. Boucles d'oreilles ressorts Ashanti plaquées or. 1985. Courtesy: *Interview Magazine*
20 à gauche Roshumba «Reine Pokou», top model pour Essence Magazine. 1986. Photo: Marie Forestier, courtesy: *Essence Magazine*. Mannequin: Roshumba
20 à droite Publicité «Reine Pokou», dans Amina. Série de peignes Baoulés avec boucles d'oreilles assorties. 1988. Photo: Uwe Ommer, courtesy: *Amina*. Mannequin: Kimi Khan
21 Série de bagues poids Baoulés géométriques plaquées or. 1994. Photo: Alain Herman
22/23 Mickaël Kra et Kevin Board. 1988. Photo: Dennis Williford
24 Série de poids Baoulés plaquées or sur robe. Hommage à Patrick Kelly. 1986. Photo: François Marquet. Mannequin: Kimi Khan
25 en haut Tour de cou en perles de cristal. Boucles d'oreilles assorties. 1988. Photo: François Marquet.
25 en bas à gauche Collier «Nœuds». Malachite et lapis lazuli perles en ressorts or Baoulé. Boucles d'oreilles «Treffle». 1987. Photo: Dennis Williford. Mannequin: Kimi Khan
25 en bas à droite Tour de cou en tourmaline. Boucles d'oreilles «Demi-lune». 1987. Photo: Dennis Williford. Mannequin: Kimi Khan
26 Croquis de colliers et bracelets différents. 1987/88.
27 Collier amulettes en métal doré. Boucles d'oreilles «Demi-lune». 1988. Photo: Dennis Williford. Mannequin: Kimi Khan

28 Publicité Patrick Kelly avec bijoux «Reine Pokou» par Mickaël Kra. 1989. Photo: Oliviero Toscani, courtesy: Mickaël Kra
29 Grace Jones portant Patrick Kelly et des bijoux «Reine Pokou» par Mickaël Kra. 1989. Photo: Oliviero Toscani, courtesy: Mickaël Kra. Mannequin: Grace Jones
30 Photos: Francine Vormese
31 Sautoirs «Les nœuds de la connaissance». Sautoirs plombs Touareg et perles de verre. Boucles d'oreilles «Cône». Défilé Salon K'Palezo, Abidjan (Côte d'Ivoire), 1997. Photo: Francine Vormese, courtesy: *ELLE*. Mannequin: Georgette Tra-Lou

PARIS

32/33 Vue vers la Place de la Concorde, Paris. Photo: Winfried Stürzl
34 Collier sauvage en perles d'hématite et lapis lazuli. Boucles d'oreilles assorties. Salon Prêt à Porter Paris, Porte de Versailles, 1992. «Mon premier défilé sur les podiums de Paris. Avec Debra Shaw, supermodel, à ses débuts. Elle est l'une de mes favorites mannequins» (MK). Photo: Jacques Hammel. Mannequin: Debra Shaw
36 Station de Métro, Paris. Photo: Wendy Mastandrea
38 Champs-Elysées, Paris. Photo: Prisma/ F1 Online
39 Ensemble modulable «Sauvage». Diadème, tour de cou, sautoir, broche, boucles d'oreilles. 1994. Photo: Alain Herman. Mannequin: Georgette Tra-Lou. Maquillage: Nadine O. Boucher.
42 Colliers cerceaux en fil tressé de cuivre orangé avec boules de verre. 2000. Photo: Alain Herman. Mannequin: Sylvie. Maquillage: Nadine O. Boucher. Coiffure: Bala Morgan
43 Collier pluie de jais et ceinture poids Baoulé. Ceinture poids Baoulé plaqué or et fil de cuir. Hommage à Claire Kane, Sénégal. 1997. Photo: Alain Herman. Mannequin: Raili. Couture: Claire Kane
46 Collier plastron en perles frisées de cuivre avec perles d'hématite et aigue marine. 1999. Photo: Alex Lucka. Maquillage: Make Up For Ever. Mannequin: Victoria
47 Mickael Kra dans son atelier à Paris. Photos: Christophe Lepetit
48 Katoucha, super model, porte une série de bandoleros en bauxite, métal, or et argent. Broches et boucles d'oreilles. Ensemble modulable pour «Reine Pokou». Ghana, 1995. Photo: Eric Don Arthur. Mannequin: Katoucha
49 Beverly Peele, supermodel, porte une cascade de perles de verre argent et perles

d'eau douce champagne. Pour Katoucha. «La Mariée» de la première collection «Les Barbares sublimes». Défilé Espace Pierre Cardin, Paris. 1993/94. Photo: X.R.X., courtesy Katoucha. Mannequin: Beverly Peele. Couture: Katoucha
50 Collier «Disque Sauvage» frangé de perles de bauxite. Bracelet de bras en corail éponge et amulettes Ashanti. Sautoir coquillage et ambre sur fil de verre. Jupe de raphia. (elle était la première à developper en Haute Couture le raphia). «La Pigmée» de la collection «Les Barbares sublimes». 1995. Photo: Cécile Londeur, Paris, courtesy Katoucha et Prince Claus Fond
51 Collier en pépin de pamplemousse. Pour Katoucha. «La Mariée» de la collection «Les Barbares sublimes». Défilé Buddah Bar, Paris. 1995. Photo: Courtesy Katoucha. Mannequin: Chrystelle St. Louis Augustin. Couture: Katoucha
52 en haut Anna Getaneh, supermodel, porte des Boucles d'oreilles pendantes en or «Masque Bambara». T-shirt imprimé. Pour Katoucha, collection «African Rock». Défilé Espace Pierre Cardin, Paris. 1994. Photo: X.R.X., courtesy Katoucha. Mannequin: Anna Getaneh. Couture: Katoucha
52 en bas Makissi, supermodel, porte un grand collier en perles torsadées de cuivre brut inserré de perles à facettes cristal ruby et barre de cornaline brute avec autour poids Baoulés. Créoles assorties. Pour Katoucha. Défilé Fouquets, Paris. 1997. Photo: Vlisco BV, Helmond/NL, courtesy Katoucha et Prince Claus Fund. Mannequin: Makissi
53 Katoucha, supermodel, porte un collier en fil de perles de verre, argent et hématite. 2000. Photo: Alain Herman. Mannequin: Katoucha. Couture: Imane Ayissi. Maquillage: Mario Epanya
54 Collier perles de verres et hématites et ressorts plaqué argent oxydé. Métal à fusil. Pour Alphadi. Défilé Opal, Carrousel du Louvre, Paris. 2001. Photo: Alain Herman. Mannequin: Kewe. Couture: Alphadi
55 en haut à gauche Collier terre cuite et gouttes de verre. Pour Alphadi. Défilé Opal, Carrousel du Louvre, Paris. 2001. Photo: Alain Herman. Mannequin: Margareth. Couture: Alphadi
55 en haut à droite Collier de chien à bretelles, gouttes de verre et métal. Pour Alphadi. Défilé Opal, Carrousel du Louvre, Paris. 2001. Photo: Alain Herman. Mannequin: Isabelle Moreno. Couture: Alphadi

Captions

Every piece of jewellery shown in this book has been created by Mickaël Kra.

2 Mickaël Kra wearing a necklace made from semi-precious stones (white agate, yellow jade and carnelian) with leather lanyard and copper and ostrich eggshell beads. 2006. Photo: Alain Herman

NEW YORK

10/11 Times Square, New York. Photo: Winfried Stürzl

12 Tuareg medallion, gold plated with filigree Baoulé chain. (A series of long necklaces made from Baoulé weights for weighing gold. Mixed metals). "The hybridisation of Africa" (MK). 1992. Photo: Alain Herman. Model: P.L. Ndiaye

13 Chrysler Building, New York. Photo: Winfried Stürzl

16 Traffic in New York. Photo: Winfried Stürzl

17 Ashanti bracelet with little bells for dancing. Ashanti spring earrings. Gold plated. 1985. Photo: Courtesy of *Interview Magazin*

20 left Roshumba wearing "Reine Pokou", top model for Essence Magazine, USA. 1986. Photo: Marie Forestier, courtesy of *Essence Magazine*. Model: Roshumba

20 right Advertising for "Reine Pokou" in Amina. A series of Baoulé combs with matching earrings. 1988. Photo: Uwe Ommer, courtesy of *Amina*. Model: Kimi Khan

21 A series of geometric Baoulé weight rings. Gold plated. 1994. Photo: Alain Herman

22/23 Mickaël Kra and Kevin Board. 1988. Photo: Dennis Williford

24 A series of Baoulé weights on a dress. Gold plated. A tribute to Patrick Kelly. 1986. Photo: François Marquet. Model: Kimi Khan

25 top A choker of crystal beads. Matching earrings. 1988. Photo: François Marquet. Model: Kimi Khan

25 bottom left Necklace "Knots". Malachite, lapis lazuli. Earrings "Club". 1987. Photo: Dennis Williford. Model: Kimi Khan

25 bottom right Tourmaline choker. Gold plated earrings "Half-Moon". 1987. Photo: Dennis Williford. Model: Kimi Khan

26 Sketches for various necklaces and bracelets. 1987/88.

27 Gold plated amulet necklace. Earrings "Half-Moon". 1988. Photo: Dennis Williford. Model: Kimi Khan

28 Patrick Kelly advertising with "Reine Pokou" jewellery by Mickaël Kra, 1989. Photo: Oliviero Toscani, courtesy of Mickaël Kra

29 Grace Jones wearing Patrick Kelly and "Reine Pokou" jewellery by Mickaël Kra, 1989. Photo: Oliviero Toscani, courtesy of Mickaël Kra. Model: Grace Jones

30 Photos: Francine Vormese

31 Ropes of beads "The Knots of Knowledge". Tuareg ropes of lead and glass beads. Earrings "Cone". Fashion show Salon K'Palezo, Abidjan (Ivory Coast), 1997. Photo: Francine Vormese. Courtesy of *ELLE*. Model: Georgette Tra-Lou

PARIS

32/33 Vue to Place de la Concorde, Paris. Photo: Winfried Stürzl

34 Necklace sauvage with hematite and lapis lazuli beads. Matching earrings. Salon Prêt à Porter Paris, Porte de Versailles. 1992. "My first fashion show on the Paris catwalks. With supermodel Debra Shaw at the outset of her career. She's one of my favourite models" (MK). Photo: Jacques Hammel. Model: Debra Shaw

36 Metro Station, Paris. Photo: Wendy Mastandrea

38 Champs-Elysées, Paris. Photo: Prisma/F1 Online

39 Modular set "Sauvage". Tiara, choker, rope of beads, brooch, earring. 1994. Photo: Alain Herman. Model: Georgette Tra-Lou. Make-up: Nadine O. Boucher

42 Necklaces made of plaited orange copper wire and glass beads. 2000. Photo: Alain Herman. Model: Sylvie. Make-up: Nadine O. Boucher. Hair: Bala Morgan

43 Necklace shower of jet and belt of Baoulé weights. Belt made of gold plated Baoulé weights and leather lanyards. Tribute to Claire Kane, Senegal. 1997. Photo: Alain Herman. Model: Raili. Fashion: Claire Kane

46 Ascot necklace of curly copper beads and beads of hematite and aquamarine. 1999. Photo: Alex Lucka. Make-up: Make Up For Ever. Model: Victoria

47 Mickael Kra in his studio in Paris. Photos: Christophe Lepetit

48 Katoucha, supermodel, wearing a series of bauxite bandoleros, metal, gold and silver. Brooches and earrings. Modular ensemble for "Reine Pokou". Ghana, 1995. Photo: Eric Don Arthur. Model: Katoucha

49 Beverly Peele, supermodel, wearing a cascade of silver glass beads and champagne freshwater pearls. For Katoucha. "The Bride" from the first "Barbares Sublimes" collection. Fashion show Espace Pierre Cardin, Paris. 1993/94. Photo: X.R.X., courtesy of Katoucha. Model: Beverly Peele. Fashion: Katoucha

50 Necklace "Disque Sauvage" fringed with bauxite beads. Bangle of sponge coral and Ashanti amulets. Long rope of shells and amber on fibreglass cord. Raffia skirt. For Katoucha (she was the first to push raffia as a high-fashion material). "La Pigmée" from the "Barbares Sublimes" collection. 1995. Photo: Cécile Londeur, Paris, courtesy of Katoucha and Prince Claus Fund

51 Necklace of grapefruit seeds. For Katoucha. "The Bride" from the "Sublime Barbarians" collection. Buddah Bar fashion show, Paris. 1995. Photo: Courtesy of Katoucha. Model: Chrystelle St. Louis Augustin

52 top Anna Getaneh, supermodel, wearing gold drop earrings "Mask Bambara". Printed T-shirt. For Katoucha. "African Rock" collection. Fashion Show Espace Pierre Cardin, Paris. 1994. Photo: X.R.X., courtesy of Katoucha. Model: Anna Getaneh. Fashion: Katoucha.

52 bottom Makissi, supermodel, wearing a grand necklace of twisted copper-bead fringe interspersed with ruby crystal facetted beads and a bar of uncut cornelian with Baoulé weights. Matching creoles. Fouquets fashion show, Paris. 1997. For Katoucha. Photo: Vlisco BV, Helmond, NL, courtesy of Katoucha and Prince Claus Fund. Model: Makissi

53 Katoucha, supermodel, wearing a necklace of crystal, silver and hematite beads. 2000. Photo: Alain Herman. Model: Katoucha. Fashion: Imane Ayissi. Make-up: Mario Epanya

54 Necklace of hematite and glass beads and oxidised silver-plated springs. Gunmetal. For Alphadi. Fashion Show Opal, Carrousel du Louvre, Paris. 2001. Photo: Alain Herman. Model: Kewe. Fashion: Alphadi

55 top left Terracotta and glass drops pendant necklace. For Alphadi. Fashion show Opal, Carrousel du Louvre, Paris. 2001. Photo: Alain Herman. Model: Margareth. Fashion: Alphadi

55 top right Dog collar with straps, glass drops and metal. For Alphadi. Fashion show Opal, Carrousel du Louvre, Paris. 2001. Photo: Alain Herman. Model: Isabelle Moreno. Fashion: Alphadi

55 bottom left Necklace of emerald glass drops and metal. For Alphadi. Fashion show Opal, Carrousel du Louvre, Paris. 2001. Photo: Alain Herman. Model: FiFi. Fashion: Alphadi

55 bottom right Rope of glass and metal beads and breaded copper weave. For Alphadi. Fashion show Opal, Carrousel du

55 en bas à gauche Collier gouttes de verre émeraude et métal. Pour Alphadi. Défilé Opal, Carrousel du Louvre, Paris. 2001. Photo: Alain Herman. Mannequin: FiFi. Couture: Alphadi

55 en bas à droite Collier sautoir verre et métal et tissage en fil de cuir. Pour Alphadi. Défilé Opal, Carrousel du Louvre, Paris. 2001. Photo: Alain Herman. Mannequin: Kewe. Couture: Alphadi

56 à gauche Parures «Bleu nuit». Bracelets sauvages au franges de perles de verre. Tubes et gouttes. Pour Louis Féraud. Haute Couture, automne/hiver 1995/96. Photo: Courtesy Louis Féraud. Couture: Louis Féraud

56 à droite Parures «Orange feu». Collier et bracelets formes organiques tubes et verres. Pour Louis Féraud. Haute Couture, automne/hiver 1995/96. Photo: Courtesy Louis Féraud. Couture: Louis Féraud

57 Parures «Vert émeraude». Collier minerve. Perles et cristal de verres et tubes. Pour Louis Féraud. Haute Couture, automne/hiver 1995/96. Photo: Courtesy Louis Féraud. Couture: Louis Féraud

59 Robe brodée avec attaches pendantes filigranes Ashanti. For Louis Féraud. Haute Couture, automne/hiver 1997/1998. Photo: Courtesy Louis Féraud. Couture: Louis Féraud

60/61 Ensemble parure au tubes de verre camaïeux bleu inspiré de la tribu Masaï du Kenya. Mickaël Kra, collection printemps/été 1998/99. Cet ensemble parure sera celui qui inspirera Féraud et Kiki à tailler une jupe pour faire l'ensemble avec le bustier «Schéhérazade» (pages suivantes). Photo: Alain Herman. Mannequin: Mariama (Miss Niger 1996). Maquillage: Nadine O. Bouchet

62 Elga pour Louis Féraud: Croquis pour l'ensemble «Schéhérazade». Printemps/été 1998/99.

63 Rebecca Ayoko, supermodel, porte l'ensemble parure et bustier «Schéhérazade» au tubes de verre avec médaillon toucouleur sénégalais. Ceinture et boucles d'oreilles assorties. Pour Louis Féraud. Haute Couture, printemps/été 1998/99. Photo: Alain Herman. Mannequin: Rebecca Ayoko. Couture: Louis Féraud. Coiffure: Eddie Kapesa. Maquillage: Christine Larivière

64 Collier de perles frisées. Argent et argent oxydé avec croix d'Agadez. Version prêt-à porter. 1999. Photo: Alain Herman. Maquillage: Nadine O. Bouchet

65 Version Haute Couture du collier de la page précédante avec deux paires de manchettes assorties. 1999. Photo: Alex Lucas. Maquillage: Make up for ever

66 Eric Enyenque («La Muse») portant un cache-sexe Haute Couture en perles de verre, perles de cristal et perles métalliques.

Avec bracelet bandolero en filigrane or et marteau pendentif Touareg. «Avec Eric les séances photo s'enchaînent avec beaucoup de professionnalisme et Eric a le sens et le ressenti de mes bijoux. Il est un grand plaisir de travailler avec lui.» (MK). Photo: Alain Herman. Mannequin: Eric Enyenque

67 Ensemble, collier de chien avec poids Baoulé «Demi-lune» or avec perles de verre champagne et avec collier de pluie assortie et bracelet. 1998. Photo: Gérard Gentil. Mannequin: Domi. Maquillage: Nadine O. Boucher. Coiffure: Mickaël Kra

68 en haut Série de colliers disques Masaï en perles de verre multicolore avec filet de poitrine. 1998. Photo: Christophe Lepetit. Mannequin: Valérie K. Coiffure: Eddie Kapesa/Mickaël Kra

68 bottom Préparation et stylisme avec Valérie K, Mickaël Kra, Tatiana et Eddie Kapesa au studio de Christophe Lepetit à Paris. 1998. Photo: Christophe Lepetit

69 Collier masques Bakota en métal or brossé. 2000. Photo: Christophe Lepetit. Mannequin: Tatiana. Coiffure: Eddie Kapesa

70/71 Gros plan sur un bustier de plume avec poids Baoulés et bracelet filigrane Baoulé. Plume perdrix et perroquet. 1999. Photo: Christophe Lepetit

72 Gros plan sur un collier en perles frisées du Ghana avec plume de perdrix. 1999. Photo: Christophe Lepetit. Mannequin: Tatiana

73 Collier en plume de perdrix. Ras de cou en baguette d'onyx noir. Boucles d'oreilles assorties. Sautoir cuir avec perles de coco. 1999. Photo: Christophe Lepetit. Mannequin: Tatiana. Maquillage: Nadine O. Boucher. Coiffure: Eddie Kapesa

74/75 Margareth, supermodel, porte une parure Haute Couture en perles de terre cuite avec ressorts métal argenté et gouttes de verre émeraude. 1999. Photos: Saydou Bernard Tall. Mannequin: Margareth Lahoussaye Duvigny. Maquillage: Nadine O. Boucher. Coiffure: Morgan Bala. Stylisme: Mickaël Kra

76 Bracelet sauvage en perles de terre cuite et perles de cristal en facettes. 1994. Photo: Alain Herman

77 Collier minerve d'inspiration Masaï en terre cuite et perles frisées plaquées or avec bretelles en tubes de verre or. Photo: Alain Herman. Mannequin: Kewe

78 Pectorale Masaï en perles de verre. Pour Alphadi, Paris, 2002. Photo: Saydou Bernard Tall. Mannequin: Lyn. Couture: Alphadi

79 Collier minerve or avec perles de verre en quartz rose et tubes de verre. Bracelet manchettes assortis. 2000. Photo: Alain Herman. Mannequin: Makissi. Coiffure: Garo Hasbanian, Paris

80/81 Dans les coulisses, défilé d'Alphadi à Rueil-Malmaison, 1999. Photo: Saydou Bernard Tall. Mannequin: Burbane (à droite). Couture: Alphadi

83 Ensemble «Absolut Mickaël Kra» comprenant diadème, collier plastron, deux bracelets et jupe. 1999.«Absolut Story. Absolut Mickaël Kra. Absolut Vodka. Absolutely Anne Vidal. Elle aussi compte pour moi et restera dans mon cœur un éternel bonheur. Un modèle dans le dépassement de soi-même, un modèle de grandeur et de rigeur» (MK). Photo: Per Zenström, service de presse News Pepper, courtesy of Anne Vidal and Marika Huelm Siegwald. Mannequin: Dawn

84/85 Collier terre cuite et perles de ressorts dorés et manchettes or et améthyste. Boucles d'oreilles «Étoile de mer». Gabon. 2001. Photo: Saydou Bernard Tall. Mannequins: Madoussou et Issa. Couture: Alphadi

AFRIQUES

86/87 «La femme Masaï». FIMA, Niamey (Niger), 2001. Photo: Christophe Lepetit. Mannequin: Diane

90/91 Diadème et collier en perles écailles de tortue en verre et sémi-précieuses multicolores. Christophe Lepetit capture la beauté lors du fameux défilé chez le Sultan d'Agadez (Niger). Pré-FIMA, 1998. Photo: Christophe Lepetit. Mannequin: Khadija Sy

92 en haut et 93 Turban de perles. Collier écharpe d'or avec plombs Touaregs. Pré-FIMA, Agadez (Niger), 1998. Photo: Christophe Lepetit. Mannequin: Valérie K

92 en bas à gauche Turban à perles de verre doré avec serre-tête et boucles d'oreilles extra longues Bororo. Pré-FIMA, Agadez (Niger), 1998. Photo: Christophe Lepetit. Mannequin: Khadija Sy

92 en bas à droite «Georgette Tra-Lou enceinte avec un collier de sautoirs de perles tombant jusqu'aux genoux. Elle est resplendissante.» (MK). Pré-FIMA, Agadez (Niger), 1998. Photo: Christophe Lepetit. Mannequin: Georgette Tra Lou

96 Parure en perles de turquoise et croix d'Agadez or. Boucles d'oreilles «Soleil» pendantifs. Hommage à Monsieur Azzedine Alaïa. Ghana, 1995. Photo: Eric Don Arthur. Mannequin: Nati

97 Mickaël Kra et Katoucha préparent Nati pour le shooting. Ghana, 1995. Photo: Eric Don Arthur. Mannequin: Nati

100 «La femme Masaï». Collier disques tubes de verre multicolore. Ceinture de tubes de verre et plumes. FIMA, Niamey (Niger), 2001. Photo: Christophe Lepetit. Mannequin: Diane

101 Collier «Papillon» poids Baoulé avec plume et cuir torsadé. Anka et Diane B sur

Louvre, Paris. 2001. Photo: Alain Herman. Model: Kewe. Fashion: Alphadi

56 left Necklaces "Midnight Blue". Bracelets sauvages fringed with glass beads. Cylinder beads and drops. For Louis Féraud, haute couture autumn/winter 1995/96. Photo: Courtesy of Louis Féraud. Fashion: Louis Féraud

56 right Necklaces "Fiery Orange". Necklace and bracelets in organic forms, cylinder glass beads. For Louis Féraud, haute couture autumn/winter 1995/96. Photo: Courtesy of Louis Féraud. Fashion: Louis Féraud

57 Necklaces "Emerald Green". Minerva necklace. Pearls and crystal glass and tubes. For Louis Féraud, haute couture autumn/winter 1995/96. Photo: Courtesy of Louis Féraud. Fashion: Louis Féraud

59 Dress embroidered with Ashanti filigree pendant chains. For Louis Féraud, haute couture, autumn/winter 1997/1998. Photo: Courtesy of Louis Féraud. Fashion: Louis Féraud

60/61 Necklace ensemble of tubular glass beads in different shades of blue inspired by the Masai tribe of Kenya. Mickaël Kra, spring/summer collection 1998/99. This necklace ensemble has inspired Féraud and Kiki to make a skirt to go with the "Sheherazade" bustier top (following pages). Photo: Alain Herman. Model: Mariama (Miss Niger 1996). Make-up: Nadine O. Bouchet.

62 Elga for Louis Féraud: sketch for the "Sheherazade" ensemble. Spring/summer 1998/99.

63 Rebecca Ayoko, supermodel, wearing the necklace and bustier ensemble "Scheherazade" with glass bugle beads and a variegated Senegalese medallion. Matching belt and earrings. Louis Féraud, haute couture spring/summer 1998/99. Photo: Alain Herman. Model: Rebecca Ayoko. Fashion: Louis Féraud. Hair: Eddie Kapesa. Make-up: Christine Larivière

64 Necklace of curly beads. Silver and oxidised silver with an Agadez cross, ready-to-wear version. 1999. Photo: Alain Herman. Make-up: Nadine O. Bouchet

65 Haute couture version of the necklace on the preceding page with two pairs of matching cuffs. 1999. Photo: Alex Lucas. Make-up: Make up for ever

66 Eric Enyenque ("The Muse") wearing a haute couture loincloth of glass, crystal and metallic beads. With a lasso bracelet of gold filigree and a Tuareg hammer pendant. 1998. "With Eric, photo sessions took place in orderly sequence with a great deal of professionalism and Eric has a sense of and a feeling for my jewellery.

It's a great pleasure to work with him." (MK). Photo: Alain Herman. Model: Eric Enyenqué

67 Ensemble, dog collar "Half-Moon" with Baoulé weights in gold with champagne glass beads. Matching flowing necklace and bracelet. 1998. Photo: Gérard Gentil. Model: Domi. Make-up: Nadine O. Boucher. Hair: Mickaël Kra

68 top A set of Masai disc necklaces in multicolour glass beads with a net collar. 1998. Photo: Christophe Lepetit. Model: Valérie K. Hair: Eddie Kapesa/Mickaël Kra

68 bottom Preparation and styling with Valérie K, Mickaël Kra, Tatiana and Eddie Kapesa at Christophe Lepetit's Paris studio. 1998. Photo: Christophe Lepetit

69 Bakota mask necklace in gold-coloured brushed metal. 2000. Photo: Christophe Lepetit. Model: Tatiana. Hair: Eddie Kapesa

70/71 Close-up of a feather bustier with Baoulé weights and a Baoulé filigree bracelet. Partridge and parrot feathers. 1999. Photo: Christophe Lepetit

72 Close up of a Ghanaian necklace with a partridge feather. 1999. Photo: Christophe Lepetit. Model: Tatiana

73 Partridge feather collar, choker with baguette-cut black onyx, matching earrings and leather thong with coconut beads. 1999. Photo: Christophe Lepetit. Model: Tatiana. Make-up: Nadine O. Boucher. Hair: Eddie Kapesa

74/75 Margareth, supermodel, wearing a haute couture necklace of terracotta beads with coils of silvered metal and emerald glass drops. 1999. Photos: Saydou Bernard Tall. Model: Margareth Lahoussaye Duvigny. Make-up: Nadine O. Boucher. Hair: Morgan Bala. Styling: Mickaël Kra

76 Bracelet sauvage, terra cotta beads and beads made of facetted crystals. 1994. Photo: Alain Herman

77 Minerva collar inspired by the Masai in terracotta and curly gold-plated beads with straps of gold cylindrical beads. Photo: Alain Herman. Model: Kewe

78 Masai Pectoral of glass beads. For Alphadi. Paris, 2002. Photo: Saydou Bernard Tall. Model: Lyn. Fashion: Alphadi

79 Necklace in gold with glass beads in rose quartz and glass bugle beads. Matching cuff bracelets. 2000. Photo: Alain Herman. Model: Makissi. Hair: Garo Hasbanian, Paris

80/81 In the wings, Alphadi fashion show at Rueil-Malmaison, 1999. Photo: Saydou Bernard Tall. Model: Burbane (right). Fashion: Alphadi

83 "Absolut Mickaël Kra" ensemble comprising a tiara, breatplate necklace, two bracelets and a skirt. 1999. "Absolut Story. Absolut Mickaël Kra. Absolut Vodka. Absolutely Anne Vidal. She, too, matters to

me and will remain an eternal joy in my heart. A model transcending herself, a model of grandeur and discipline." (MK). Photo: Per Zenström, press service News Pepper, courtesy of Anne Vidal and Marika Huelm Siegwald. Model: Dawn

84/85 Necklace of terracotta and gold coil beads and gold and amethyst cuffs. Earrings "Sea Star". Gabon. 2001. Photo: Saydou Bernard Tall. Models: Madoussou and Issa. Fashion: Alphadi

AFRICA

86/87 "Masai Woman". FIMA, Niamey (Niger), 2001. Photo: Christophe Lepetit. Model: Diane B

90/91 Tiara and necklace of glass tortoiseshell beads and multicoloured semiprecious stones. Christophe Lepetit has captured its beauty at the famous fashion show in the residence of the Sultan of Agadez (Niger). Pré-FIMA, 1998. Photo: Christophe Lepetit. Model: Khadija Sy

92 top and 93 Turban of beads. Gold scarf necklace with Tuareg leads. Pré-FIMA, Agadez (Niger), 1998. Photo: Christophe Lepetit. Model: Valérie K

92 bottom left Turban of gilded glass beads with headpiece and extra-long Bororo earrings. Pré-FIMA, Agadez (Niger), 1998. Photo: Christophe Lepetit. Model: Khadija Sy

92 bottom right "Georgette Tra-Lou, pregnant, wearing knee-length ropes of beads. She is dazzling." (MK). Pré-FIMA, Agadez (Niger), 1998. Photo: Christophe Lepetit. Model: Georgette Tra-Lou

96 Necklace of turquoise beads and a gold Agadez cross. Drop earrings "Sun". A tribute to Monsieur Azzedine Alaïa. Ghana, 1995. Photo: Eric Don Arthur. Model: Nati

97 Mickaël Kra and Katoucha making Nati ready for a shoot. Ghana, 1995. Photo: Eric Don Arthur. Model: Nati

100 "Masai Woman", disc necklace of multicoloured glass beads. Belt of glass bugle beads and feathers. FIMA, Niamey (Niger), 2001. Photo: Christophe Lepetit. Model: Diane B

101 Necklace "Butterfly", Baoulé weights with feathers and twisted leather fringe. Anka and Diane B on the banks of the Niger River at nightfall. FIMA, Niamey (Niger), 2001. Photo: Christophe Lepetit. Models: Anka and Diane B. Fashion: Alphadi

102 Necklaces in copper wire decorated with glass balls worn on a series of long ropes of Indigo crystal beads, Tuareg leads, gold. Matching snake bracelets. FIMA, 1999. Photo: Courtesy of Jean Pierre Aujoulet. Model: Alek Wek

les rives du Fleuve Niger à la tombée de la nuit. FIMA, Niamey (Niger), 2001. Photo: Christophe Lepetit. Mannequins: Anka and Diane B. Couture: Alphadi

102 Colliers cerceaux en fil de cuivre dressé avec boules de verre portés sur une série de longs sautoirs en perles de cristal indigo, plombs Touareg, or. Bracelets serpents assortis. FIMA, 1999. Photo: Courtesy Jean Pierre Aujoulet. Mannequin: Alek Wek

103 Finale du FIMA avec Diane B et Mickaël Kra, Niamey (Niger), 2001. Photo: Christophe Lepetit

104 Bustier en perles de terre cuite et frange. Metissacana (Oumou Sy), Dakar (Sénégal), 2000. Photo: JC.DV, courtesy Mickaël Kra. Mannequin: Madoussou

105 Collier masques Bakota or du Gabon. Metissacana 2000 (Oumou Sy), Dakar (Sénégal). Photo: JC.DV, courtesy Mickaël Kra. Mannequin: Aïda

109 Perles - le bijou ancien des San. Photo: Nigel Pavitt/John Warburton Lee/The Bigger Picture

112 Collier «Botswana Snake» - un best-seller fait à partir de la coquille d'œuf d'autruche. Photo: Petra Lochbaum

114/115 Workshop «Pearls of the Kalahari» à Ghanzi (Botswana) avec l'équipe de 23 femmes San, 2002. Photo: Annette Braun

116 à gauche Essayage avec Namasha pendant le workshop «Pearls of the Kalahari». Ghanzi (Botswana), 2002. Photo: Annette Braun

116 à droite Dora, une des participantes, sert de modèle. Ghanzi (Botswana), 2002. Photo: Annette Braun

117 Workshop «Pearls of the Kalahari». Ghanzi (Botswana), 2002.

118 en haut Namasha regarde et applique le savoir-faire de Mickaël Kra, Micki travaille son bracelet, Maria natte le collier «Waterfall». Gobabis (Namibia), 2004. Photos: Annette Braun

118 en bas Workshop «Pearls of the Kalahari». Gobabis (Namibia), 2004. Photo: Annette Braun

119 La fabrication des perles à partir de la coquille d'œuf d'autruche est un travail de patience et de précision. Photo: Courtesy EED/WIMSA

120 Les femmes sont venues de loin et elles apportent leurs ficelles de coquille d'œuf d'autruche. Workshop «Pearls of the Kalahari». Gobabis (Namibia), 2004. Photo: Annette Braun

121 Participantes du workshop «Pearls of the Kalahari». Gobabis (Namibia), 2004. Photo: Annette Braun

122 «Namibian Wrap». Collier écharpe en perles de verre ivoire et bronze. Workshop à Gobabis (Namibia), 2004. Photo: Annette Braun

123 «Namibian Wrap». Collier écharpe en perles de verre porté par X'oan, «la pure beauté du Bush Kalaharien» (MK). Workshop à Gobabis (Namibia), 2004. Photo: Annette Braun

124 «Waterfall». Collier de pluie de coquille d'œuf d'autruche enfilé sur lanières de cuir. Workshop à Gobabis (Namibia), 2004. Photo: Annette Braun

125 Collier ras de cou en perles d'œuf d'autruche et perles de verre argent inspiré des symboles San. Workshop à Gobabis (Namibia), 2004.Photo: Annette Braun

130 Série de colliers en perles de coquille d'œuf d'autruche avec perles d'onyx noir et tissage San. South African Fashion Week (SAFW), Johannesburg (Afrique du Sud). 2005. Photo: Ivan Naudé

131 Série de colliers bandoleros en perles de coquille d'œuf d'autruche. Collier multirang en cuir et chips coquille d'œuf d'autruche. Paris, 2006. Photo: Stéphane Tourné. Mannequin: Alioune

132 Série de sautoirs et colliers bandoleros écharpe en perles coquilles d'œuf d'autruche et épines de porc-épic. Namibia, 2003. Photo: Darryl Evans. Mannequin: Madoussou. Coiffure: Eddie Kapesa

133 Long collier «pluie Sauvage» couture chips de coquille d'œufs d'autruche montés sur lanière de cuir et manchette assortie. Namibia, 2003. Photo: Darryl Evans. Mannequin: Madoussou. Coiffure: Eddie Kapesa

134/135 «Pearls of the Kalahari». Présentation de la collection au FIMA, Niamey (Niger), 2003. Photo: Winfried Stürzl. Mannequin à gauche: Bala

136–141 «Pearls of the Kalahari». Présentation de la collection, Biotop Dasha au Lac Rose, Dakar (Sénégal), 2005. Photos: Stéphane Tourné. Mannequins: Aïsha Dosso et al.

142 Parure en bouton de coquilles d'œuf d'autruche. Ethical Fashion Show (Isabelle Quéhé), Paris 2004. Photo: Djim Masrangar

143 Série de colliers pluie en quartz rose et perles de verre argent. Cerceau disc argent. Bracelet assorti en chips de quartz rose. Ethical Fashion Show (Isabelle Quéhé), Paris 2004. Photo: Djim Masrangar. Mannequin: Shirley

145 Bracelets en perles de coquilles d'œuf d'autruche montées sur cuir ciré. Photographié au studio Pablo Picasso. Paris 2005. Photo: Jaime Ocampo. Mannequin: Princesse Esther Kamatari. Stylisme: Mickaël Kra

146 Parure de tête en perles de coquilles d'œuf d'autruche montées sur cuir ciré.

Photographié au studio Pablo Picasso. Paris 2005. Photo: Jaime Ocampo. Mannequin: Princesse Esther Kamatari. Stylisme: Mickaël Kra

148 Collier Haute Couture «Pearls of the Kalahari», perles de verre bronze, perles de coquilles d'œuf d'autruche et plumes d'autruches. Photographié au studio Le Petit Oiseau, Paris. 2004. Photo: Djim Masrangar. Mannequin: Caroline Chipotel. Maquillage: Nadine O. Boucher. Coiffure: Eddie Capeza. Stylisme: Mickaël Kra

149 Bustier asymétrique Haute Couture en perles de coquille d'œuf d'autruche. Avec fil de cuir doré, perles de quartz rose, d'agate blanche et de jade jaune avec plumes d'autruche et de perroquets. Paris, 2006. Photo: Stéphane Tourné

150 Bustier en perles de verre, inspiré des Zulu d'Afrique du Sud. South African Fashion Week (SAFW), Johannesburg (Afrique du Sud), 2005. Photo: Ivan Naudé.

151 Collier bandolero ras de cou. Sautoirs quartz rose et perles de verre argent. South African Fashion Week (SAFW), Johannesburg (Afrique du Sud), 2005. Photo: Ivan Naudé. Mannequin: Emilie

152/153 En coulisses. Photos: Pierre Hoffmann, Faustfilm + Projekt/Britta Lorch, Soraya, W. Stürzl et courtesy Mickaël Kra

154/155 «Zulu couture». Série de colliers écharpes en perles de verre multicolors. Niamey (Niger), 2003. Photo: Winfried Stürzl. Mannequin: Anthea

156/157 Collection «Pearls of Kalahari». Djinda Kane et Bala sur les bords du fleuve Niger. Niamey (Niger), 2003. Photo: Winfried Stürzl. Mannequins: Djinda Kane et Bala

158/159 «Zulu couture». Série de colliers écharpes en perles de verre multicolores. Niamey (Niger), 2003. Photo: Winfried Stürzl. Mannequin: Anthea

160/161 Collier et bracelet «Double Serpent». Perles de coquille d'œuf d'autruche. Série de photos prise au Comptoir Colonial, Douala (Caméroun), 2004. Photos: Pierre Hoffmann, Faustfilm + Projekt/Britta Lorch. Mannequin: Mahouve

162 Collier «pluie sauvage», perles de coquille d'œuf d'autruche et cuir, bracelet de bras assorti. Série de photos prise au Comptoir Colonial, Douala (Caméroun), 2004. Photo: Pierre Hoffmann, Faustfilm + Projekt/Britta Lorch. Mannequin: Mahouve

170/171 Collection «Pearls of the Kalahari». Finale FIMA, Niamey (Niger), 2003. Récompensé par le «Cheich d'Or» d'Alphadi. Photo: Winfried Stürzl

172 Article: extrait de «This Day» (South Africa), 4 oct. 2004, et différentes couvertures

174/175 Collage. Photos: Courtesy Mickaël Kra

103 Finale of FIMA with Diane B and Mickaël Kra, Niamey (Niger), 2001. Photo: Christophe Lepetit

104 Bustier of terracotta beads and fringe. Metissacana (Oumou Sy), Dakar (Senegal), 2000. Photo: JC.DV, courtesy of Mickaël Kra. Model: Madoussou

105 Necklace of gold Bakota masks from Gabon. Metissacana (Oumou Sy), Dakar (Senegal), 2000. Photo: JC.DV, courtesy of Mickaël Kra. Model: Aïda

109 Beads - the ancient adornment of the San. Photo: Nigel Pavitt/John Warburton Lee/The Bigger Picture

112 The «Botswana Snake» necklace – an ostrich eggshell beads bestseller. Photo: Petra Lochbaum

114/115 First "Pearls of the Kalahari" workshop in Ghanzi (Botswana) with a team of 23 San women, 2002. Photo: Annette Braun

116 left Trying on with Namasha during the "Pearls of the Kalahari" workshop, Ghanzi (Botswana), 2002. Photo: Annette Braun

116 right Dora, one of the participants, modelling for Mickaël Kra. Ghanzi (Botswana), 2002. Photo: Annette Braun

117 "Pearls of the Kalahari" workshop, Ghanzi (Botswana), 2002. Photo: Annette Braun

118 top Namasha watching and applying Mickaël Kra's expertise, Micki working on her bracelet, Maria weaving the "Waterfall". Gobabis (Namibia), 2004. Photos: Annette Braun

118 bottom "Pearls of the Kalahari" workshop. Gobabis (Namibia), 2004. Photos: Annette Braun

119 Making beads from ostrich eggshells requires a lot of patience and precision. Photo: Courtesy of EED/WIMSA

120 The women have come from far bringing their strands of ostrich eggshell beads to the workshop, Gobabis (Namibia), 2004. Photo: Annette Braun

121 Participants of the "Pearls of the Kalahari" workshop, Namibia 2004. Photo: Annette Braun

122 "Namibian Wrap". Scarf necklace of ivory and bronze glass beads. Workshop at Gobabis (Namibia), 2004. Photo: Annette Braun

123 "Namibian Wrap". Scarf necklace of glass beads worn by X'oan, "pure beauty from the Kalahari bush" (MK). Workshop at Gobabis (Namibia), 2004. Photo: Annette Braun

124 "Waterfall". Flowing necklace of ostrich eggshell strung on leather lanyards. Workshop at Gobabis (Namibia), 2004. Photo: Annette Braun

125 Multistrand necklace of ostrich eggshell beads and silver glass beads inspired by San

symbols. Workshop at Gobabis (Namibia), 2004. Photo: Annette Braun

130 A series of necklaces of ostrich eggshell beads with black onyx beads and San weaving, SAFW Johannesburg (South Africa). 2005. Photo: Ivan Naudé

131 A series of bandolero necklaces of ostrich eggshell beads, multistrand necklace of leather and chips of ostrich eggshell. Paris, 2006. Photo: Stéphane Tourné. Model: Alioune

132 Series of long scarf necklaces of ostrich eggshell beads and porcupine prickles. Namibia, 2003. Photo: Darryl Evans. Model: Madoussou. Hair: Eddie Kapesa

133 Long necklace "Wild Rain", uniformly cut chips of ostrich eggshell mounted on a leather lanyard and matching cuff. Namibia, 2003. Photo: Darryl Evans. Model: Madoussou. Hair: Eddie Kapesa

134/35 "Pearls of the Kalahari" collection. Presenting the collection at FIMA 2003, Niamey (Niger). Photo: Winfried Stürzl. Model (left): Bala

136–141 "Pearls of the Kalahari" collection. Presenting the collection, Biotop Dasha au Lac Rose, Dakar (Senegal), 2005. Photos: Stéphane Tourné. Models: Aïsha Dosso et al.

142 Necklace of ostrich eggshell buttons. Ethical Fashion Show (Isabelle Quéhé), Paris, 2004. Photo: Djim Masrangar

143 Series of flowing necklaces of rose quartz and silver glass beads, silver hoop. Matching bracelet of rose quartz chunks. Ethical Fashion Show (Isabelle Quéhé), Paris 2004. Photo: Djim Masrangar. Model: Shirley

145 Bracelet of ostrich eggshell beads mounted on waxed leather. Photographed at the Pablo Picasso studio. Paris 2005. Photo: Jaime Ocampo. Model: Princesse Esther Kamatari. Styling: Mickaël Kra

146 Head jewellery of ostrich eggshell beads mounted on waxed leather. Photographed at the Pablo Picasso studio. Paris 2005. Photo: Jaime Ocampo. Model: Princesse Esther Kamatari. Styling: Mickaël Kra

148 Haute couture "Pearls of the Kalahari" necklace, bronze glass beads, ostrich eggshell beads and ostrich plumes. Photographed at Le Petit Oiseau studio, Paris. 2004. Photo: Djim Masrangar. Model: Caroline Chipotel. Make-up: Nadine O. Boucher. Hair: Eddie Capeza. Styling: Mickaël Kra

149 Asymmetrical haute couture bustier of ostrich eggshell beads. With copper-gilt wire, rose quartz, white agate and yellow jade beads, ostrich plumes and parrot feathers. Paris, 2006. Photo: Stéphane Tourné

150 Bustier of glass beads, inspired by the Zulus of South Africa. South African Fashion Week (SAFW), Johannesburg (South Africa), 2005. Photo: Ivan Naudé

151 Bandolero multistrand necklace. Ropes of rose quartz and silver glass beads. South African Fashion Week (SAFW), Johannesburg (South Africa), 2005. Photo: Ivan Naudé. Model: Emilie

152/153 Off the stage. Photos: Pierre Hoffmann, Faustfilm + Projekt/Britta Lorch, Soraya, Winfried Stürzl and courtesy of Mickaël Kra

154/155 "Zulu Fashion". A series of scarf necklaces of multicoloured beads. Niamey (Niger), 2003. Photo: Winfried Stürzl. Model: Anthea

156/157 "Pearls of the Kalahari" collection. Djinda Kane and Bala on the bank of the Niger River. Niamey (Niger), 2003. Photo: Winfried Stürzl. Models: Djinda Kane and Bala

158/159 "Zulu Fashion". A series of scarf necklaces of multicolour glass beads. Niamey (Niger), 2003. Photo: Winfried Stürzl. Model: Anthea

160/161 Necklace and bracelet "Double Serpent". Ostrich eggshell beads. A series of photos taken at the Colonial Trading Post, Douala (Cameroon), 2004. Photos: Pierre Hoffmann, Faustfilm + Projekt/Britta Lorch. Model: Mahouve

162 Necklace "Wild Rain", ostrich eggshell beads and leather, matching bangle. Series of photos taken at the Colonial Trading Post, Douala (Cameroon), 2004. Photo: Pierre Hoffmann, Faustfilm + Projekt/Britta Lorch. Model: Mahouve

170/171 "Pearls of the Kalahari" collection. Finale FIMA 2003, Niamey (Niger). Funded by the "Cheich d'Or" of Alphadi. Photo: Winfried Stürzl

172 Article from "This Day" (South Africa), 4 October 2004, and different covers

174/175 Collage. Photos: Courtesy of Mickaël Kra

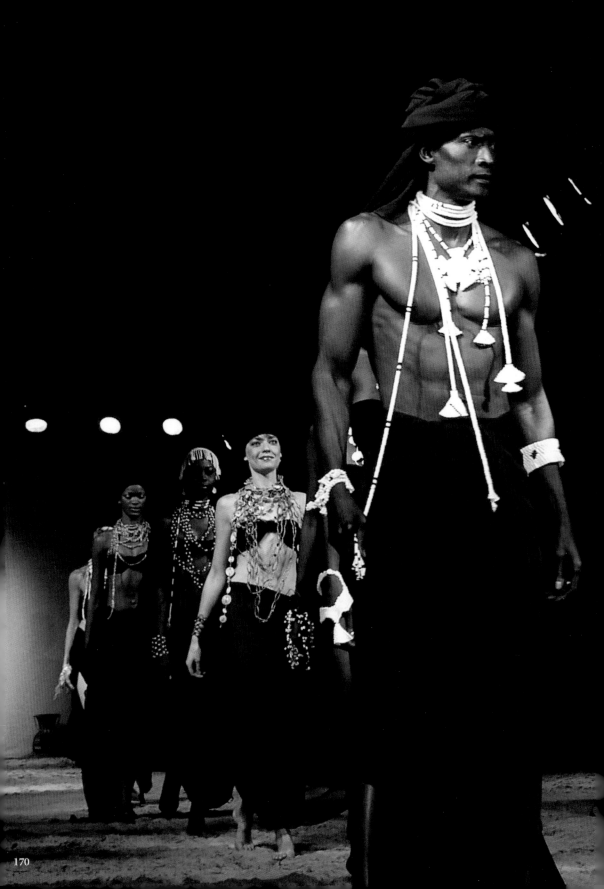

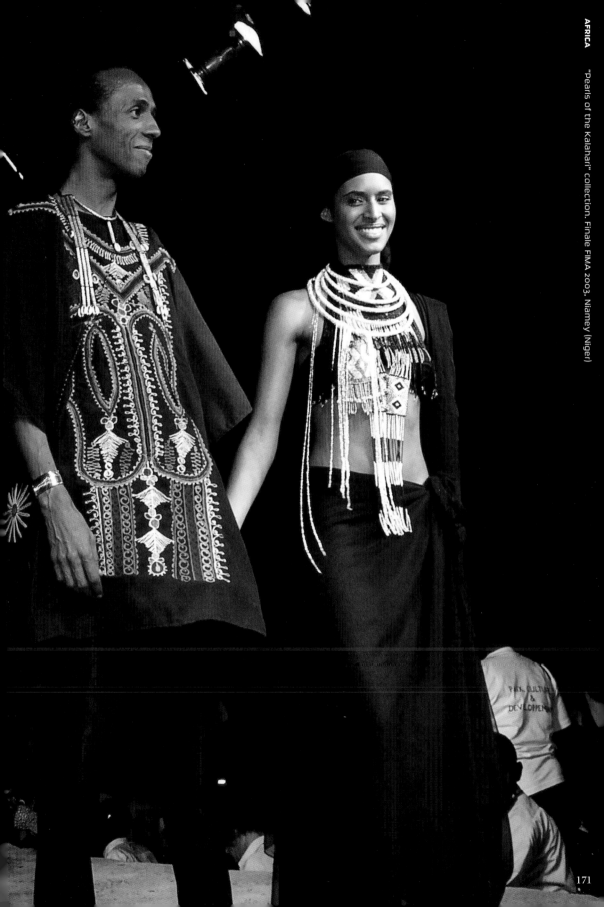

AFRICA

"Pearls of the Kalahari" collection. Finale FIMA 2003, Niamey (Niger)

The pearls of

A European designer based in Paris finds his way to ancient Africa. Mickael Kra has used the traditional skills of San communities to make world-class ethnic jewellery, writes **ADAM LEVIN**

THE drama and imagination of Paris-based designer Mickael Kra and the traditional skills of isolated San communities have taken ethnic jewellery to the realm of world-class couture.

Born to Dutch and Ivorian parents, jeweller Mickael Kra made his name in Europe over the past decade exploring Africa's ancient jewellery traditions and reinventing them as sexy, modern collections that look more like elaborate body armour than accessories.

Drawing on the techniques of the Akan goldsmiths of his homeland, Kra has worked extensively with the lost-wax method, crafting maquettes of the tribe's symbolic motifs, and casting them as beads, in bronze, silver or lighter, more affordable metals, and stringing them into gleaming bundles. Kra's expertise lies in researching labour-intensive craft traditions, streamlining them for commercial production, and restyling them with his distinctive flair.

Just as Akan kings displayed their wealth by appearing in public festooned in heaps of gold, so Kra presents his majestic collections on Europe's catwalks, sending his models down the ramp draped in his signature shimmer.

The models are often naked but for the intricate installations around their necks, arms or waists — thus blurring the line between jewellery and couture. As a result, Kra has produced acclaimed collections for Yves Saint Laurent, Pierre Balmain and Louis Ferraud. Last year, he was commissioned by luxury label Ungaro, to produce a range of beaded garments for its Milan collections.

Kra is currently in southern Africa, polishing off his latest fusion of African soul and European sophistication. The "Pearls of the Kalahari" is the result of two workshops run in Botswana and Namibia, organised by the Rossing Foundation and the EED — a German church-based organisation — and various NGOs that facilitate cultural exchange programmes between Germany and its former colony, in an attempt to create feasible economic programmes for marginalised communities.

In two fortnight-long sessions, Kra worked with San women, helping them refine their rudimentary skills to produce a world-class collection.

It has been four years since I last interviewed Kra — in the flurry of a Saharan sandstorm, while he was participating in the first International Festival of African Fashion in Niger — and today, in his fitted black suit and jungle of curls, he is bubbly and energetic as ever. Like some mystic snake-charmer, he extracts a never-ending strand of ostrich-shell beads from his leather pouch and winds it around his neck. "Voila," he beams. "My latest *bandolero*! Chic, *non*?"

Kra is quite comfortable hopping between hi-tech French laboratories and rustic African villages, and is always exhilarated by the synergy of these disparate worlds. Although he felt at home while living in the isolated communities of Gantzi, Tsumkwe and Gobabis, he was a little alarmed by local techniques.

"They were using their teeth, bits of stone, anything," he exclaims, horrified. "And their hands were like cardboard!"

Kra introduced some less taxing techniques, and incorporated glass beads along with traditional leather and ostrich shell, but he allowed the women to work at their leisure.

"The result," he says, "is some of the finest hand-crafted products I have ever seen."

The small bracelets and chokers often sold as souvenirs were reborn on a far more dramatic scale, and the ailing tradition was injected with a hot, cosmopolitan glamour.

Hopefully, as the "Pearls of the Kalahari" make their way around the faraway world of haute couture, these impoverished communities will come to solve the urgent dilemma of generating income and preserving a dying desert craft.

DIVINE RETRIBUTION?
We all adored and admired Sudanese supermodel Alek Wek for challenging the ster otypes of black beauty with her striking looks, until Wek postponed and finally faile ... at the Face of Cape Town Fashion Week. Now just last week Wek was ... ation at London Fashion Week, but the box of sh ... disappeared and has still

Authors / Auteurs

Annette Braun has carried out as cultural consultant to the Church Development Service (EED) numerous innovative art and cultural projects promoting dialogue and exchange with Africa. Projects that combine art and development include the presentation of designer fashions from Senegal at Expo 2000 in Hannover; the touring exhibition and publication *Soweto – A South African Legend* (Arnoldsche Art Publishers, 2001); the art installation "The Scars of Memory" by Kofi Setordji on the genocide in Ruanda (2004); "Pearls of the Kalahari" – workshops with Mickaël Kra in Botswana and Namibia (2003–2004). She is co-editor of the illustrated book *Bushman Art* (Arnoldsche Art Publishers, 2003).

Esther Kamatari is Princess Royal of Burundi. She was the top star of the catwalk at exclusive international fashion shows during the 1980s. Today she takes care of children who have been victims of the conflicts in her native Burundi as well as children from other countries and has, for instance, contributed to a boat for Lebanon by sending donations. Her humanitarian commitment to children and women is wide-ranging, hands-on and without boundaries: above all, reconstructing the social fabric. Her autobiography, *La Princesse des Rugo* (Edition Bayard, 2003) has been translated into German and Dutch.

Adam Levin Adam Levin is an award-winning South African author and journalist who is regarded as the country's key fashion writer. He has published several books, e.g. *The Wonder Safaris: African Journeys of Miracles and Surprises* (Struik Publishers, 2003) and *The Art of African Shopping* (Struik Publishers, 2005). His work has appeared in major fashion magazines, including *VOGUE* and *ELLE*.

Sandra P. Tjitendero is the wife of the late first Speaker of the Namibian National Assembly and has been involved for many years in the social and educational advancement of her people. She is chairperson of the Namibian Literacy Trust and the founder and executive director of the Omusema Unity Foundation, which strives for the improvement of rural living conditions.

Francine Vormese is a journalist with *ELLE* France, where she has produced, styled and written many interviews on international fashion designers and photo reports about emerging fashions in Japan, India and China. As travel editor she has shown the sophisticated styles of the world in *ELLE Décoration*. Since the 1990s, she has written features about modern Africa and taken photographs of it both for *ELLE* and *ELLE Décoration*. Co-author of *La beauté du siecle* (Editions Assouline, 2000), *Les années ELLE* (1995), *Le best of des voyages du ELLE Décoration* (Filipacchi Editions, 1999). She is greatly interested in crafts and handmade textiles. Her blog "Sourcing styles" at ELLE.fr started in March 2006.

Bibliography (a selection)
Bibliographie sélective

Pauline Duponchel, *Textiles Bogolan du Mali*, Collections du MEN 8, Musée d'Ethnographie, Neuchâtel, 2004
Anne Grosfilley, *Afrique des textiles*, Edisud, 2004
Joseph Ki-Zerbo, *A quand l'Afrique?*, Editions de l'Aube, 2004
Michaela Manservisi, *African Style*, Cooper & Castelvecchi, 2003
Renée Mendy-Ongoundou, *Elegances Africaines*, Editions alternatives, 2002
Sylvia Serbin, *Reines d'Afrique et héroïnes de la diaspora noire*, Editions Sepia, 2005
The Art of African Fashion, Prins Claus Fund, Africa World Press, 1998

ELLE Décoration, décembre–janvier 2000
ELLE France: 12 septembre 1994, 5 mars 1998
Revue Noire, Art Contemporain Africain, Revue trimestrielle No. 27, 1998

Alphadi & Micka

Sandra & me
at home in Windhoek

AIR MAIL

BY AIR MAIL
PAR AVION

MICKAEL KRA

SAFW
annette, Xoan
Micka sur le stand

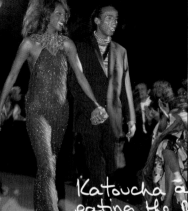

Katoucha and me
eating the runway!

NAMIBIA
N$ 5.00

Mamau Chérie

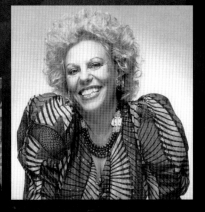

Michael is wearing
Claire Kane

Annette & I

Kimi Khau
my Darling

Michael
central park
Manhattan

Mikael Kra

Essayage sous les
palmes: Khadija Sy

Mickaël Kra - Curriculum Vitae

1960	Born 19 July in Lille (France)
1984–1991	Parsons School of Design New York, BFA
1991	Official designer and award winner for the Miss Europe crown
	Creation of the "Reine Pokou" jewellery
	Salon International du Textile et de l'Habillement (SITHA), Abidjan (Ivory Coast)
	«Reine Pokou» jewellery is sold by the aviation company Air Afrique
	Distribution of "Reine Pokou" jewellery in the U.S. (Macy's, San Francisco; Henri Bendel, New York; Saks, Fifth Avenue, New York; Giorgio, Beverly Hills)
1992	Salon Prêt à Porter, Paris
1993	Salon Prêt à Porter, Paris
1993–1998	Creation of jewellery for Louis Féraud, Paris, spring/summer and autumn/winter haute couture collections
1994–2003	Creation of jewellery for Alphadi, Paris/Niamey, haute couture collections
1994–2000	Caravane d'Alphadi (Gabon – Ivory Coast – Senegal – Cameroon – Tchad – Mali; collaboration, creation, realisation)
1996	Creation of jewellery for Pierre Balmain, Paris
	Creation of jewellery for Boutique François Iᵉʳ, Paris, haute couture, spring/summer
	Espace Jeunes Créateurs, Forum des Halles, Paris
1997	Creation of jewellery for Katoucha Couture, Paris
	K'Palezo, Le Salon de la Mode et des Accessoires, Abidjan (Ivory Coast)
1998	FIMA (Festival International de la Mode Africaine), Niger
1999	Manja (Festival de la Mode Malgache), Madagascar (Prix d'excellence, received from the Ministry of Industry)
2000	FIMA (Festival International de la Mode Africaine), Niamey (Niger)
2001	Renée Mancini chaussures (New York, Paris, Beverly Hills)
2002	Ly Dumas & Friends, fashion show on the closing of the Musée des Arts d'Afrique et d'Océanie, Paris
	SIMOD (Semaine Internationale de la Mode/Oumou Sy), Dakar (Senegal)
	Annual Fashion Show, Cameroon
	Model promotion, Douala (Cameroon)
	Workshop for the empowerment of San craftswomen in Ghanzi, Kalahari (Botswana), creation of the ostrich eggshell beads collection "Pearls of the Kalahari" (ready-to-wear version)
2003	Katoucha and Miss France fashion shows
	Workshop with San women for the "Pearls of the Kalahari" ready-to-wear collection in Windhoek (Namibia), training and quality control of the ostrich eggshell beads jewellery
	Fashion Show with the "Pearls of the Kalahari" haute couture collection at the National Art Gallery in Windhoek
	FIMA (Festival International de la Mode Africaine), Niamey (Niger) with the "Pearls of the Kalahari" haute couture collection, "Cheich d'Or" award 2003
2004	Fashion Week, Libreville (Gabon)
	Workshop with San women in Gobabis (Namibia), finalisation of the ostrich eggshell beads collection "Pearls of the Kalahari" (ready-to-wear version)
	Ethical Fashion Show, Paris, with the "Pearls of the Kalahari" haute couture collection
	Sira Vision with Collé Sow Ardo, Dakar (Senegal)
	Dakar Fashion Week, Senegal, with the "Pearls of the Kalahari" haute couture collection
2005	Afric' Collection, Douala (Cameroon)
	Cameroon Fashion Week
	Biotop, Lac Rose, Dakar (Senegal), with the "Pearls of the Kalahari" haute couture collection
	SAFW (South African Fashion Week), Johannesburg (South Africa) with the "Pearls of the Kalahari" collection
	TOP EBENE, Black model contest, organised by top model Katoucha, Fort de France (La Martinique, France)
	Ethical Fashion Show, Paris, with the "Pearls of the Kalahari" haute couture collection
2006	Sira Vision with Collé Sow Ardo, Dakar (Senegal)
2006	Collaboration with the fashion designer Imane Ayissi
2006	Black is Beautiful, Paris (fashion show at the Ecole des Beaux-Arts for the President of the Republic of Senegal, Abdullayi Wade)
	Prix H.B. pour la Paix, awarded by the Ambassador of Ivory Coast in Dakar (Senegal)
	TOP EBENE, Black model contest, organised by top model Katoucha, Dakar (Senegal)